INDIA

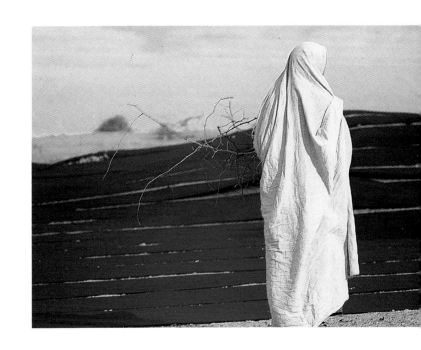

TIGER BOOKS INTERNATIONAL

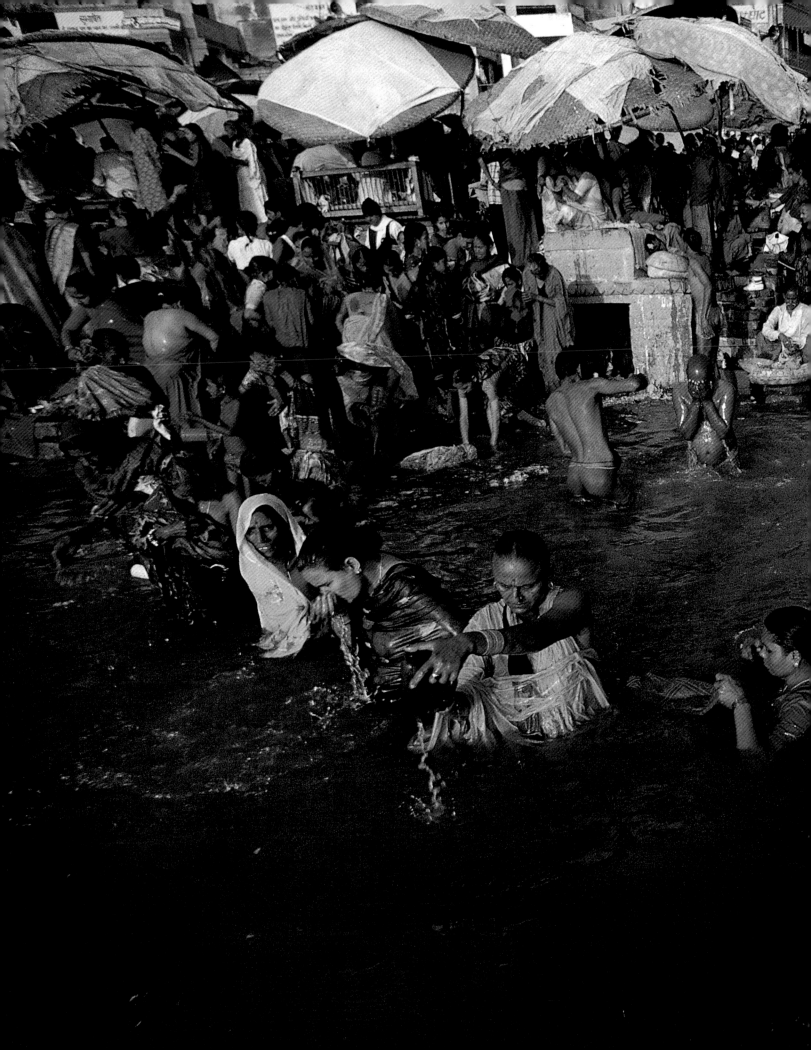

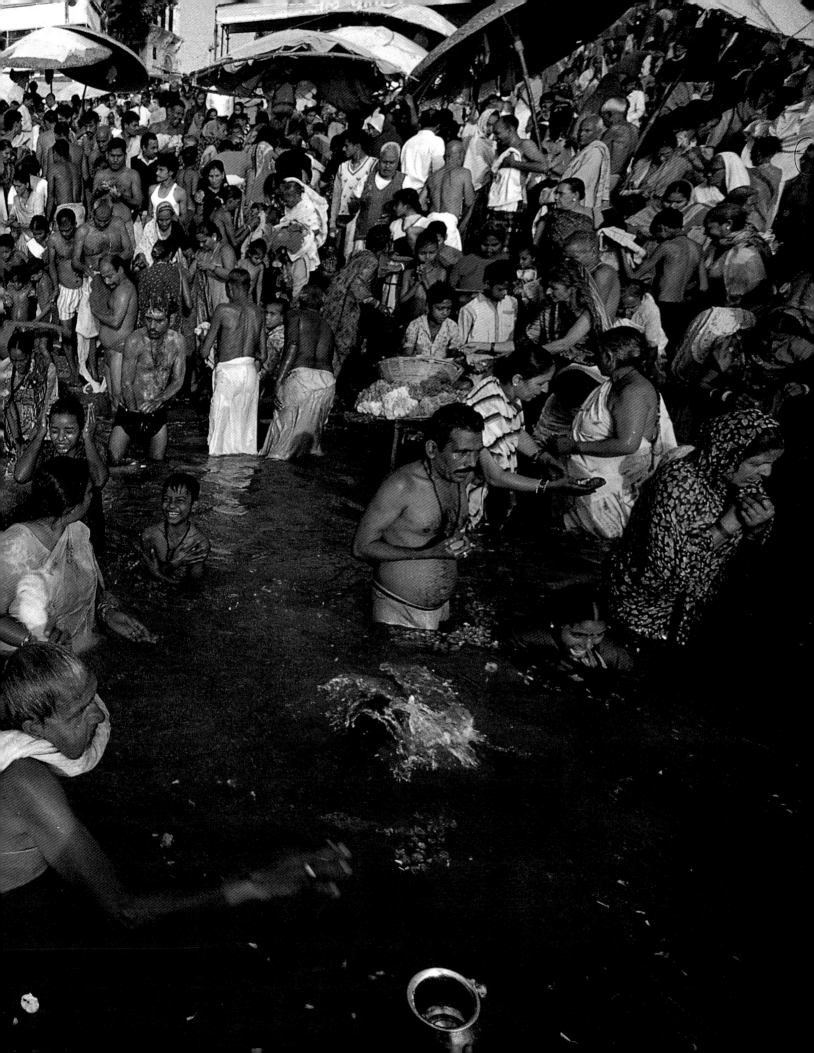

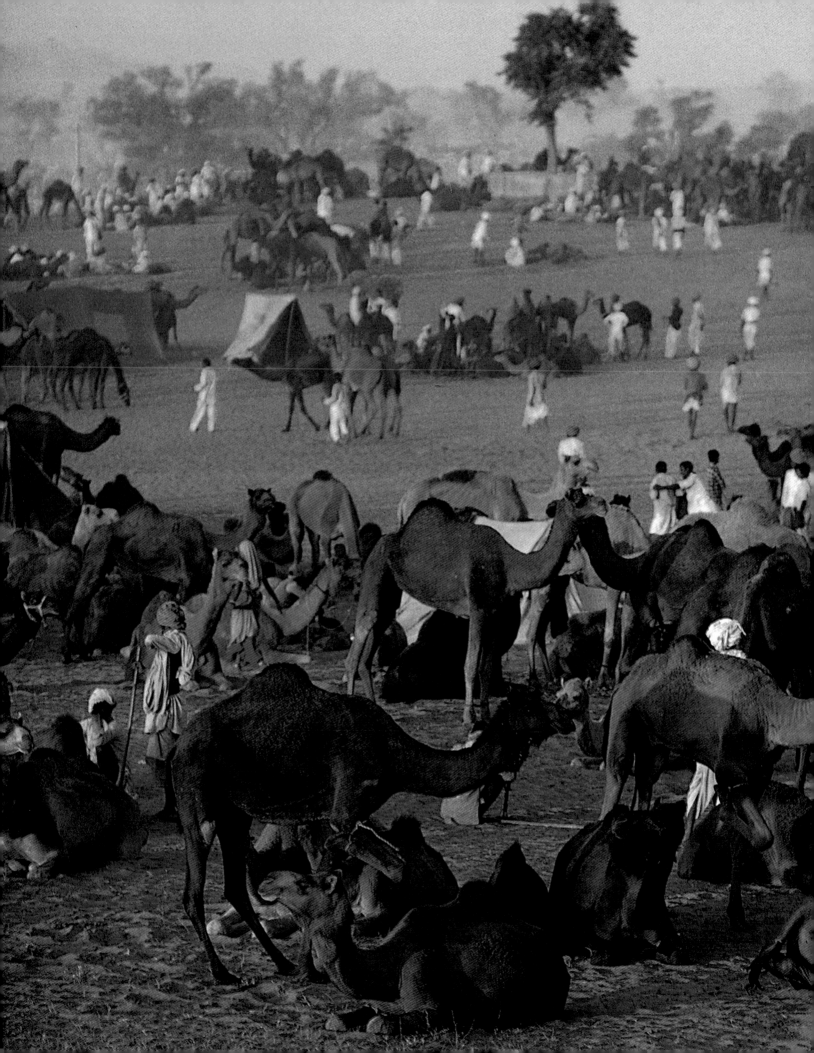

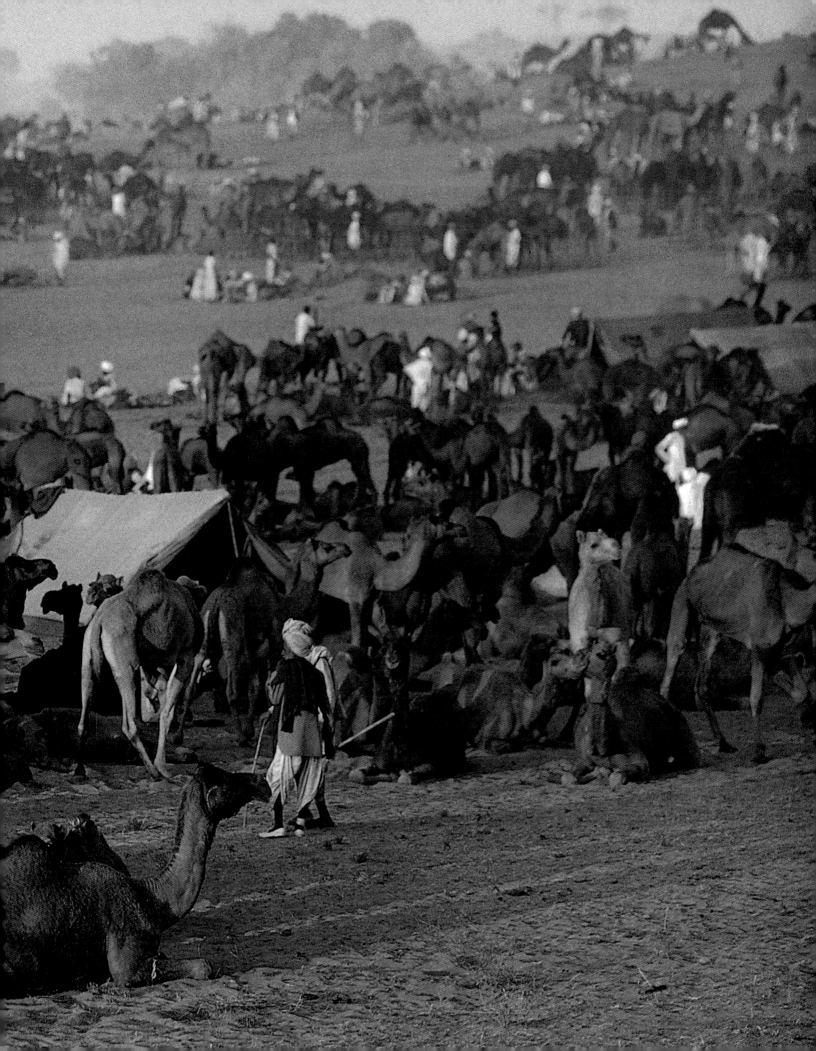

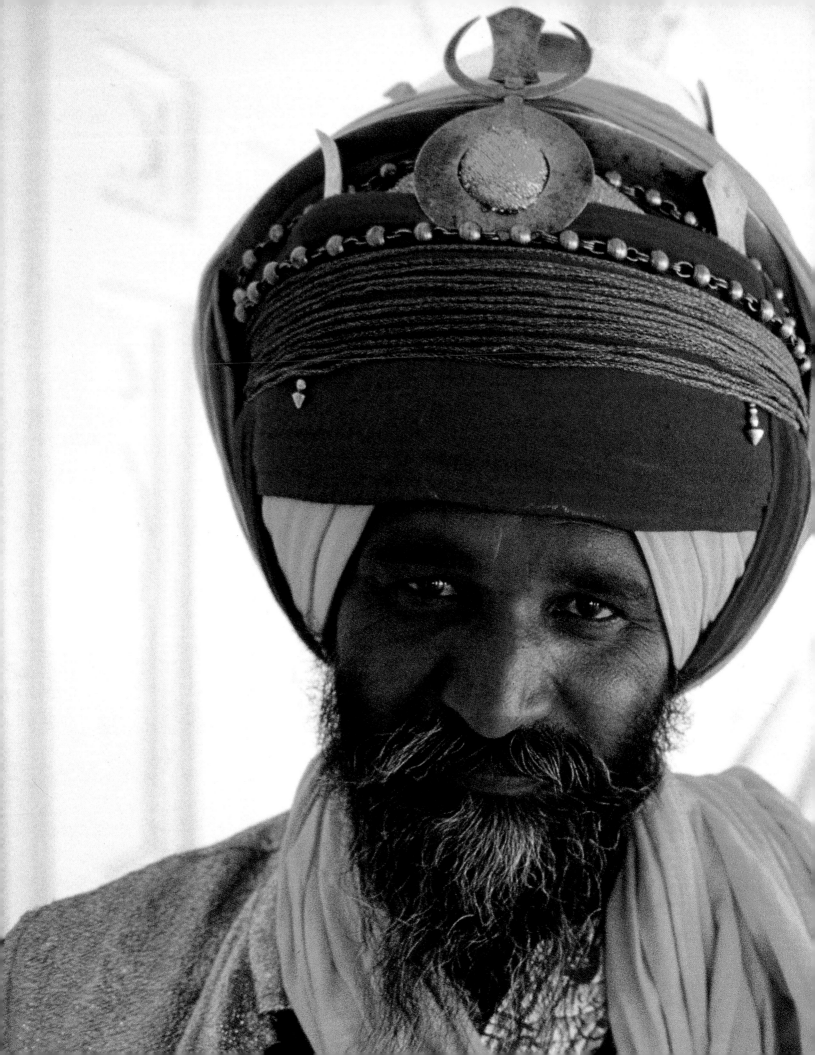

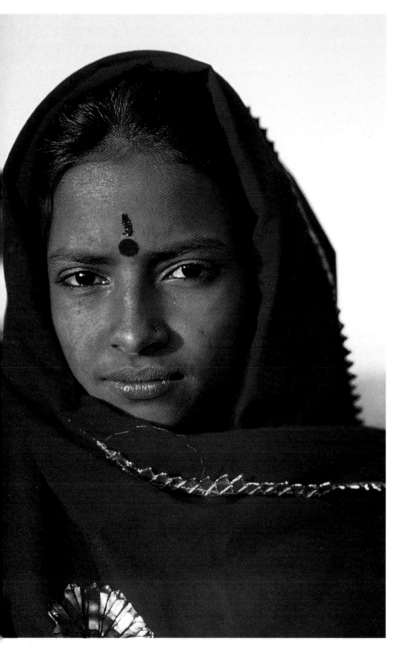

Text by
Adrian Mayer

Graphic design
Patrizia Balocco

Map
Arabella Lazzarin

Contents

1 *Fabrics, dyed in bright colours and laid out to dry in the sun, create a pleasing and harmonious contrast with the outfit worn by a woman of Rajasthan.*

2-3 *Hindus bathe in the river Ganges at the holy city of Varanasi. The river is worshipped as a goddess who descended to earth and is closely associated with Shiva, a central deity in the Hindu pantheon and the major presence in Varanasi.*

4-5 *The Rajasthan town of Pushkar's temples are the centre of pilgrimage at the autumnal full moon time. Many thousands then worship and immerse themselves in the adjacent lake. At the same time, some 50,000 cattle and camels are brought for an enormous fair and market, the centre of several days of festivity.*

6-7 *Sikhs follow a religion proclaimed by ten Teachers (guru) and enshrined in a Holy book. Its ascetic followers, such as this man, are known as the immortals". They can be distinguished by their blue turbans and yellow shawls.
Their headquarters are in a temple known as the Throne of the Timeless in Amritsar, Punjab.*

8 *A young woman, bearing on her forehead an auspicious mark, the tilak.*

9 *Guardians and deities on a temple spire in southern India. Such spires are highly decorated, every inch of space being worked.*

12-13 *The Jain religion stems from the teaching of a founder some 2,500 years ago. Its temple carvings, such as these on the 10th-century Parshvanatha temple at Khajuraho, resemble Hindu sculpture in depicting guardian animals and loving couples.*

14-15 *The Victoria Terminus is Bombay's busiest railway station, handling some 1000 trains daily. Designed by F. W. Stevens and opened in time for Queen Victoria's 1887 Jubilee, it presents a fascinating mixture of eastern and western architecture. Domes, pinnacles, turrets and arches combine to make it a cathedral to the age of steam.*

16-17 *Srinagar, the capital of Kashmir, is a well-known holiday centre, having mountains and lakes nearby and cool climate in summer. The first Britons to arrive were not allowed by the Maharaja to buy land; so they decided to live in houseboats, each a small apartment. The tradition lives on, making a stay in Srinagar a unique experience.*

18-19 *Surely the world's most famous building, the Taj Mahal at Agra was built by the Mughul emperor Shah Jehan as a resting place for his beloved wife Mumtaz Mahal. Taking from A.D. 1632 to 1653 to complete, its massive size is so transformed by its proportions and its form as to make it seem insubstantial and dreamlike.*

This edition published in 1994 by TIGER BOOKS INTERNATIONAL PLC , 26a York Street Twickenham TW1 3LJ, England.

First published by Edizioni White Star. Title of the original edition: India, un viaggio nel Paese dello spirito. © World copyright 1994 by Edizioni White Star, Via Candido Sassone 22/24, 13100 Vercelli, Italy.

ISBN 1-85501-478-5

Printed in Singapore by Tien Wah Press. Color separations by Magenta, Lit. Con., Singapore.

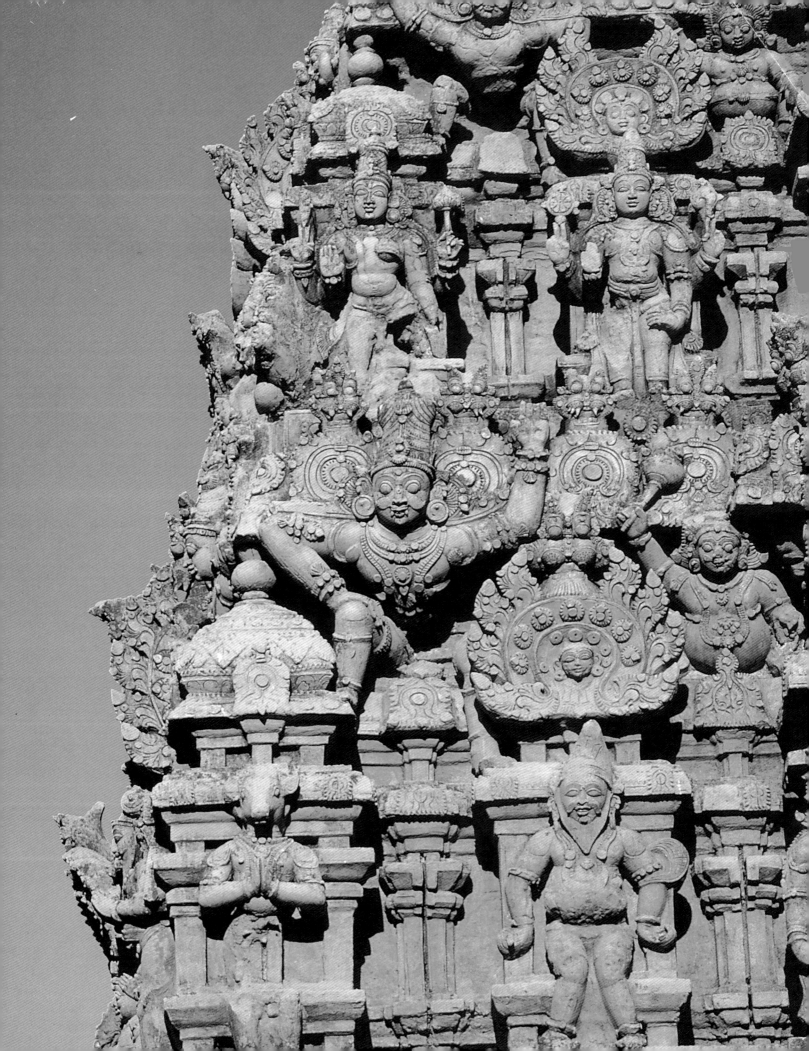

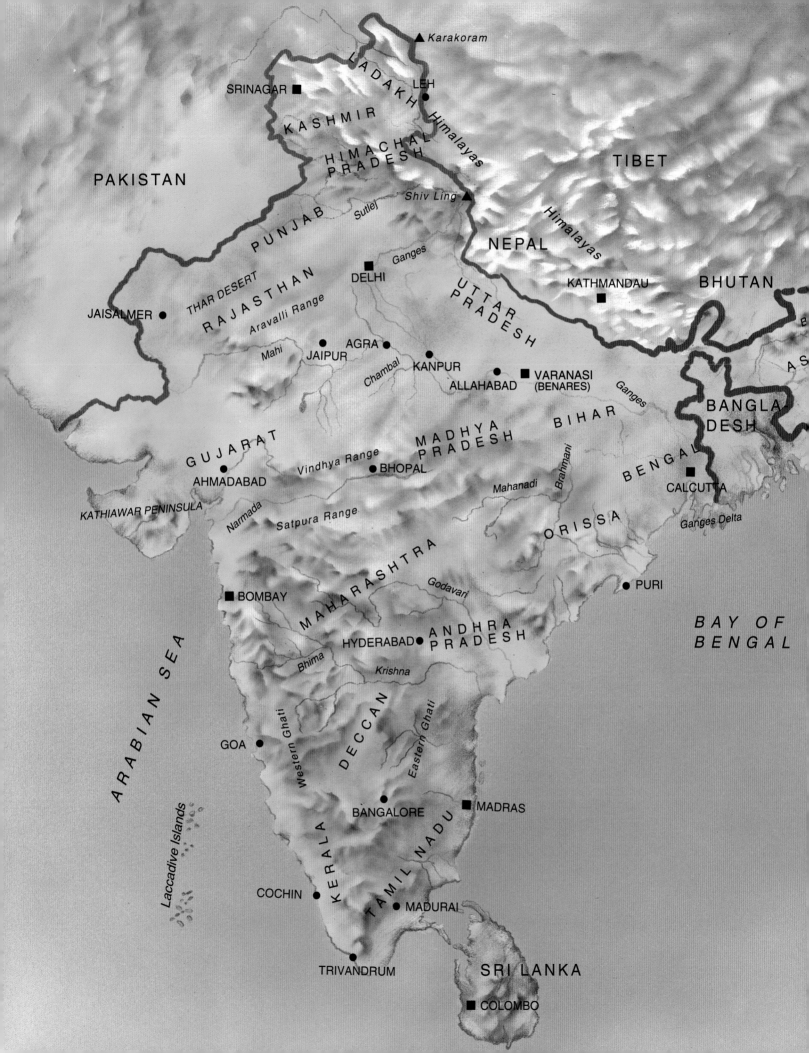

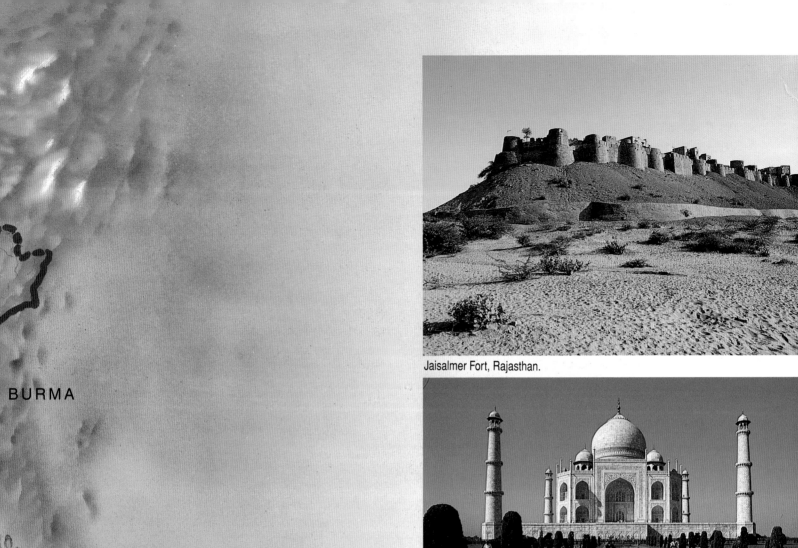

BURMA

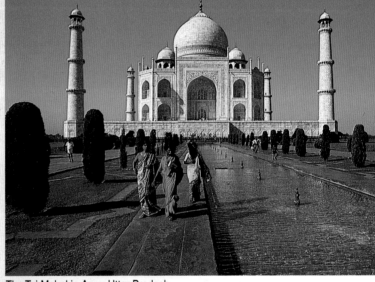

Jaisalmer Fort, Rajasthan.

The Taj Mahal in Agra, Uttar Pradesh.

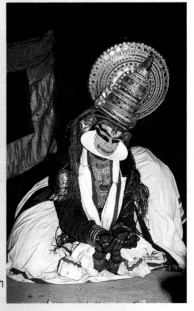

A kathakali dancer with
the typical costume.

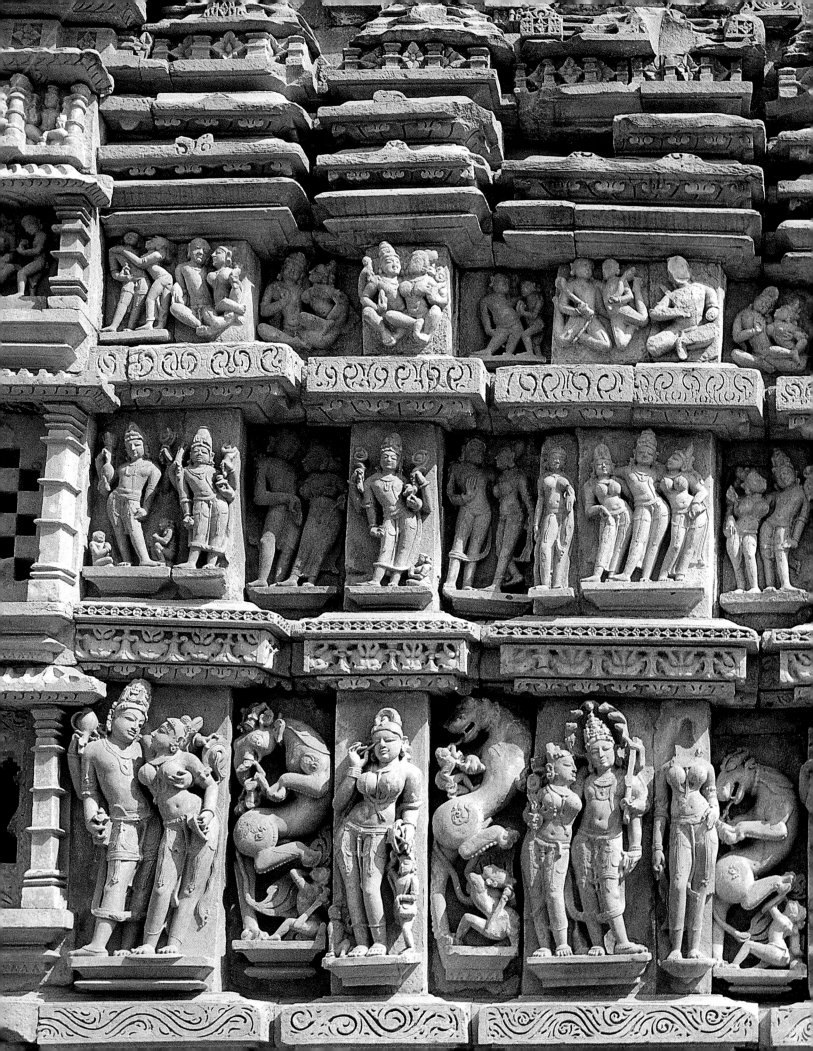

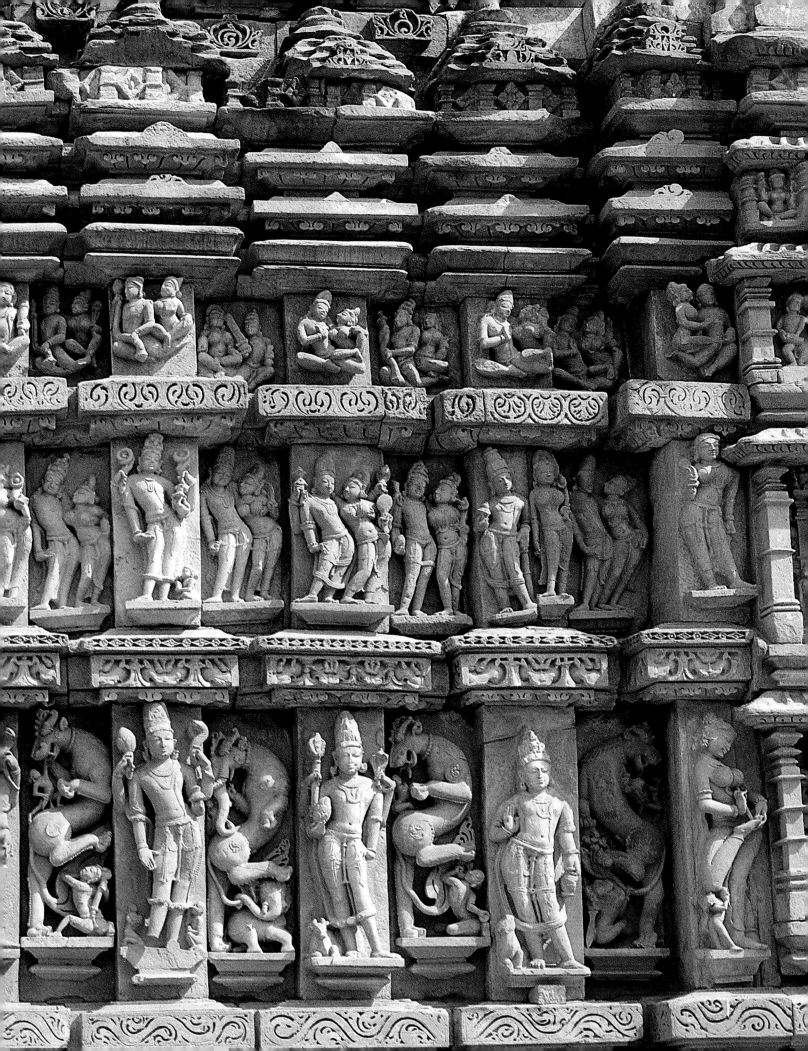

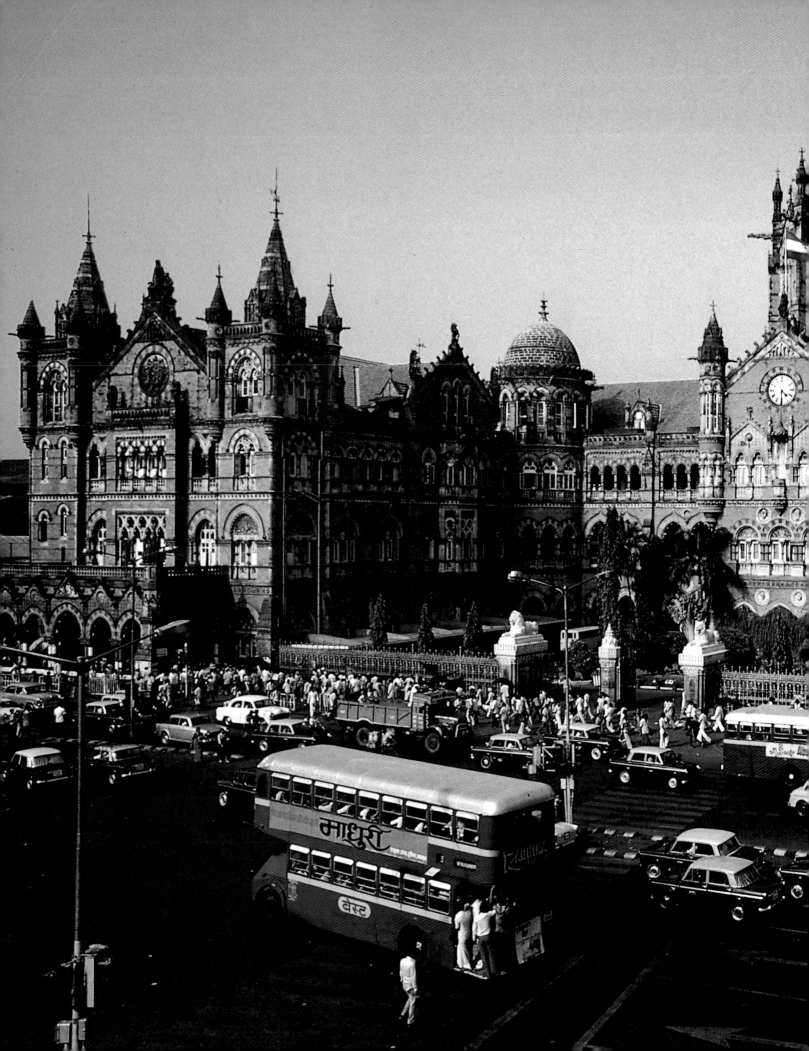

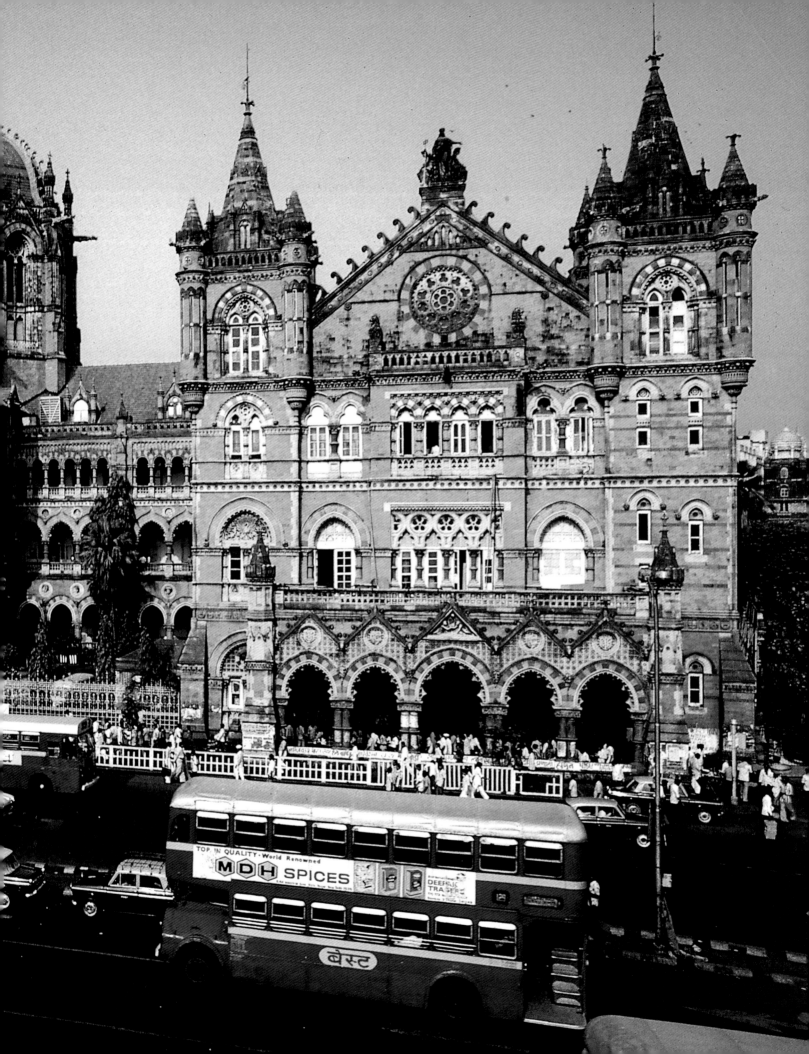

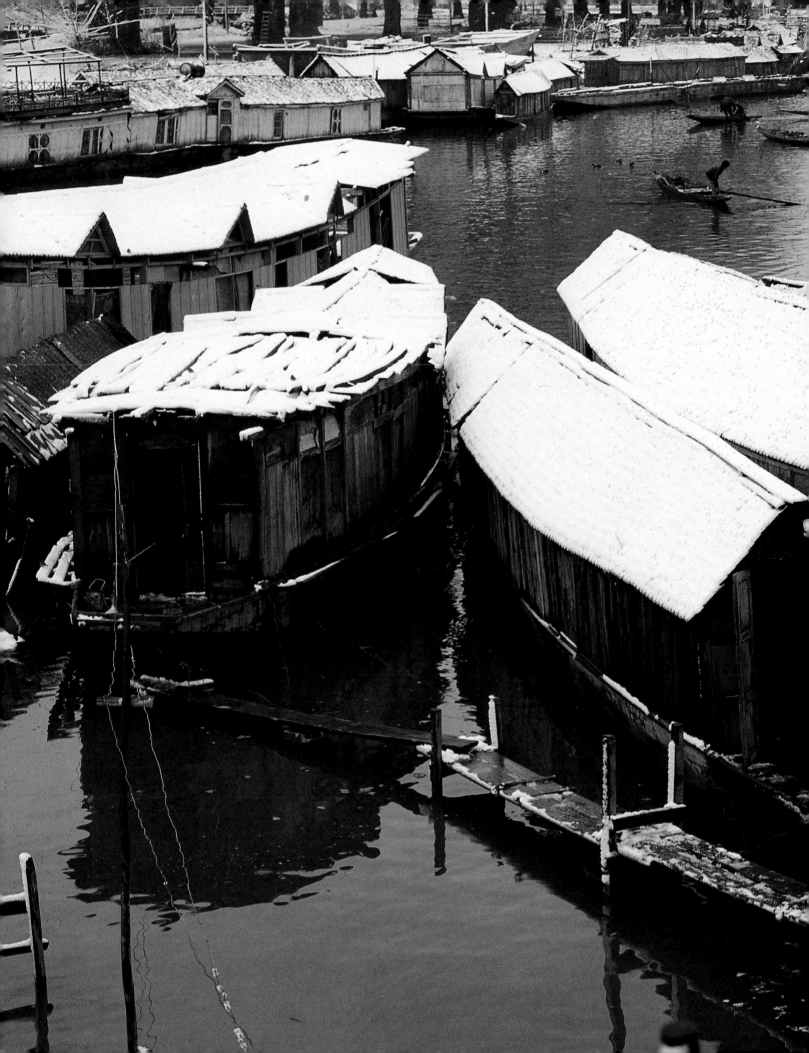

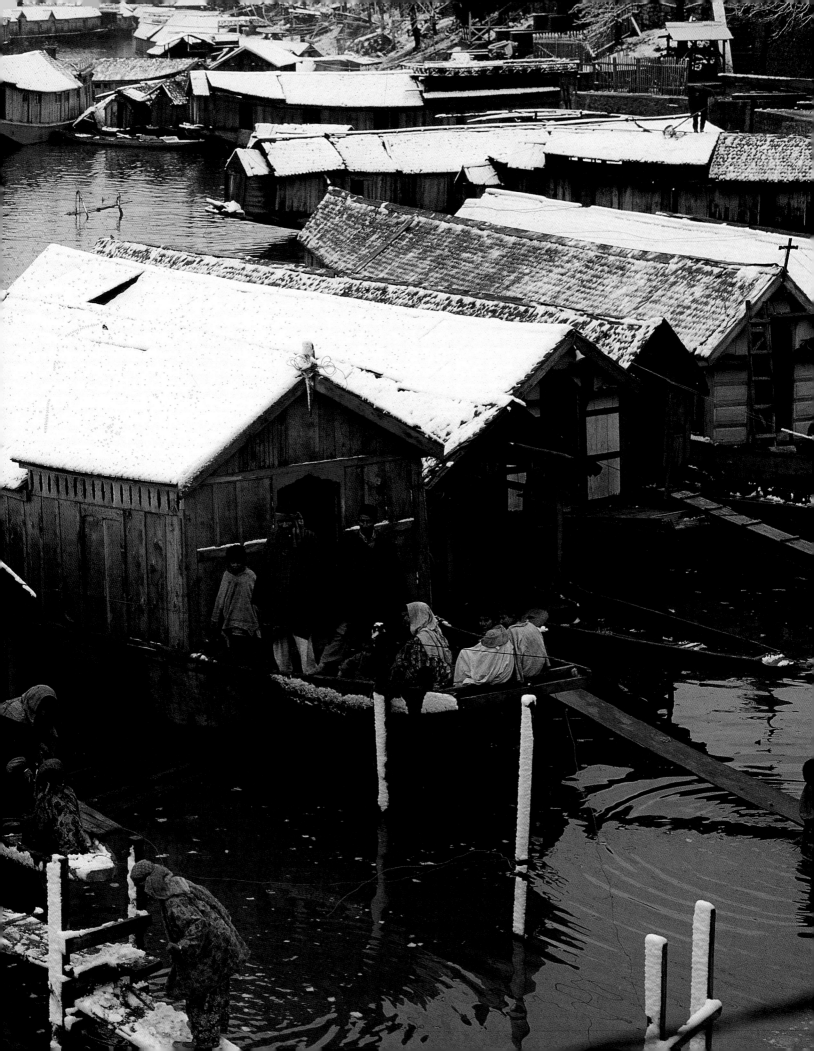

Introduction

Perhaps more than any other country in the world, India is a place of a natural, social and cultural variety that produces for visitors an endless series of surprises and pleasures. The reasons for this are not hard to find. Firstly, India is an enormous country, almost the size of western Europe, and contains more than 850 million people: small wonder that there should be regional differences of both physical and human scenery.

The second reason lies in India's recorded history of more than 4,000 years. During this time empires have risen and fallen, many religions have taken root and flourished and a succession of foreigners has settled after conquest or trade. The result is a luxuriant range of cultural forms - of language, dress, architecture, social organisation and so forth. Yet, over-arching these differences is a unity which is not only political but is based both on a common cultural heritage and on the adaptation of new elements to the traditional situation.

Here lies the fascination for the traveller. He sees the great temples, mosques and palaces which symbolise the highest aspiration of religions and kingdoms and form the milestones of this immense history: he sees the texture of life as it flows past the window of the bus or car, in city or village, a life-style which contains both the traditional and the modern: and in travelling through this vast country he meets the people of India, the world's largest democracy, lively people who respond to the interested and sympathetic traveller and who, however poor they are, have a strong sense of their cultural identity. But it is time to speak separately of some of the strands which go to make up the total experience of the traveller in India.

As to India's geographical variety, the northern side of the triangular peninsula is formed by the mighty Himalayas, their snowy peaks towering over delectable valleys and their glaciers producing the rivers which sweep down to the wide plain of the river Ganges, believed to be a nourishing goddess on whose bank stands the sacred city of Varanasi. To the west the land

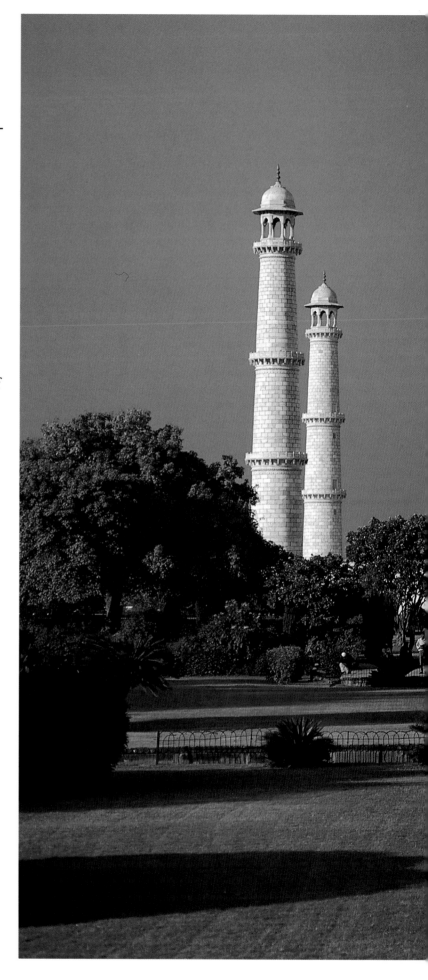

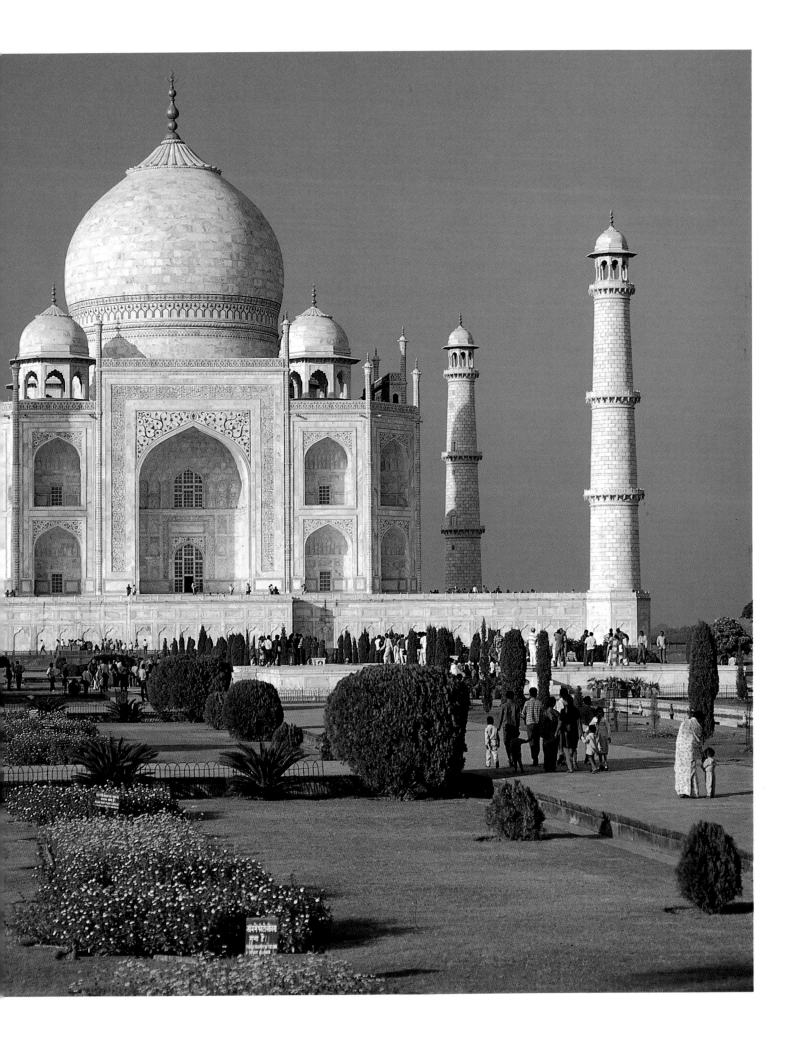

becomes increasingly dry until the arid lands of Rajasthan are reached: and to the east lie the flood-prone plains of Bangladesh and the dense jungles which mark the limits between south and southeast Asia. To the south, upland plateaux lead to the Deccan peninsula, whose hills are among the most ancient of the globe and whose eastern coasts contain rich river deltas, whilst on the west stretch the palm-fringed beaches of Kerala and Goa.

These regions have in the past supported a rich variety of wildlife. The Himalayas contain bears and musk deer; in Assam can be found the Indian rhinoceros and bison; in Gujarat are the only Asian lions and the Indian wild ass; and more generally, tiger, elephant, panther, cobra and python, and many species of deer can be found in the Indian jungles. There are also many species of birds, some indigenous and others migrants such as the rare Siberian crane. In modern times, the increase of hunting together with the clearing of jungles for agriculture and the use of pesticides has greatly diminished the wildlife population and threatened the continuance of some important species. The visitor can now hope to see animals mainly in the twenty or so wildlife sanctuaries and national parks located in different parts of the country.

The climate is dominated by the monsoon, the season of rains which follows a period of intense heat in April and May. These rains come to the southwest coast in June, breaking with violent but welcome intensity and proceeding inland with diminishing force. They bring life to the parched earth and start the annual round of agriculture.

By October the first monsoon is over, and it is the turn of rains sweeping in on the east coast to water the deltas of the Deccan. However, some regions often lie beyond the monsoon's reach, resulting in the variation between arid and lush countryside. The variation in rainfall is shown by the crops grown- from the verdant paddy in the southern deltas to the golden wheat of the Punjab, from the coconut palms of Kerala to the tall sugar cane of Maharashtra. The colours of soil and rock change as do the types of house and form of village, and with this goes cultural variation.

A major form of this is the language spoken. Constitutionally, India is a Union made up of twenty-five States and a number of centrally administered territories. Hindi, the national language, is spoken across most of northern

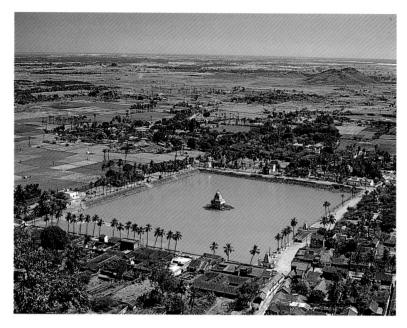

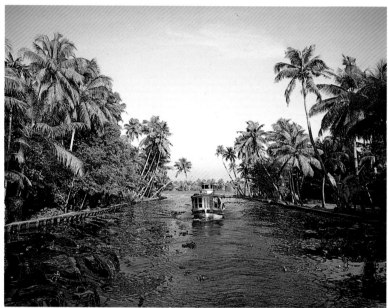

20 top *A landscape in the southern state of Tamilnadu. Tiled houses and irrigated fields of paddy (rice) cluster around a palm-fringed pond, at the centre of which is a small shrine. Further away stretches fallow land, cultivated only during the rainy season.*

20 bottom *Between Cochin and Quilon, on the southwest coast, a distance of one hundred miles, stretches a network of lakes and natural or manmade canals. Along these backwaters live families cultivating their fields and coconut groves. They provide a constantly changing scene for the traveller on one of the many passenger boats which ply the backwaters.*

21 top *Fishing is a major industry on the west coast of India. Traditionally, shallow fishing was done from the shore, as in the picture, or from canoes and small boats. More recently, mechanised deep-sea fishing has been introduced. A large variety of fish are caught, as well as lobsters and prawns.*

21 bottom *Kovalam, near to Trivandrum, the capital of Kerala, is a number of small beaches nestling between low headlands. Behind them stretch groves of coconut palms and fields of verdant paddy. There are many hotels, small and large, catering for those desiring a relaxed holiday.*

22-23 *The Keoladeo National Park, lying some 37 miles west of Agra, has always been a breeding ground for duck of all kinds. The shooting parties organised by the Maharaja of Bharatpur, in whose Princely State it lay before independence, were legendary. They included viceroys, visiting royalty, and many British and Indian notables. Since 1964 the place has been a nature reserve, which is now the home of over 300 varieties of bird, 80 of them duck. Many are annual migrants from southern India or from parts of northern Asia, although the most famous visitors, the Siberian cranes, are now almost extinct.*

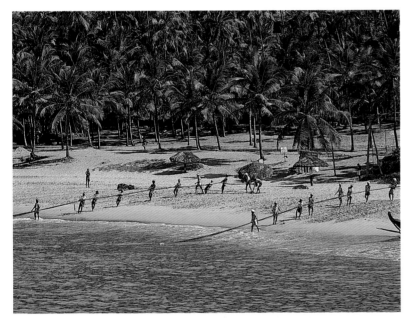

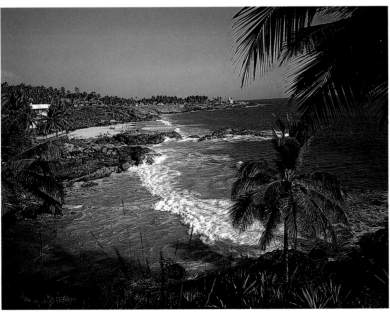

India, although taking different regional forms. However, the boundaries of an equal number of States coincide with areas in which others of India's officially recognised languages are spoken. Many of these languages have their own scripts as well as rich classical literatures; and with them tend to cluster other cultural differences - in dress and cuisine, for example, or in festivals and domestic customs. Variety does not end here: different social groups within each region may have their own traditions within a broadly similar pattern, and in some States there are tribal peoples having customs very different from those of the peasant population.

Besides the country's size, a reason for diversity lies in its location. The peninsula has been called a gigantic *cul-de-sac*, admitting invaders, traders and travellers from Iran and over the mountain passes from central Asia, but blocking with almost impenetrable country their further access to the east. Hence, each newcomer has both influenced and then been absorbed into an increasingly complex culture.

Inevitably, little is known about the earliest inhabitants of the sub-continent, who have left us stone implements, as well as rock drawings dating from about 5500 B.C.; and the culture of the Indus valley (2500-1500 B.C.) will largely retain its secrets until its script can be deciphered. The first of the arrivals about whom we know more were the Aryans, who came from central Asia during the second millennium B.C. Pastoral nomads, they brought with them a reverence for the cow and the language (Sanskrit) in which they conducted their rituals with hymns to the gods of the natural world. They were followed by Persians extending to India the empire of Cyrus, and then Alexander the Great in 323 B.C. Seeking fresh worlds to conquer, Alexander penetrated into the Punjab before his homesick men refused to go further and he was forced to return. In the centuries that followed, kingdoms were carved out in the northwest by both Greeks from their kingdoms in Afghanistan and by conquerors from central Asia.

In A.D. 711 the first raid into India was made by a chief adhering to a new faith - Islam. Then in 1192 the first Muslim kingdom was founded in Delhi. This became the seat of successive dynasties, which controlled varying extents of northern and central India and which lasted until 1527, when the final overland invaders, the Mughuls, took control. The heyday of the Mughul empire lasted for 150 years, with

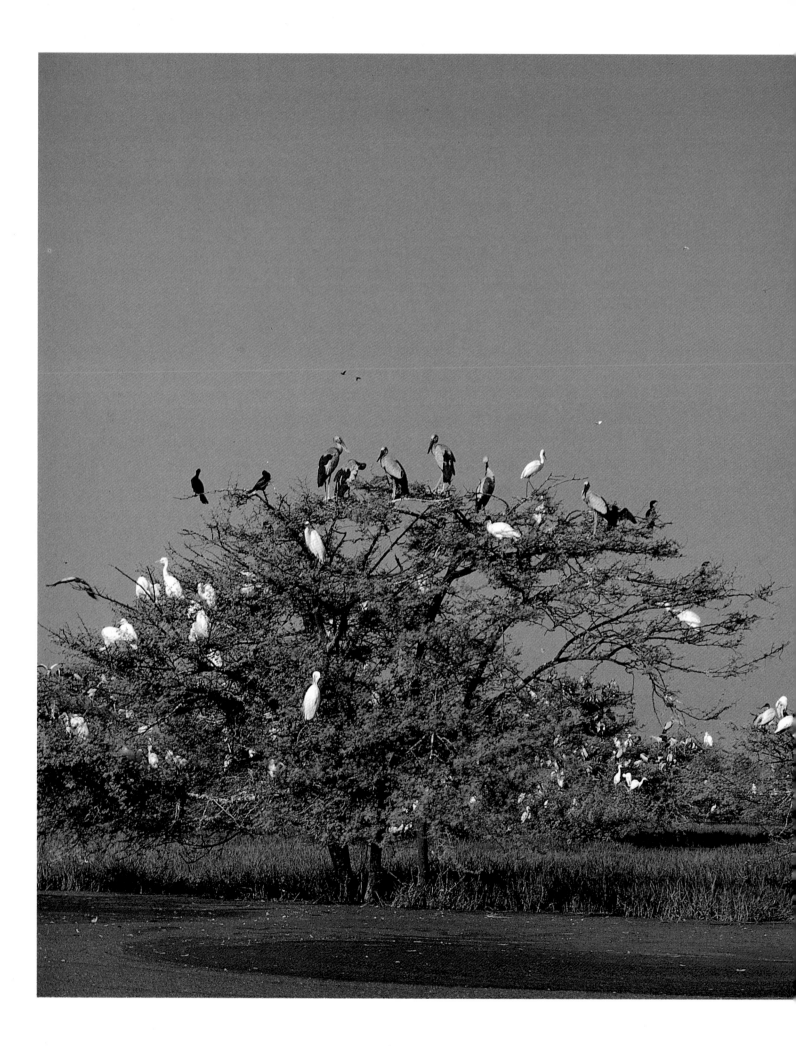

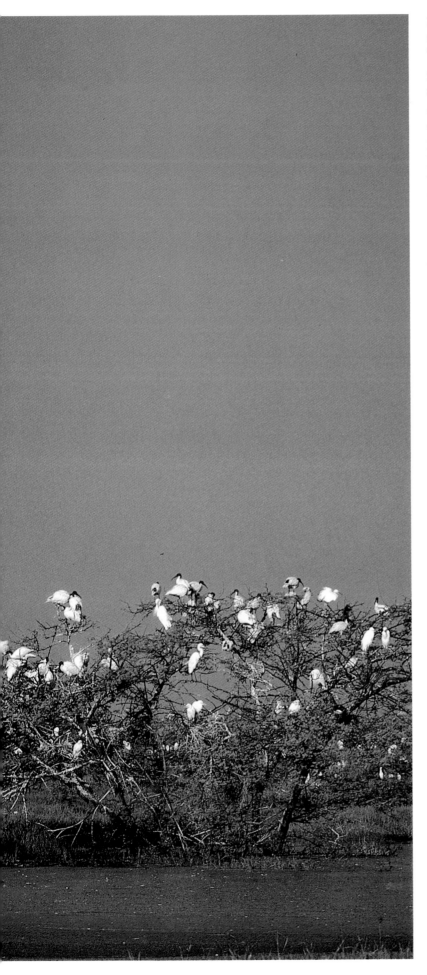

four great Emperors who ruled over all but the extreme south amid unparalleled magnificence. Then, into the power vacuum left by the empire's gradual dissolution came competing local kings and generals as well as European powers. Starting with Vasco de Gama's arrival by the direct sea route in 1498, a succession of European nations established settlements for trade with India. Some remained enclaves on the coast: but the French and British came to vie for control of the inland regions, the latter emerging as the sole European power in the land. By 1818 the British had defeated their Indian rivals and they established an empire which lasted until 1947, when it gave way to the independent nations of India and Pakistan.

Of course not all important dynasties were established by immigrants. The first great empire, the Maurya, embraced at its height in the 3rd century B.C. most of the subcontinent, a dominion equalled only by the Mughuls; and the Gupta empire in the 4th-5th centuries A.D. extended over northern India. Nor should one forget the great temple-building dynasties of the south - Pallava, Chola, Hoysala and many others - nor the empire of Vijayanagar whose ruined capital remains to impress and enchant us.

India's history is not unique in being a tale of constant struggle and warfare between kings, between a king and his rebellious nobles, between aspirants to a throne. Because of this, India contains a large number of royal centres. The palaces, temples and mosques that these men built provide the visitor with fascinating and beautiful places to see; and they show the development of art and architecture, especially of a religious nature. There are many religions in India, including Christianity, Judaism, Jainism, Sikhism and Zoroastrianism (the Parsees): but the three described below have been the most significant.

About 80% of India's population is classed as Hindu. But Hinduism is difficult to define, since there is no central organisation or single book of doctrine, neither is there one founder. Rather it is a cluster of beliefs and a way of life, within which variations of interpretation exist. If an origin there be, it exists in the meeting of the religion of the pastoral Aryans with the beliefs of the existing population over 3,000 years ago. The religion of the Aryans centred on gods with elemental powers - over fire, the sun, death, as well as the universe itself. Mainly masculine, these deities were combined with a local religion in part

centred on the spiritual powers inherent in natural objects, and in part based on cults of fertility.

In the ensuing centuries a religion grew up with many deities, bewildering to westerners used to monotheism. At the apex are three great gods. Brahma is the creator, a somewhat distant god to whom temples are seldom built. Vishnu is associated with the preservation of the universe and of the order within it. When disorder threatens, he is incarnated to defeat evil and restore the good - his incarnations can be seen in much temple sculpture, and are most famously evidenced in his two human forms, those of the ideal king Rama, and Krishna the lord and teacher. The third god has a more complex nature: Siva is both destroyer and creator, controlling change and containing within himself those contradictory elements which underline a dynamic world.

To this triumvirate of gods must be added the goddesses who are so important in Hindu belief. For it is the feminine element which has the spiritual potency to activate matter. Thus, each of the great gods has his consort, and is thereby made whole. But there are also the goddesses of pure energy: they have many names - Kali, Chamunda, Durga - but are as one in their dual nature, being both terrifying and destructive as well as gentle and supportive of the devotees who surrender to them.

In Hindu temples the visitor will see the goddess in both her guises, the great gods in their various manifestations, and the embodiments of many other deities who together make up a pantheon of divine aspects of that unbounded consciousness which is the universe.

The second of India's religions was founded by a prince who in the 6th century B.C. forsook his exalted place in the world to seek the remedy for the human predicament of dissatisfaction and desire. The Buddha achieved enlightenment in about 590 B.C., and thereafter taught his message of an ethical code of meditation and right action which would lead to freedom from desire and to personal fulfilment. After his death, the teaching continued through the monastic communities that the Buddha had established. The conversion of the Mauryan Emperor Asoka (273-232 B.C.) transformed this situation. For Asoka dedicated the rest of his reign to the spread of the doctrine, within and beyond India: and in this way, Buddhism became a world religion.

For a millenium it remained a major religion

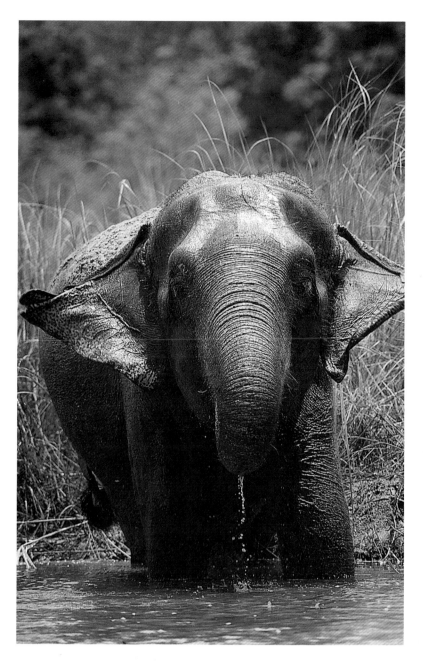

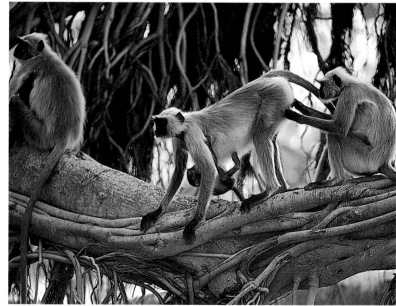

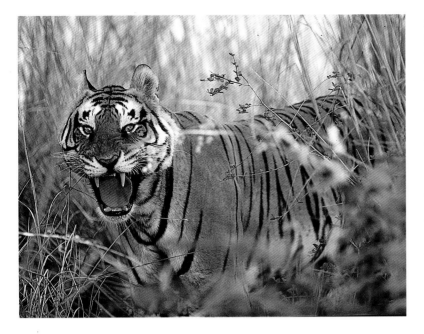

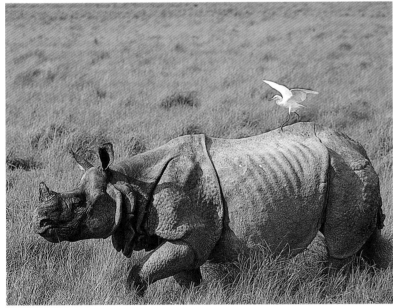

24 top *The Indian elephant is still found in southern India, the Himalayan foothills and Assam. It is still used in the forests, hauling tree trunks in inaccessible places. Besides this, it has a significant place in religious festivals and symbolism.*

24 bottom *Monkeys in India are highly adaptable, being found both in the wild as well as in groves of trees near villages and even in towns.*

25 top *The tiger was formerly plentiful, especially in the jungles maintained by the Princes for sport. Recently, poachers and the encroachment of humans into the forests have almost exterminated them.*

25 bottom *The Indian one-horned rhinoceros is to be found in two national parks in the northeastern state of Assam. Due to poaching its numbers are much reduced, although it is hoped to reverse this trend.*

26-27 *The festival in honour of Ganesh, the elephant-headed god who removes obstacles, is held in the rainy season. The god's image is installed in each locality of a town and worshipped for nine days. On the tenth, all the images are borne in a single procession to water, where they are immersed. The picture shows the young men of a Bombay locality, red with auspicious dye, bearing their image to Chowpatty beach, a popular spot on the Marine Drive.*

28-29 *On the border of Sikkim with Nepal lies the majestic Kangchenjunga, at 28,170 feet the world's third highest mountain. Its name literally means "Five ledges of snow", referring to the five peaks which make up the mountain. Traditionally, Kangchenjunga is seen by the Sikkimese as a deity, whose epiphet is "Chief Tiger" and whose nature is on the whole a mild and impassive one.*

in India. But then it gradually weakened in the face of a Hindu counter-reformation which partly incorporated the Buddha's teachings (and even his person as an incarnation of Vishnu): and Buddhism now has few followers in the land of its origin.

The third of the major religious influences was Islam, which took root in India with the establishment of the first Muslim kingdom. Like Hinduism, Islam provides its followers with a way of life as well as a system of belief. The Prophet Muhammed preached submission and obedience to the will of Allah as expressed through His revelation to the Prophet, the Qur'an. Also revealed were rules of correct behaviour, on the adherence to which depended the soul's fate at the final judgement. These rules were highly specific, resting not only on general injunctions (pilgrimage, prayer, alms etc.) but also on many details of civic and personal conduct. By contrast to Hinduism, Islam was a proselytising religion, and during the centuries many native inhabitants were converted. Though some were forcible conversions, more common were conversions through the influence of saints who represented the devotional (sufi) aspect of Islam. At present, over 10% of the population of India is Muslim.

Much Indian architecture is linked to these three religions. The earliest existing architecture is Buddhist and dates from a century after Asoka's reign. But it is not truly architecture, for existing buildings were of wood and brick and have not survived. Rather it is in the form of chambers cut into rocky hill faces - often called caves, though they are man-made. Because they contain pillars, rafters and all the form of a building's interior, we can surmise what the earlier freestanding buildings may have looked like. The most famous "caves" are at Ajanta and Ellora, but there are many other sites in the region, the later ones Hindu. They were used by monastic communities, some as places to live and others as prayer halls. Such chambers continued to be cut until the 9th century A.D.; the prayer halls contain *stupas*, the dome-shaped symbol of the universe which is a much older form, and was used as a place for sacred relics.

The first existing free-standing, stone structures are associated with the Gupta dynasty (4th-5th century A.D.). These are Hindu temples, and they are of a quite different form from Buddhist places of worship. For whereas the Buddhist devotees pray together in a open hall,

Hindu ritual is performed by a priest in a chamber called the "womb house" in front of the sacred image. The chamber is the central (and darkest) part of the temple, and access is restricted to the purified priest. In front is a pillared hall in which worshippers can gather, and over the chamber is a tower, symbolising the holy mountain, abode of the gods. On the inside and outside walls are sculptured images of the deities, their attendants, and the guardians and sustainers of the temple. The architecture is massive and without arches, being reminiscent of its "cave" origin. In the course of time, temples grew in size and magnificence, being sometimes embellished by even larger gateways to the courtyards in which they were situated. The style of spire, the pillars etc. changed over time and region. But the basic ground plan remained the same.

The very different form of the mosque reflects its origin. A mosque is, quite simply, a place reserved for prayer. In the early days, it was the courtyard of a house, or just a line drawn in the desert sand, behind which the devotees faced towards Mecca. This direction was marked by a spear thrust into the sand, or by a stone set into one wall of the courtyard. In time, this was replaced by an arched niche, beside it being a pulpit, and over these a vault which amplified the prayer leader's voice to the congregation. Later, arches and arcades were added, as well as domes: and calligraphy and geometric patterns of great elegance adorned the walls. But the mosque remains simple in design, its courtyard an oasis of purity and quiet for both individual and congregational prayer. Similarly the many mausolea, of which the Taj Mahal is the crowning glory, stand majestically in enclosed gardens symbolising paradise, in one wall of which a mosque allows prayers for the dead to be offered.

India is a land of forts, built on mountain tops, in deserts or on the banks of rivers. Some are quite small, others contain towns or even cities within their walls. Many have stirring traditions of bravery, of sieges and of sackings when warriors sallied out to certain death and their womenfolk immolated themselves rather than accept dishonour. Though fortified places have been built from the earliest times, the existing sites are those of Hindu and Muslim rulers over the past millenium. The architecture of their palaces reflects both the native Hindu tradition as well as the influence of Muslim overlords. Best known are the massive fort-palaces built by the Mughul emperors at Agra and Delhi

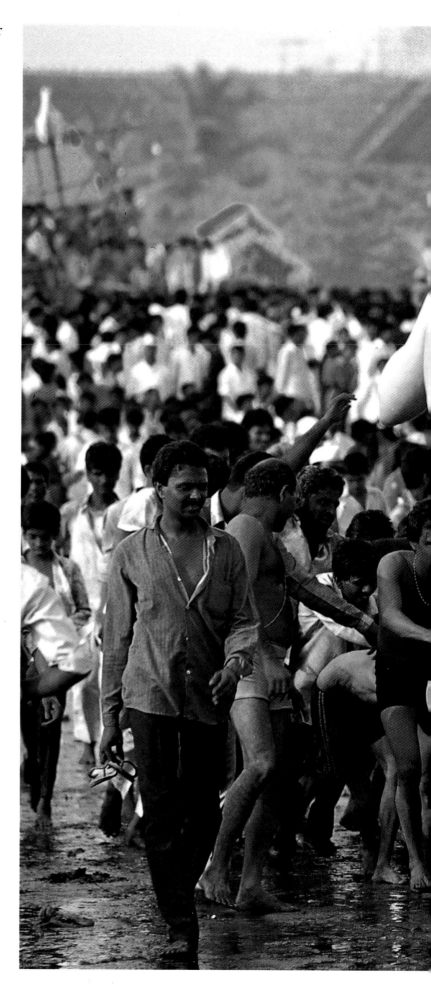

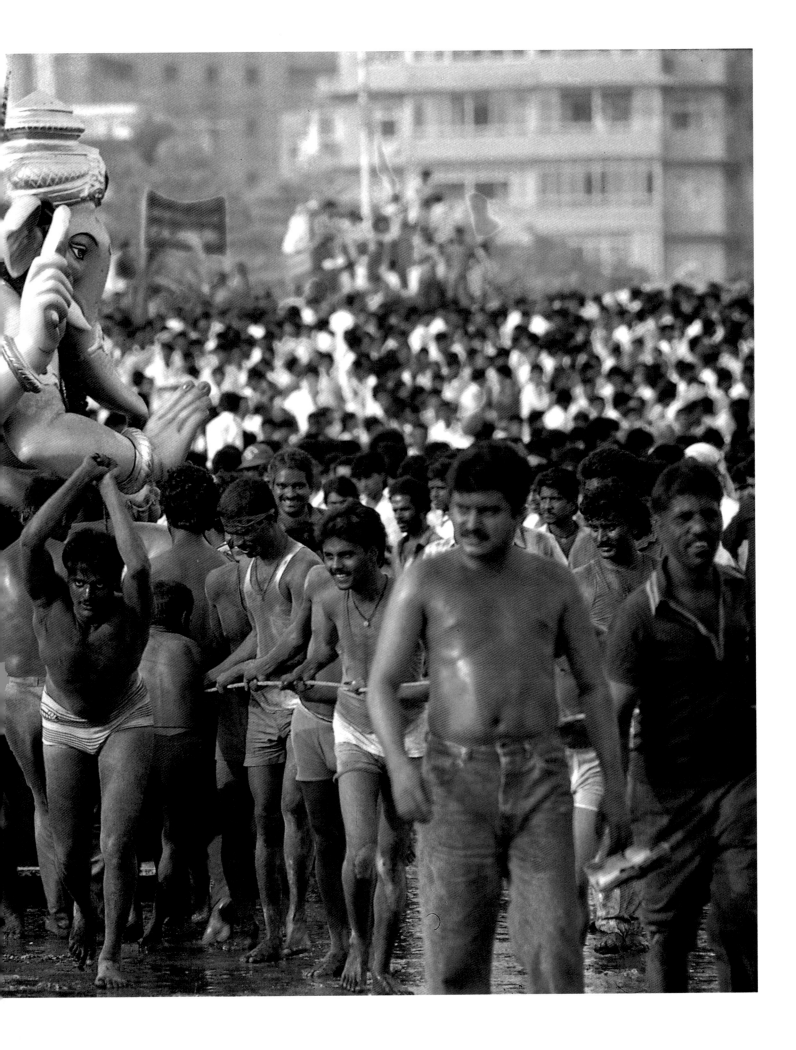

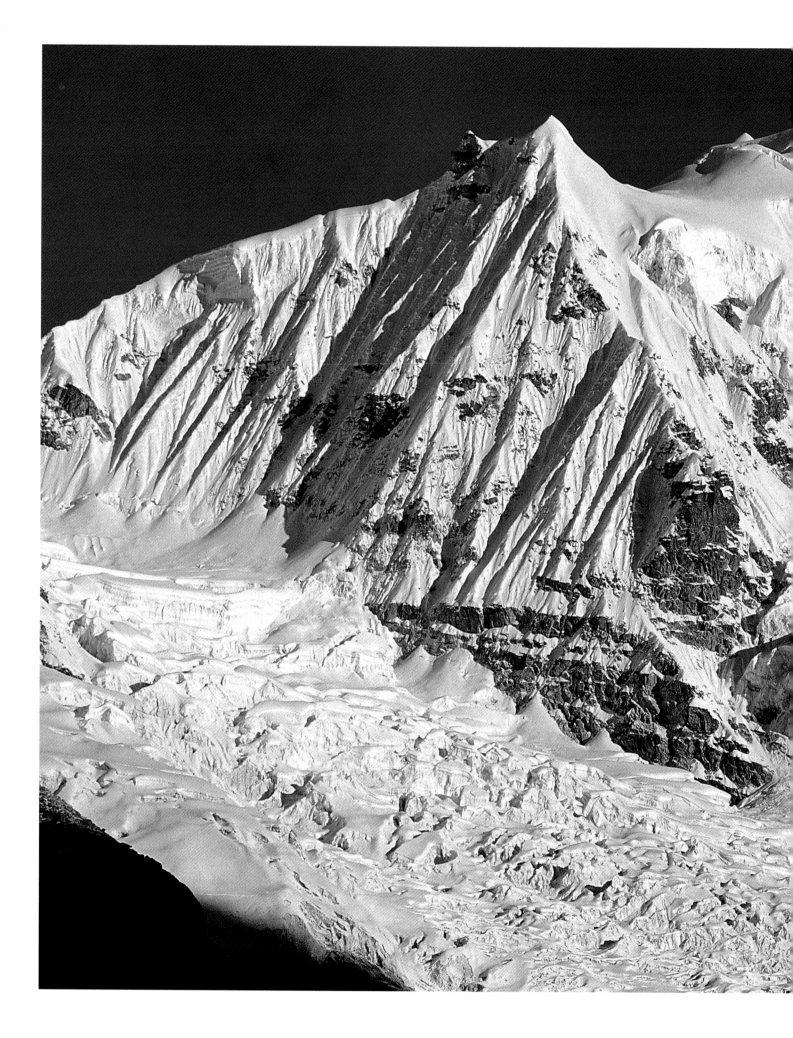

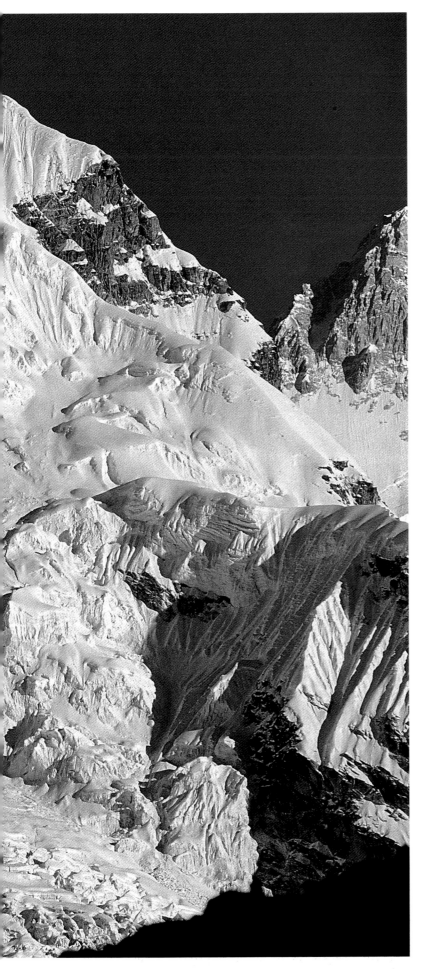

and the magnificent fortresses of Rajasthan, until 1948 the capitals of Maharajas. Visitors can wander over all of India in search of these evocative and often romantically sited places. The courts were not only seats of political power: their rulers were also patrons of the arts.

Wall painting has a long history in India, most monuments and sculptures formerly being painted; but the only substantial remains are at Ajanta where 5th-century A.D. murals provide unforgettably graceful images of the life of that time and of the Buddhist world. Much commoner are illustrated manuscripts of mainly Hindu religious texts, the earliest dating from the 11th century A.D. Later, the Mughul emperors were connoisseurs who encouraged both Indian and Persian artists to produce miniatures which delight the eye by their delicacy and mastery of line. These in turn stimulated the rulers of the Rajput states of northern India into patronising schools of painting which explored the natural world, Hindu mythology and the daily life of the ruler. The visitors will see these paintings in palaces and museums, and may also have the opportunity to hear classical music and see one of the several styles of dance at public performances.

Urban living has a long tradition in the sub-continent, for the Indus culture existed in well-planned towns. Over the centuries many cities have grown up whose houses cluster around a centre of rule - a palace or a fort - as well as a market centre. Other cities have had as their focus a holy place, which has grown into a centre of pilgrimage. Such a city is Varanasi, the home of Lord Siva, whose presence promises salvation for those who die within its boundaries. In marked contrast are the port cities - Bombay, Madras and Calcutta - founded by the British in the 17th century, which are now amongst the world's largest metropoli. The visitor will see traditional houses, temples and public buildings in the older places, as well as the modern sections which have more recently grown up: and in Bombay and Calcutta he will be struck by the variety of architectural styles, ranging from classical and gothic buildings (many constructed in the 19th century) which replicate those in Europe, to constructions which blend western and eastern architecture in unique and surprising ways.

A Life of Colours and Contrasts

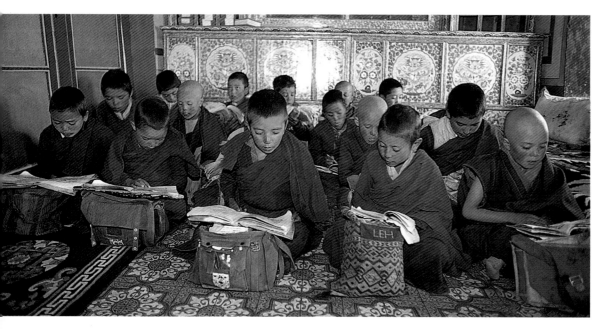

30 top *Buddhism originated in India and flourished there for over 1,000 years. But by the end of the 10th century A.D. Hinduism had reasserted its hold, and Buddhism became restricted to a few mountainous regions, such as Ladakh and Sikkim. Here, some novices recite their prayers at a monastery near Leh, the capital of Ladakh.*

30 bottom *Groups of Sikh children study in the open air, not far from Jalandar, in the Punjab. The name of this region, which is heavily populated with Sikhs, derives from the Persian invasion. Because of the five rivers that flow through this region, in fact, the Persians named it* Panj, *meaning "five",* -aab, *meaning "waters".*

31 *A young woman of western India. Rather than a sari, she is wearing a full skirt and bodice together with a long shawl, of the kind which is feminine wear in Rajasthan and other western regions.*

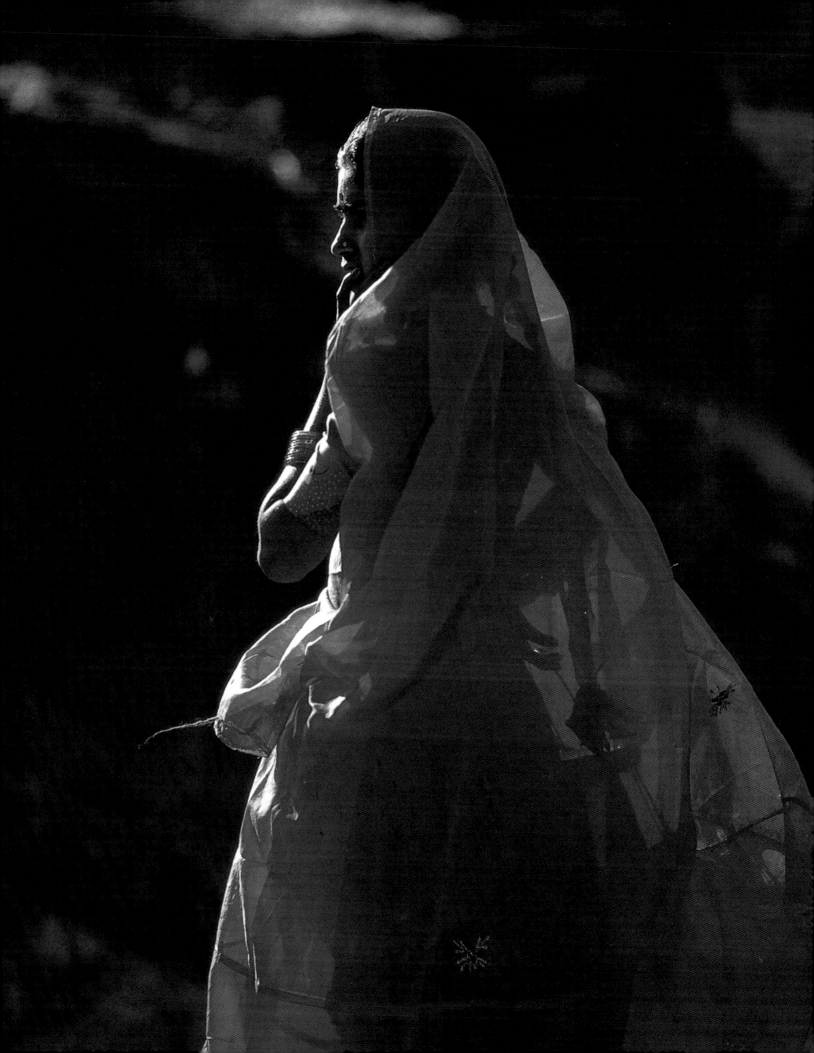

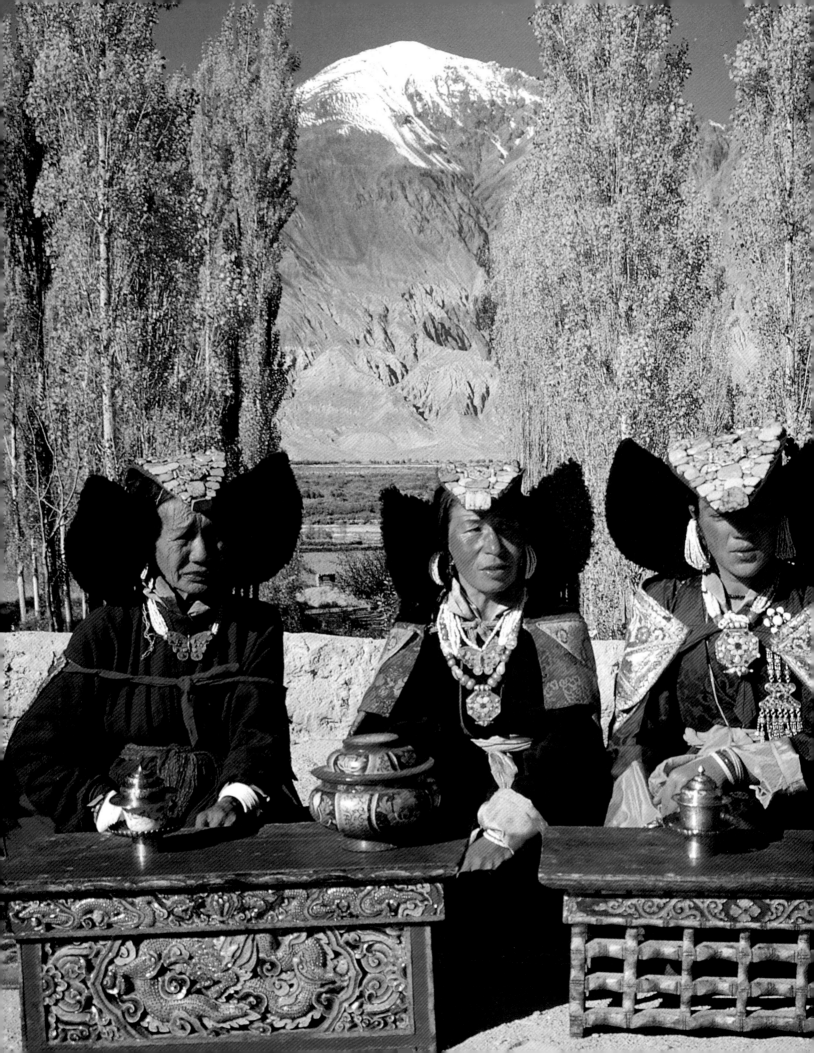

The Elevated Regions

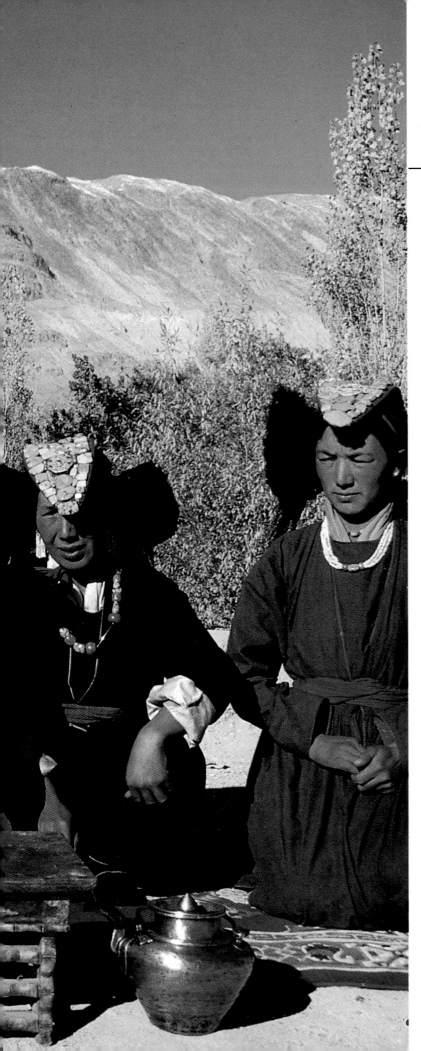

32 *A group of women from the northern region of Ladakh, and specifically from the valley of Nubra, show off their sumptuous traditional dress. The most distinctive feature of the entire outfit is their* perak, *a type of headgear formed by a stole that is literally covered with turquoise stones.*

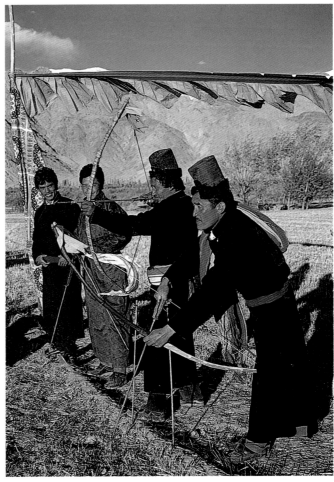

33 *An archery contest is about to start in a village near Leh, Ladakh. Archery is an important sport in several Himalayan regions, being the national sport in Bhutan, where teams are cheered on by large numbers of supporters.*

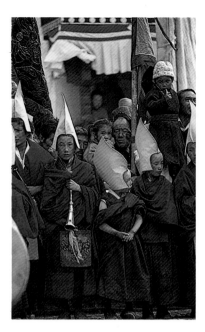

34 In these photographs, we see two phases of the religious festival that is held every year at Thikse. This monastery is one of the most important religious buildings in Ladakh, and it houses hundreds of monks. It was built in the fifteenth century in the mountains south of Leh. In the photograph above, a group of young monks belonging to the Yellow Hat sect take part in a ceremony. At the bottom is shown a phase of the ritual representation that involves a series of dances performed by monks disguised with wooden masks.

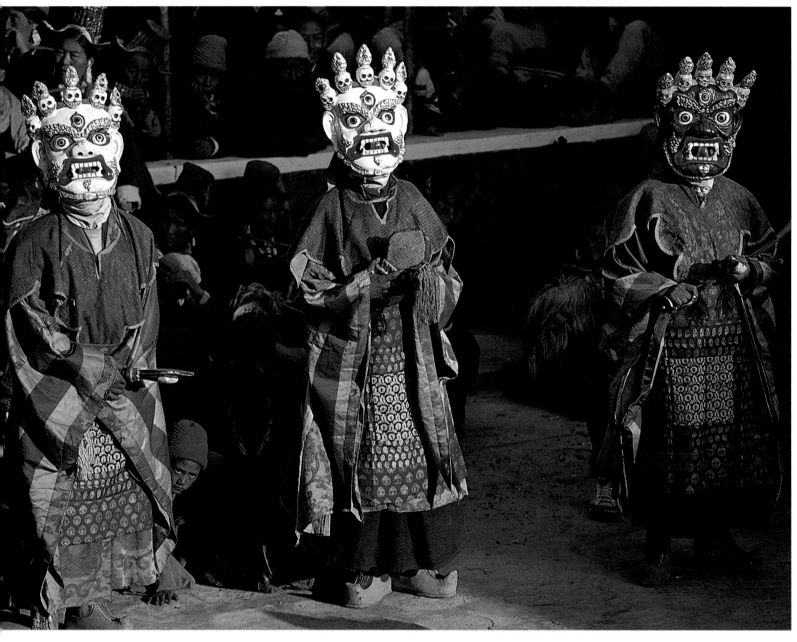

35 *Buddhism came to the mountain state of Sikkim in the 18th century, brought by monks from Tibet. There are now over fifty monasteries, both in the capital Gangtok and in the countryside, dominated by the eternal snows of Mount Kangchenjunga. One of the largest and most magnificent of these is the Rumtek monastery. It is the seat of the Karmapa Lama, a highly revered spiritual figure who is head of the Kagyupa sect of Tibetan Buddhism, founded in the 11th century.*

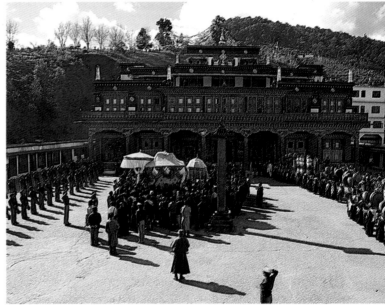

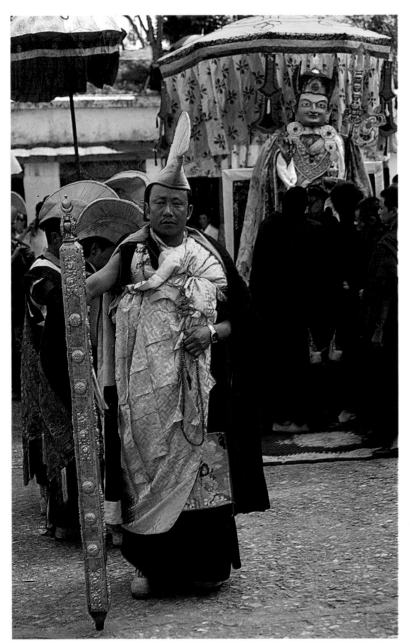

The Rumtek monastery is built in the traditional style of Tibetan architecture, though the present buildings are modern, replacing those damaged in an earthquake. The picture shows the main building, vividly painted both inside and outside with Buddhist divinities and fierce guardian figures. In the courtyard we see the procession and part of the large gathering which took part in the funeral of the late Karmapa Lama.

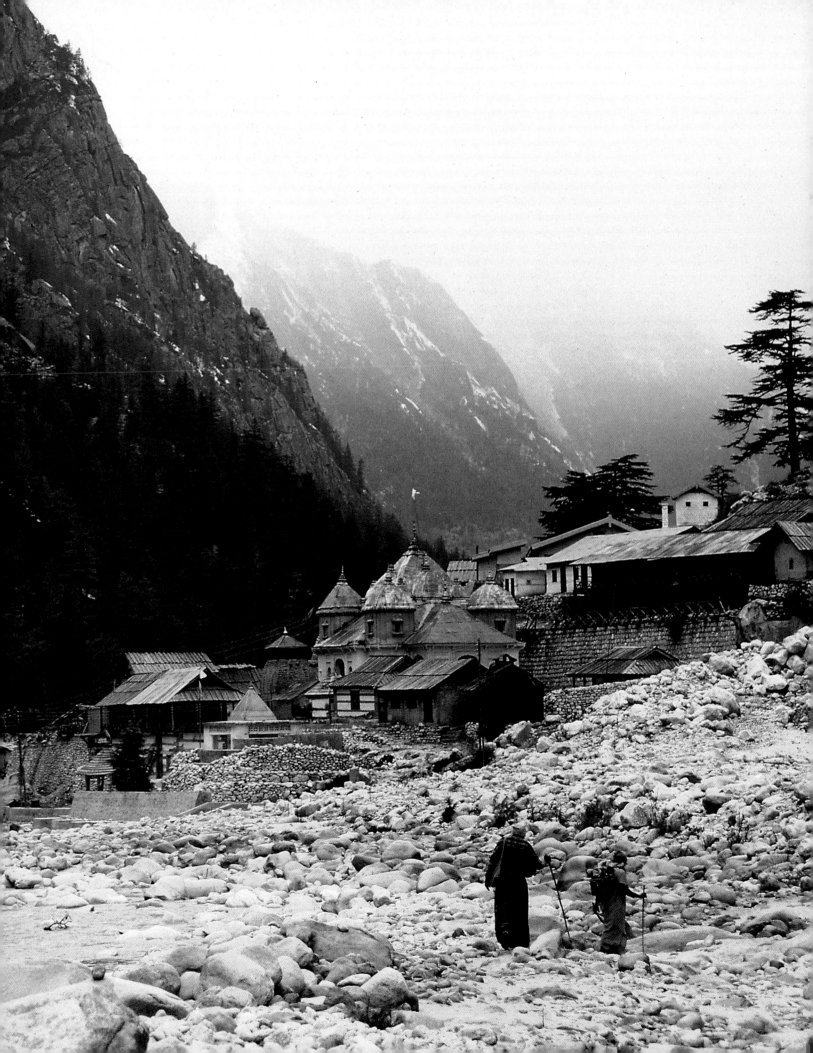

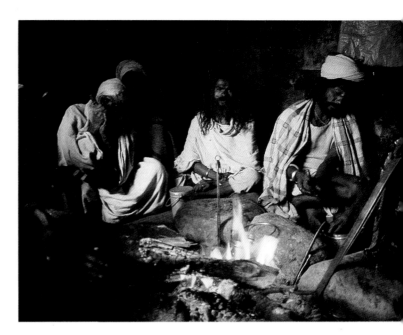

36-37 *Gangotri is a small village located in the far northern area of Uttar Pradesh. This town is the inhabited center closest to the source of the Sacred River - the Ganges. Here, the main inhabitants are* sadhu *- these are holy men who devote their entire lives to contemplation and meditation. It is said that these holy men survive on no other nourishment than rays of sunlight, and that they live to be three or four hundred years old.*

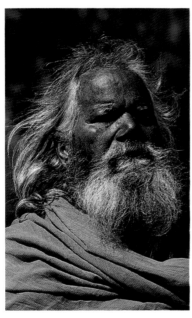

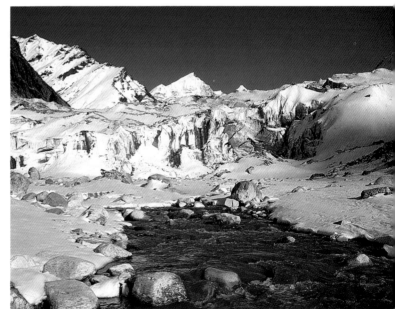

37 centre and bottom *The Ganges rises from Mount Shivling, and specifically from the Gaumukh glacier; this mountain is sacred to Hindus and to* sadhus.

38-39 *These rocks, shaped by the flowing waters of the Ganges, accommodate a* sadhu *engaged in meditation, seated in the distinctive lotus position, or* padmasana.

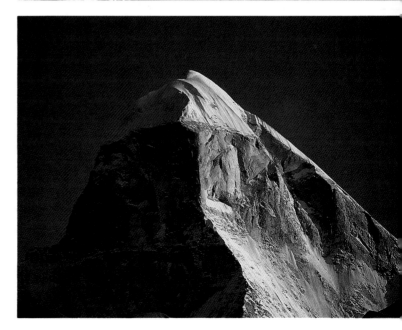

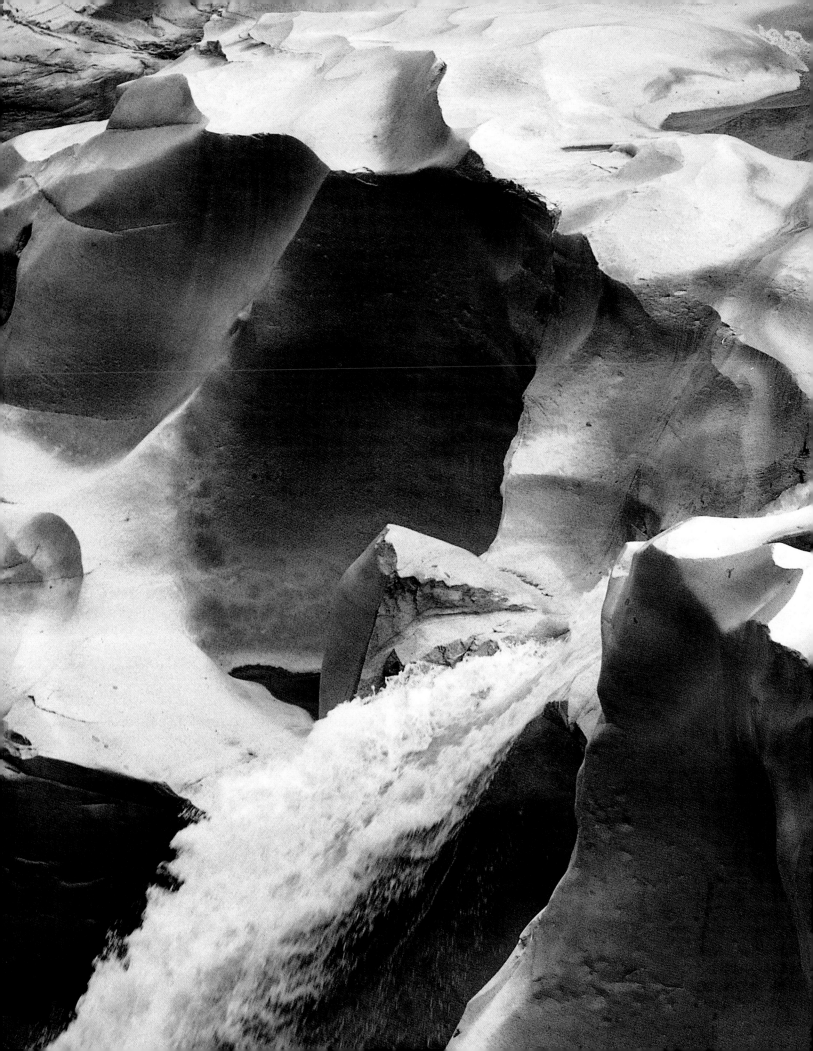

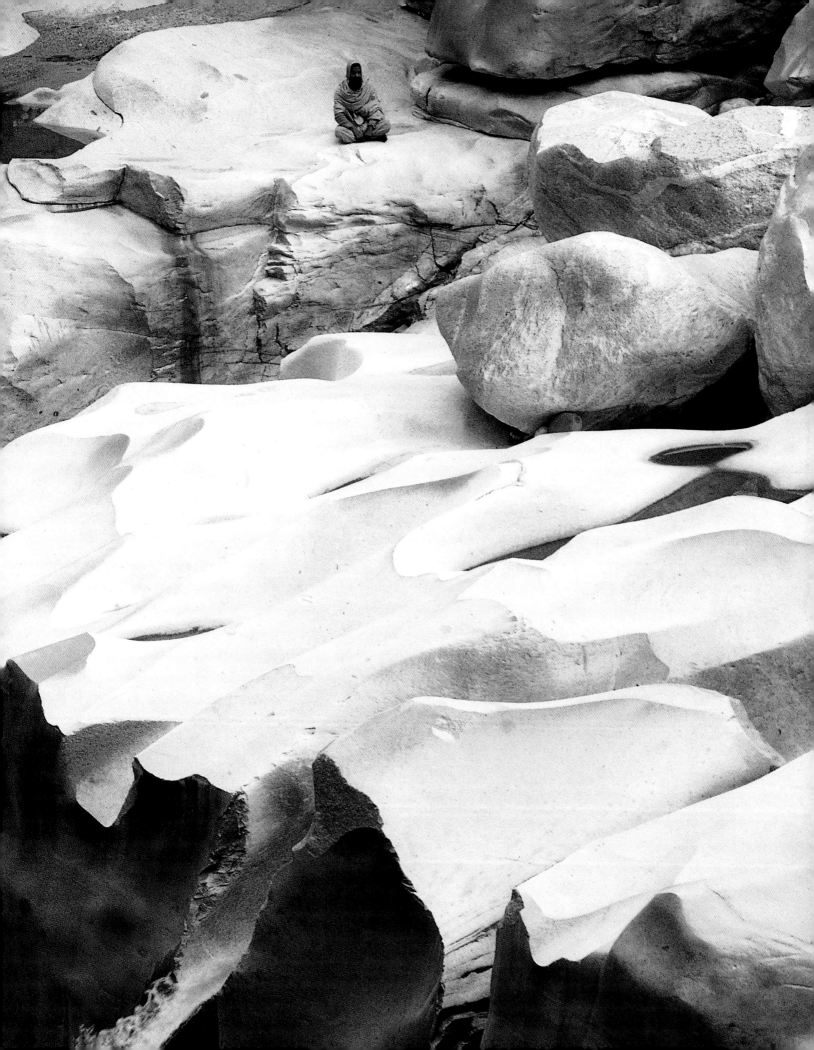

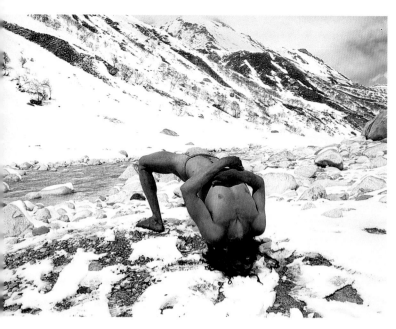

40-41 *Yoga is a system of thought which advocates the suppression of all mental activities as a means of reaching the true light of the spirit. To this end, devotees first discipline the body through posture and the regulation of breath. This enables them to proceed with exercises in contemplation and concentration until the mind is dissolved and true illumination ensues. Here we see an ascetic engaged in such yogic exercises, having achieved a detachment of the senses which makes him impervious to the surrounding snow and ice.*

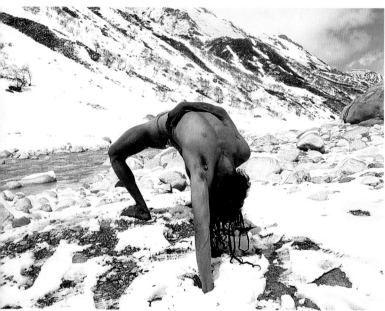

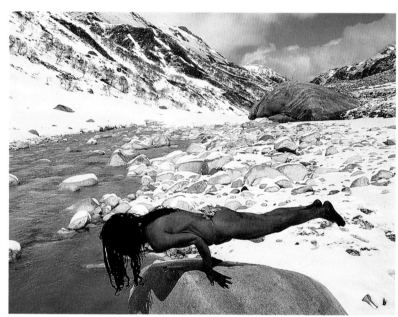

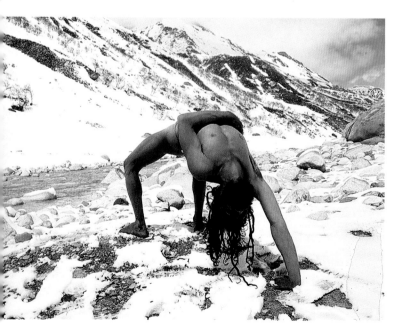

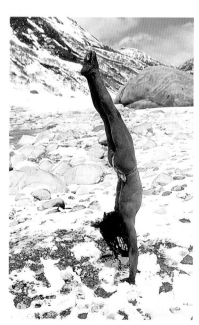

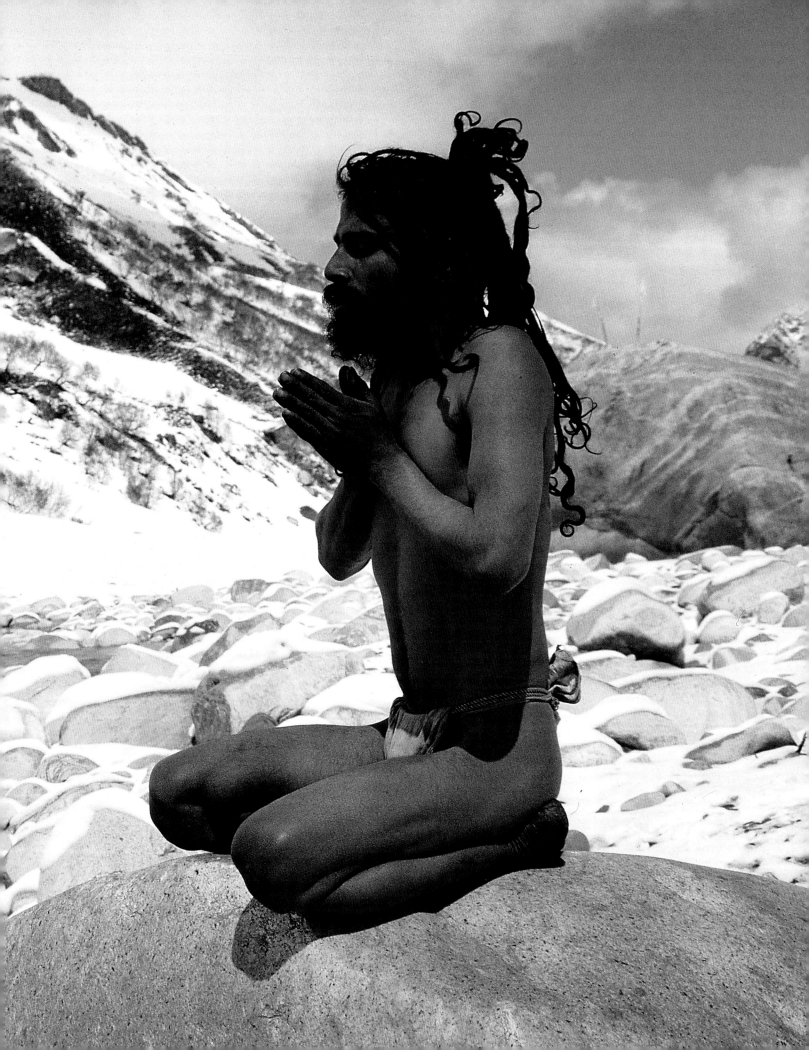

42-43 *The first tea plant was obtained from China and the first tea garden planted in 1856 in the Darjeeling District. Soon it had spread to the nearby hills of Assam and to southern India. The picture shows the leaves being picked by women in the early morning, to be taken for drying and processing in the nearby plantation factory. The higher the altitude, the better the tea. Darjeeling has an altitude of some 6,500 feet. Hence, the seventy-eight Darjeeling gardens produce among the best teas in the world.*

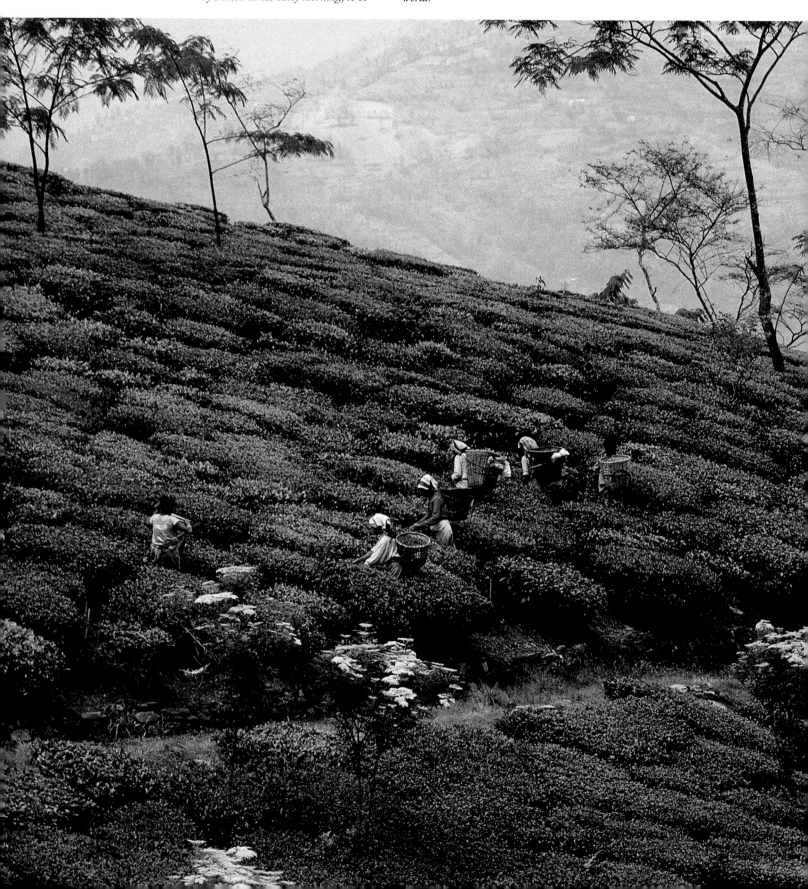

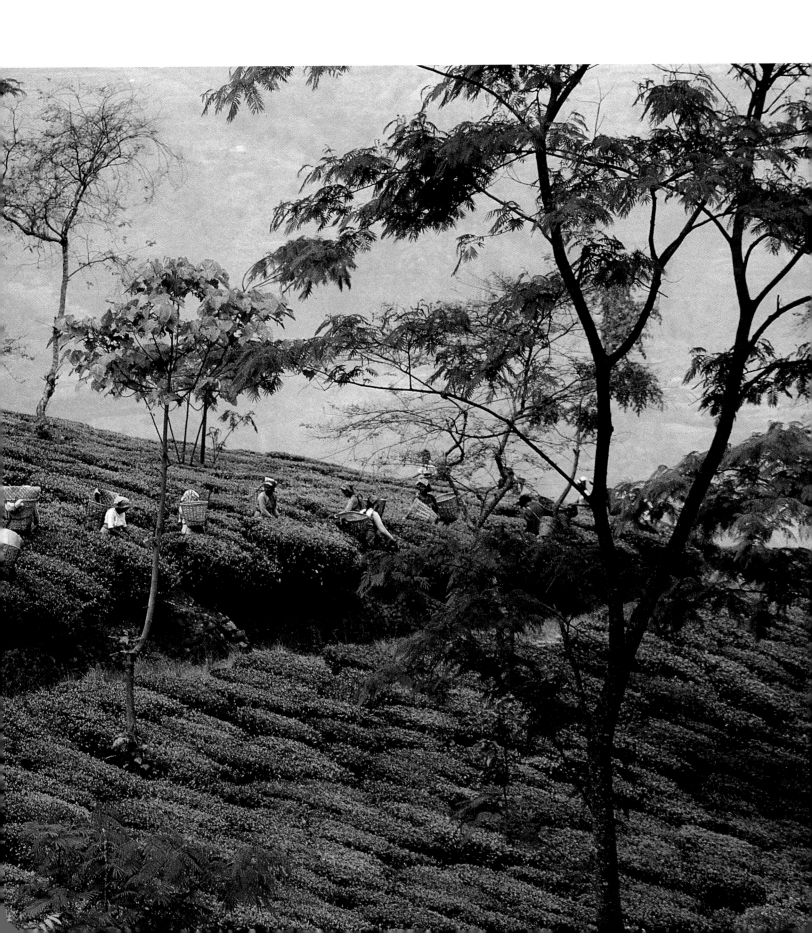

Rajasthan, a Luminous Land

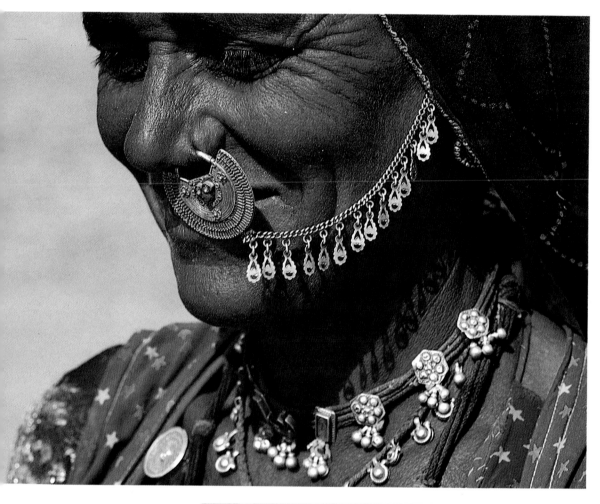

44 *top Country women in Rajasthan are fond of decoration, wearing jewellery both of coins and of manufactured necklaces, nose-rings and amulets on which local artisans have lavished their skills.*

44 bottom *Rajasthan is at the edge of the monsoon zone, receiving an unpredictable amount of rain. In the dry and semi-arid zones pastoralists flourish, their herds of sheep providing wool and meat.*

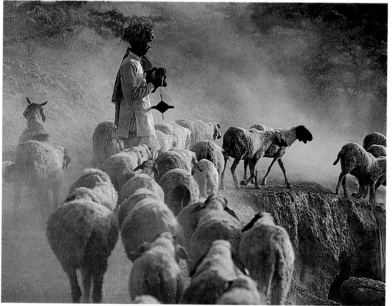

45 *A rustic of Saurashtra in the far west of the country. Most of the population wears sober, modern dress: but a minority continues with the traditional dress and jewellery sported by this young man.*

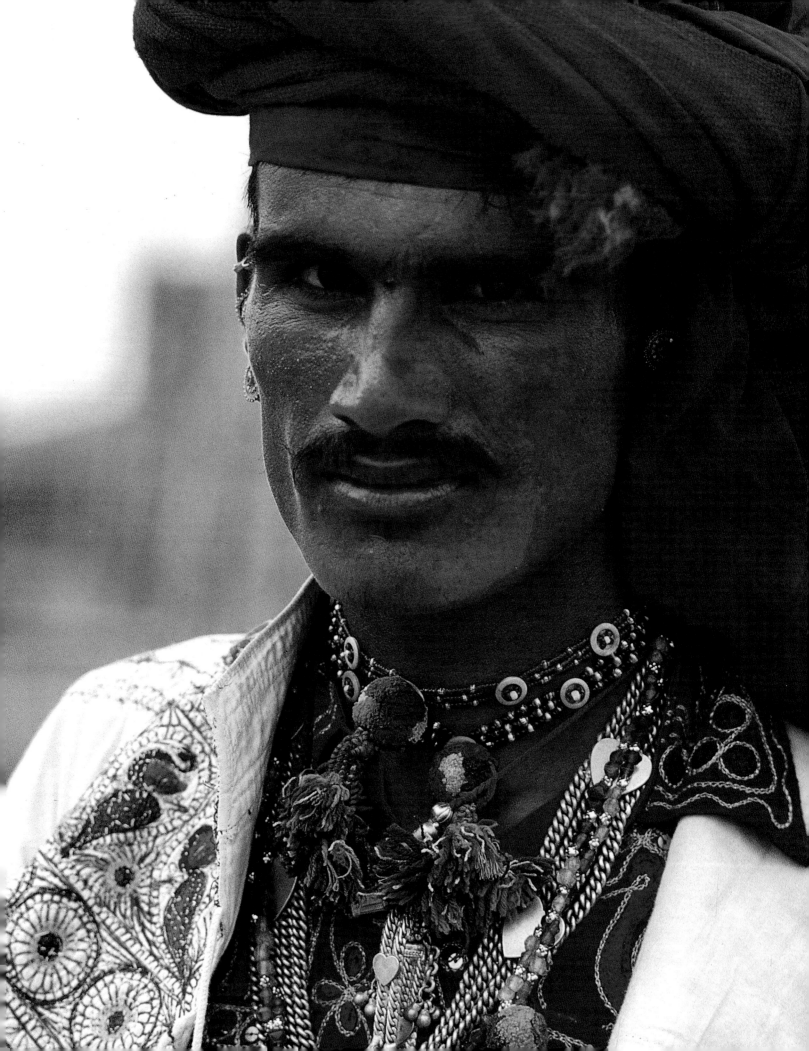

46 *Musicians and dancers entertain a group of villagers at a country fair in western India.*

47 top *Rajasthani women, showing their traditional jewellery. Given at marriage, silver jewellery belongs to the wife and is, in a sense, the insurance of her well-being.*

47 bottom *A woman prepares the food for a meal at the Pushkar fair in Rajasthan. The camels which are brought to the fair are well groomed and decorated with cowrie halters, especially if they are being offered for sale.*

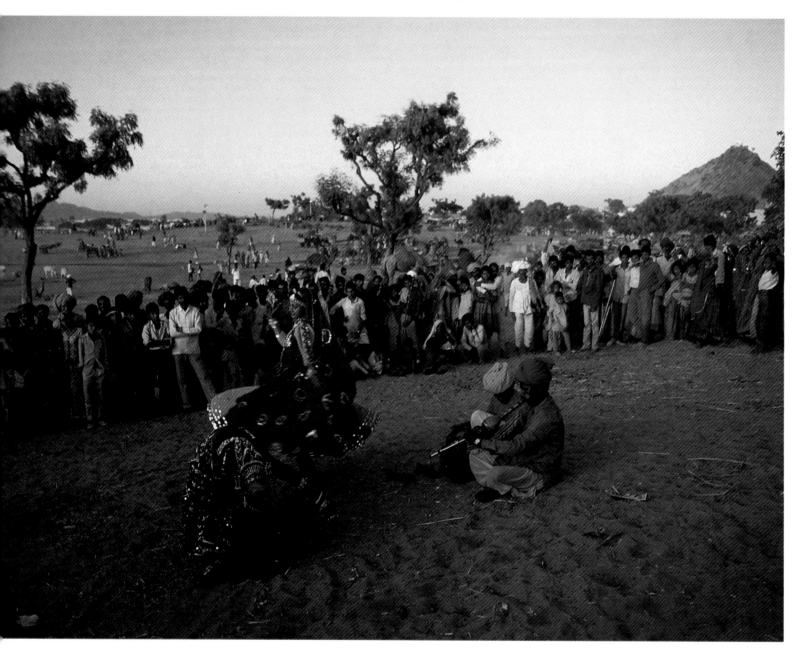

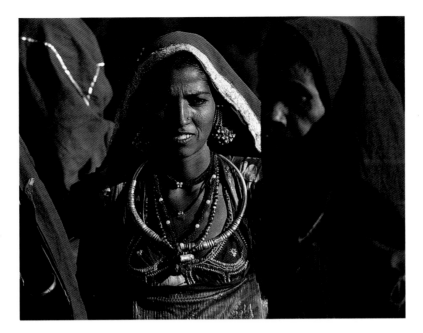

48-49 *The Thar desert lies in western Rajasthan, stretching towards the border with Pakistan. It is in large part an expanse of stony plain, but is in places enlivened by massive sand dunes. In this arid area live camel herders, their spartan existence broken only by the occasional visit to the bazaar of Jaisalmer.*

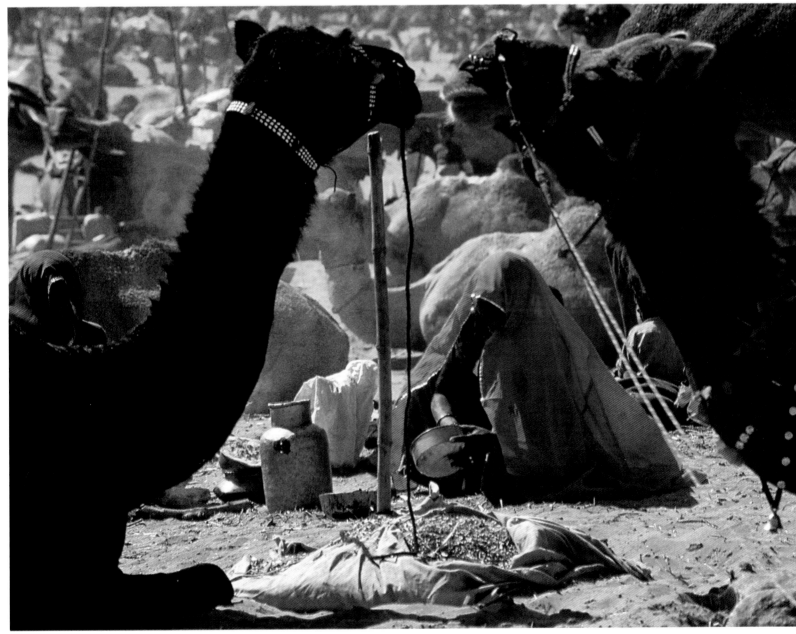

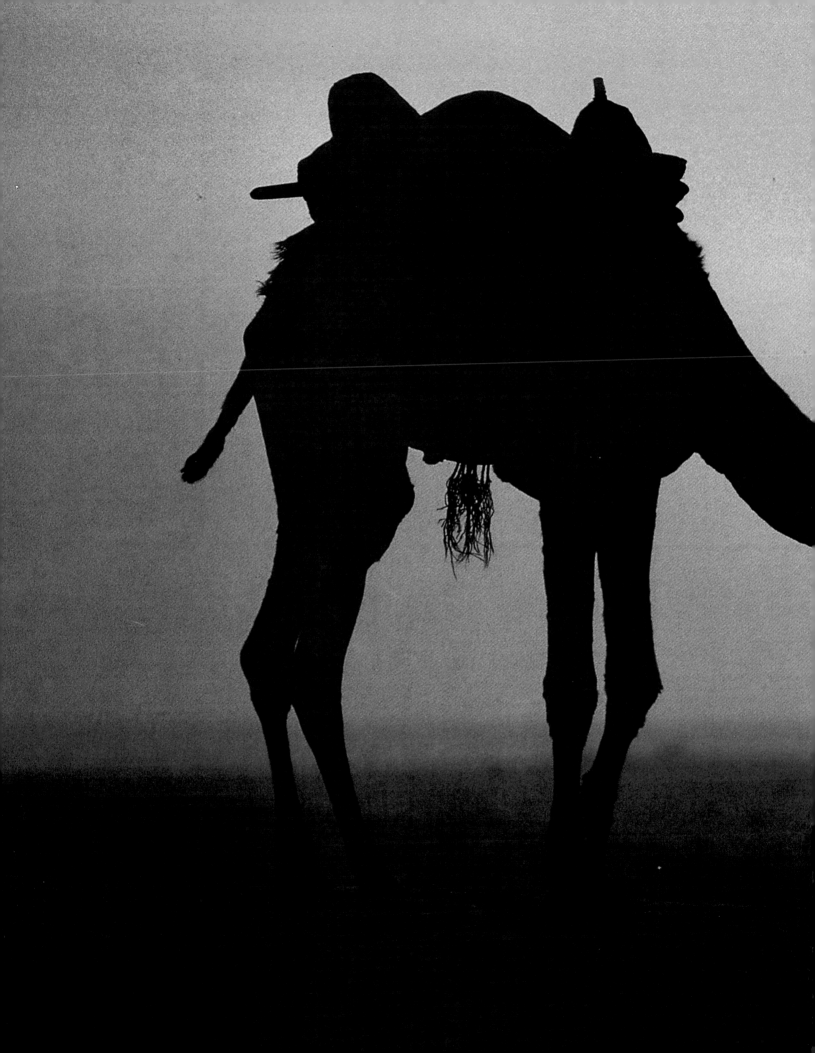

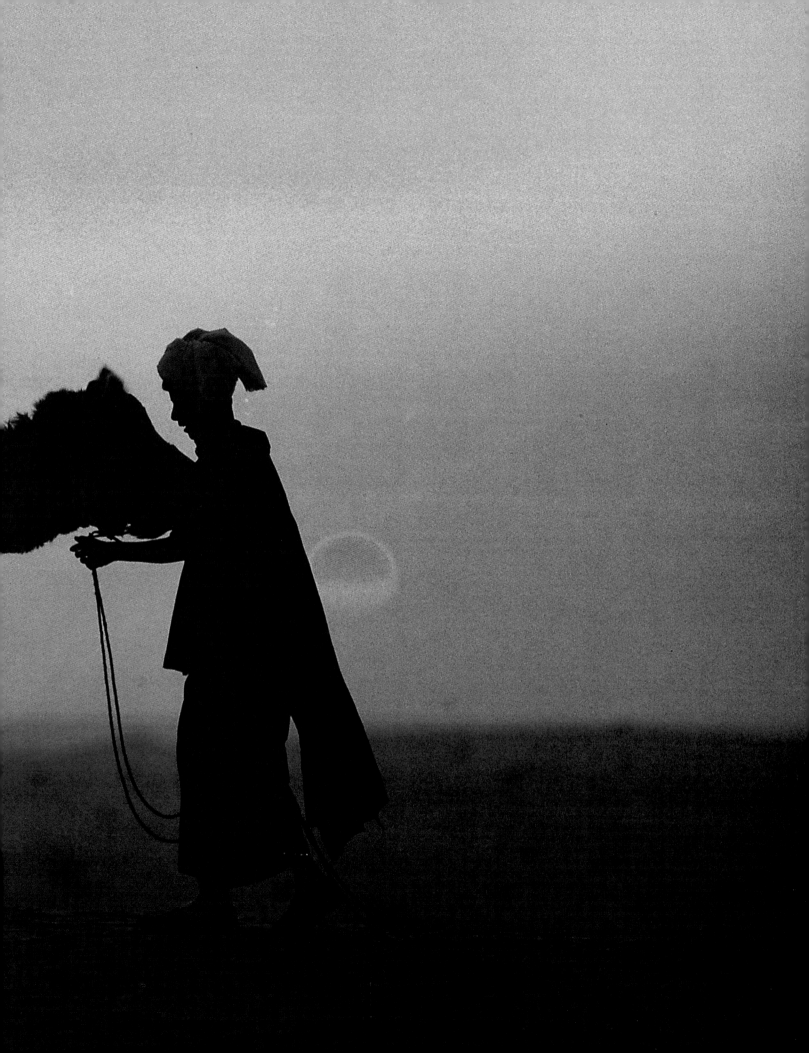

Faces and Traditions

50 left *The intense gaze of this man is almost hidden by his imposing moustache, well oiled and coiled in a spiral on each cheek.*

50 right *The beauty of the women of Rajasthan is legendary, and the bright colours of their outfits and their luminous faces often contrast sharply with the surrounding environment. Rajasthan is a region that presents two different faces: on the one hand there is the Thar desert, an arid strip of land, and the Aravalli mountain chain; on the other, there are placid lakes and lavish palaces with sumptuous gardens.*

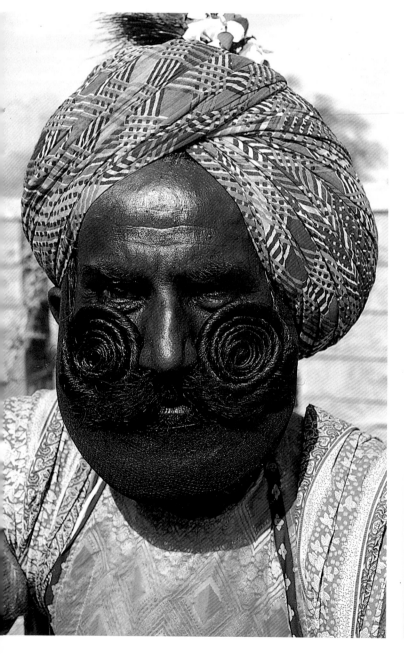

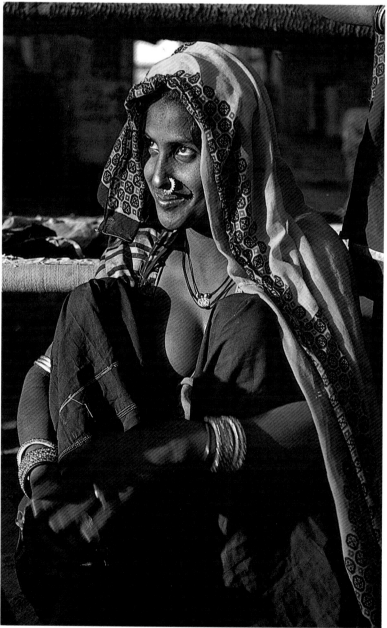

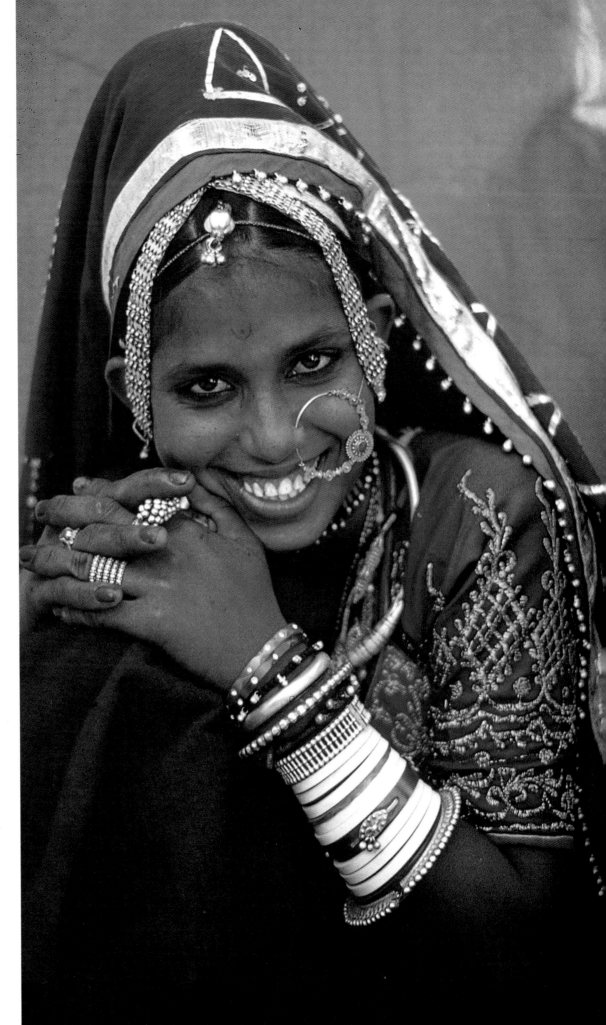

51 *Married women generally wear what to westerners is a considerable amount of jewellery. This is of materials and styles which vary from region to region and class to class. Here is a woman of western India of modest means, who wears a full complement of the ornaments which she possesses.*

52-53 *Weddings in India are held with as much pomp and expense as the parties can afford - sometimes social expectations even driving them into debt. At the upper limit lie such weddings as this one, between aristocratic families in Rajasthan.*

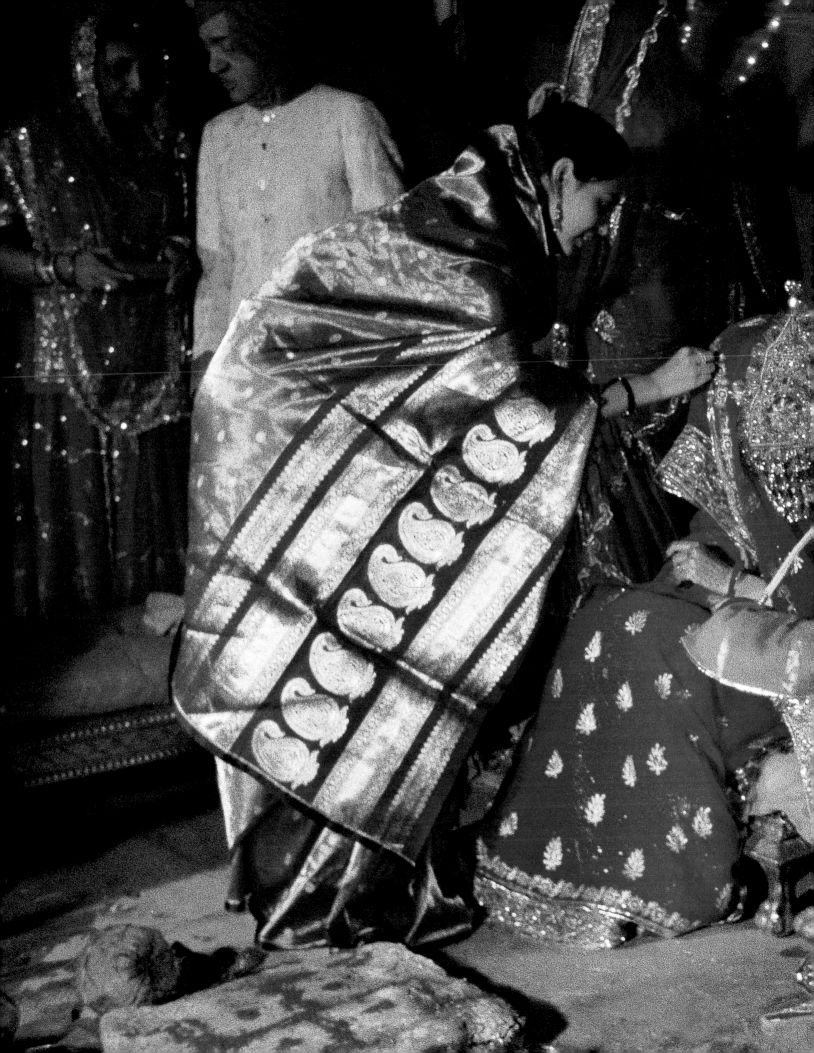

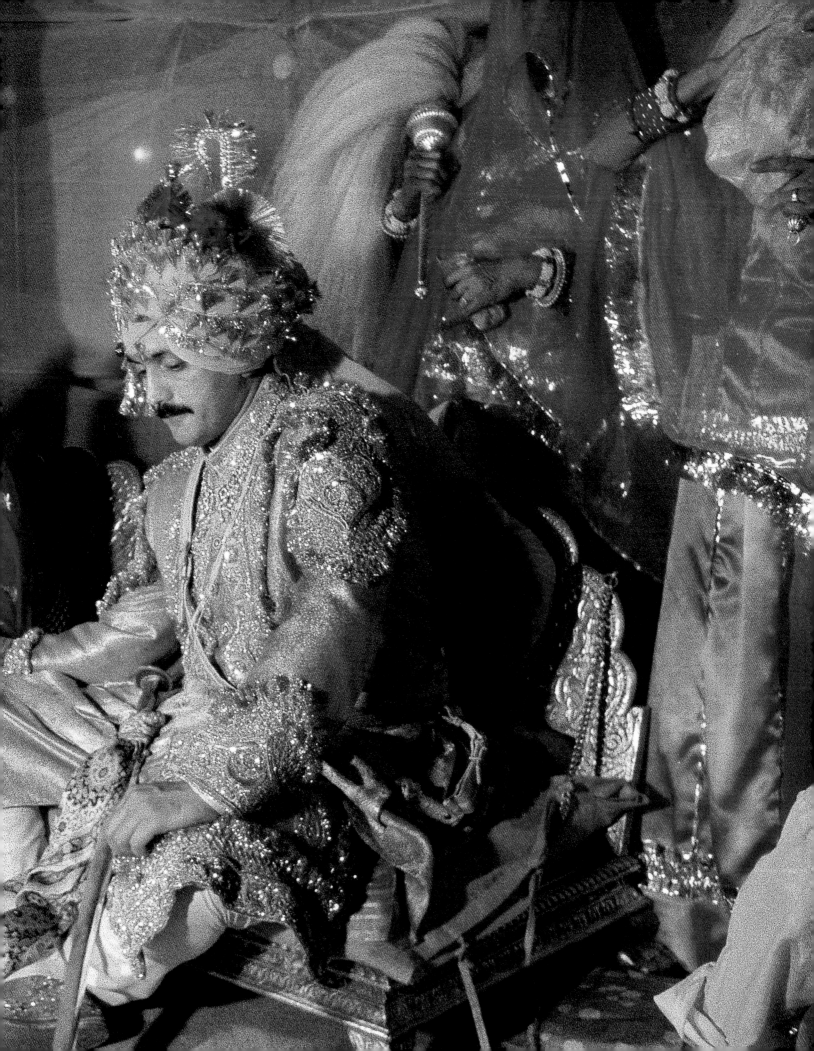

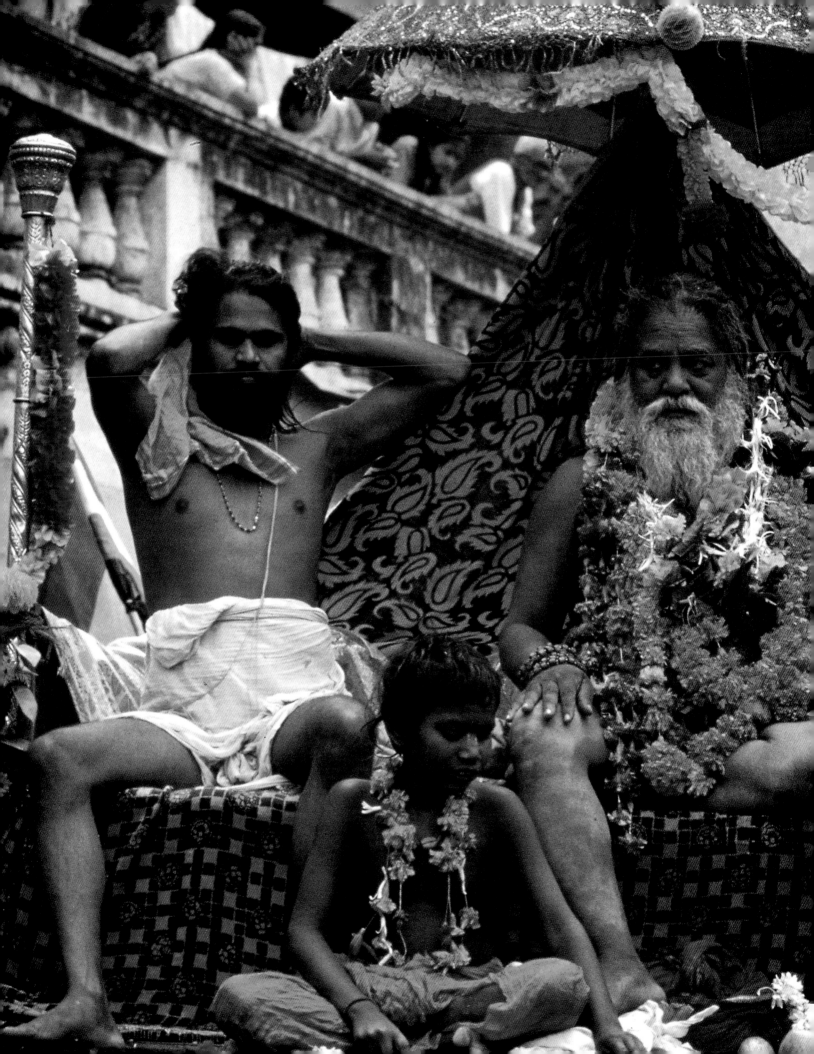

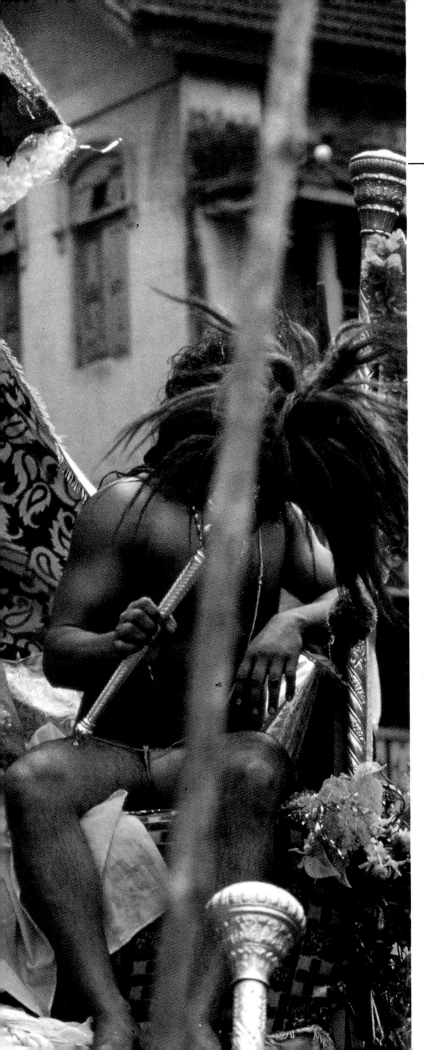

The Inscrutable Paths of the Spirit

54-55 and 56-57 *Pilgrimages are a most important aspect of Hinduism. At the sacred place, the pilgrim may bathe in a river or lake. On especially auspicious days, the pilgrim believes that he is bathing in life-giving water. The most important of these occasions are the twelve-yearly bathing festivals held at four sacred places in northern and central India. Millions of people immerse themselves at these times: and they are occasions for sects of ascetics to gather, going together to immerse themselves.*

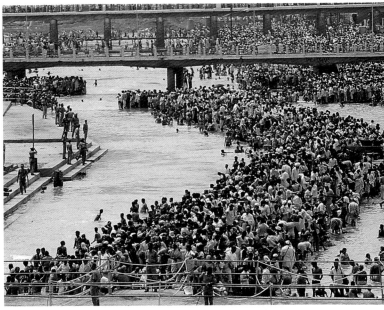

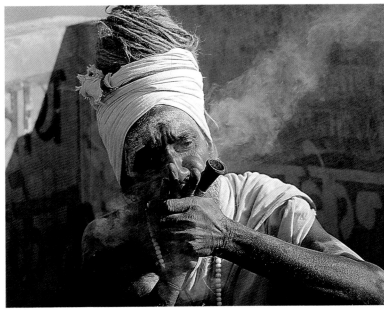

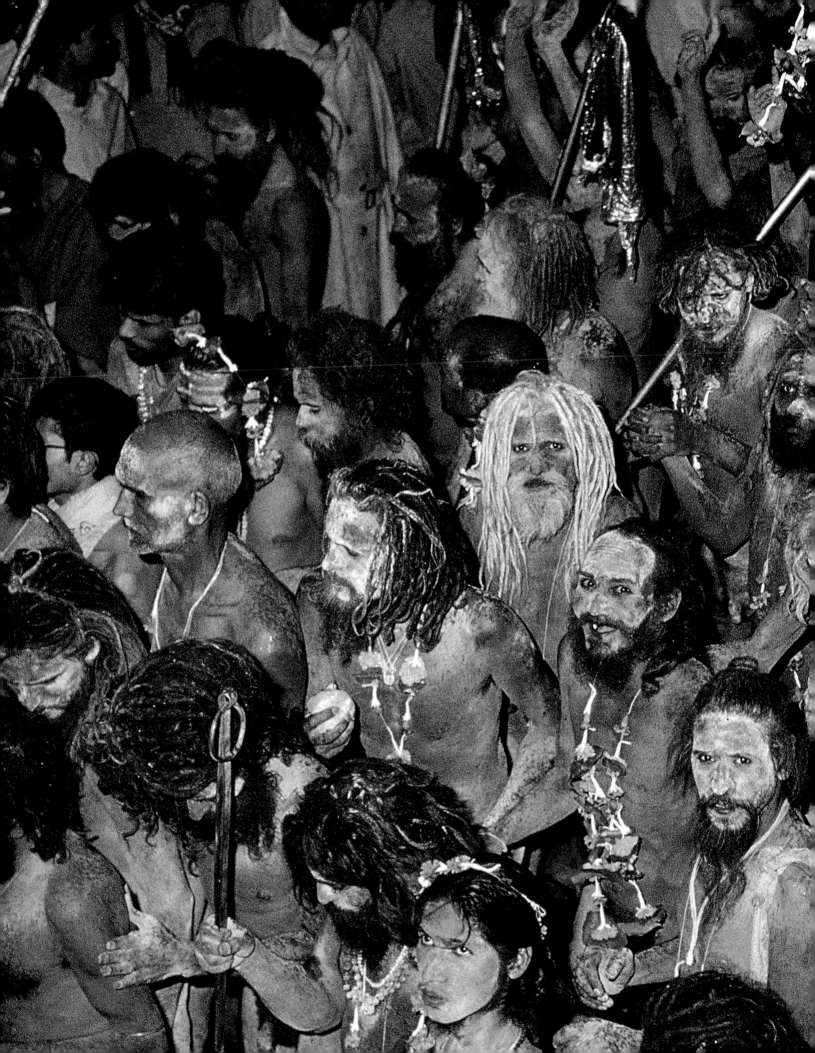

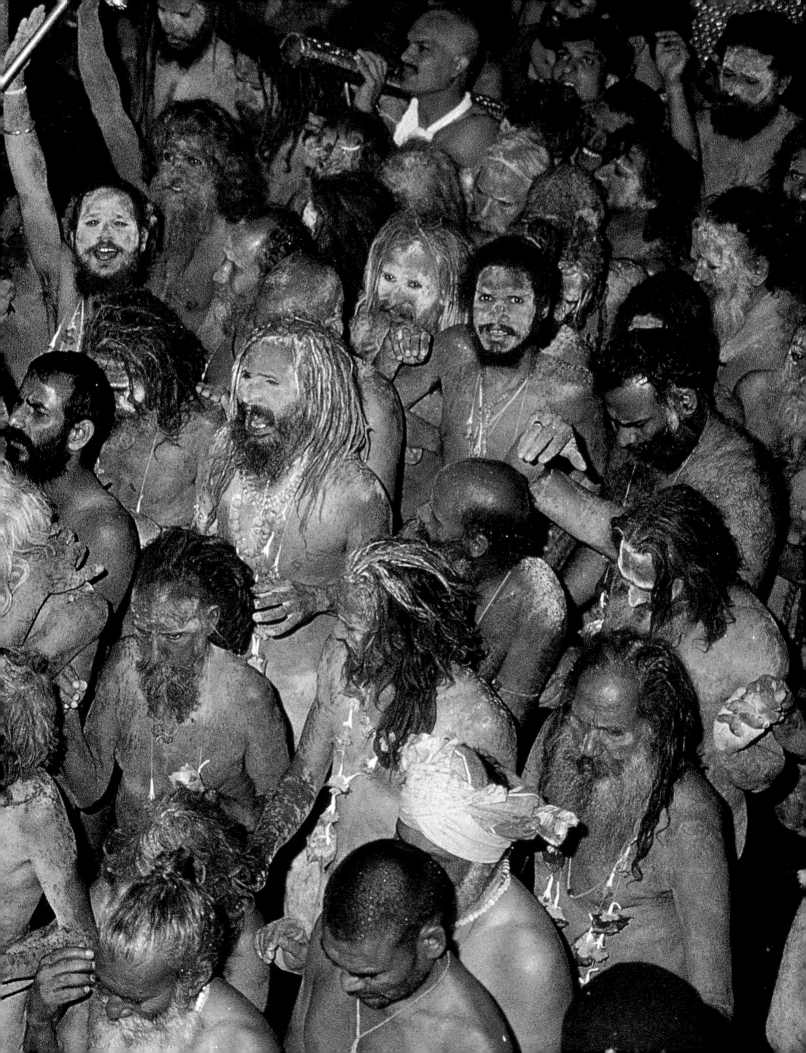

The Diverse Forms of Devotion

58-59 *Sikhs celebrate the* Hola *festival, marking the coming of spring, with carnival and abandon, as do the Hindus. A major event is the throwing of coloured dye by the revellers. In the background of the picture on the left is the temple of Anandpur Sahib, hallowed since its founding by the 9th Sikh Teacher. It was the scene of his cremation after martyrdom, and of the 10th and last Teacher's institution of the Sikh fellowship through baptism. At the same time, major gatherings will have fairs at which large crowds gather including ascetics who indulge in fencing matches.*

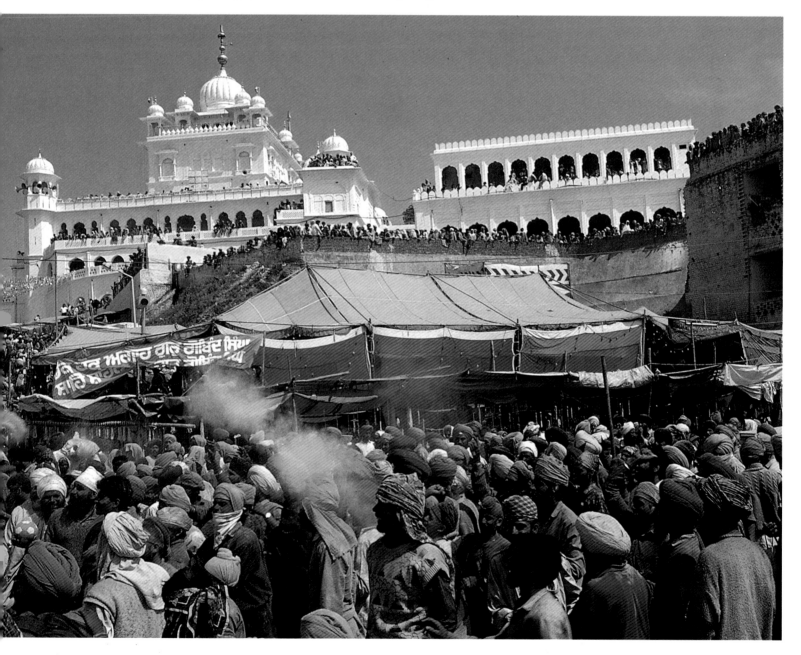

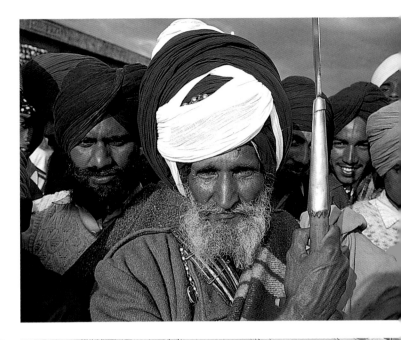

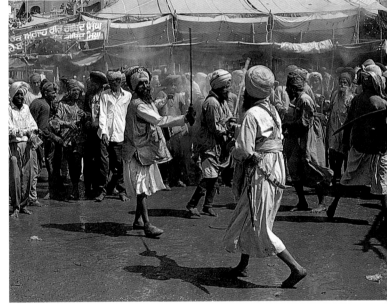

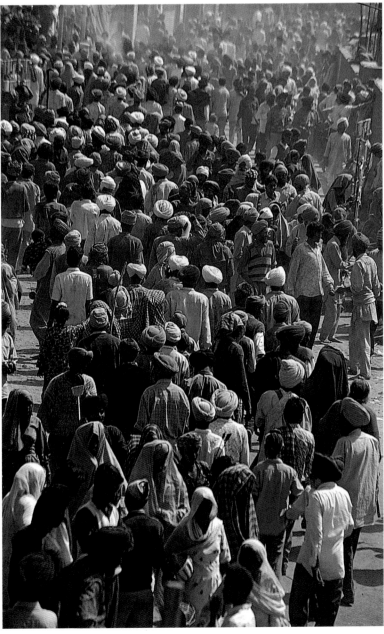

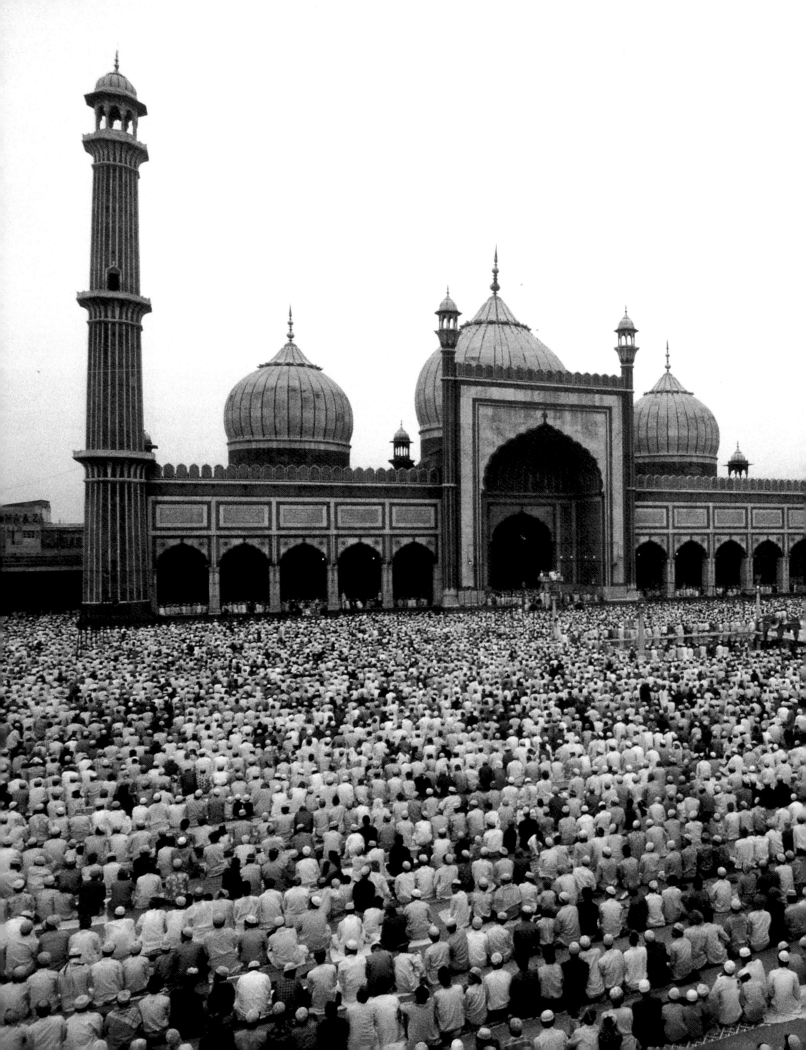

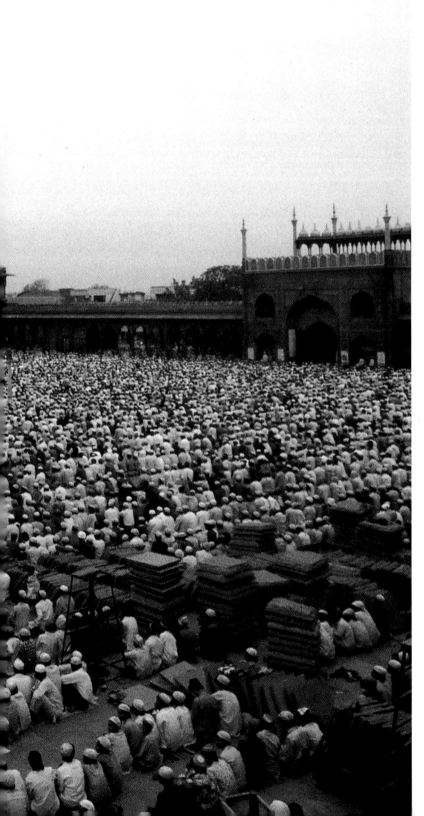

60 *Delhi's great mosque, built by the emperor Shah Jehan in 1644-1658, is the scene of one of the two annual festivals in which the whole local Muslim community gathers for prayers. One occasion marks the end of the month of fasting observed by all Muslims, the other commemorates Abraham's willingness to sacrifice his son at God's command.*

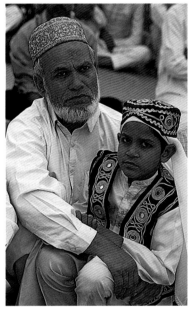

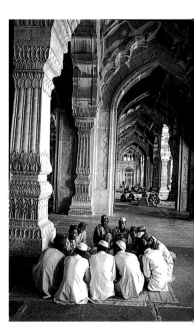

61 left *The two festivals are occasions for rejoicing. Like this father and son, families don their best clothes before exchanging visits and presents with relatives and friends. This is followed by a feast and the giving of alms to the poor.*

61 right *The 19th-century great mosque in Bhopal, one of the largest in India, is the scene of groups having religious instruction.*

62-63 *Two women pass in front of the delicate inlaid stonework of a Mughul building.*

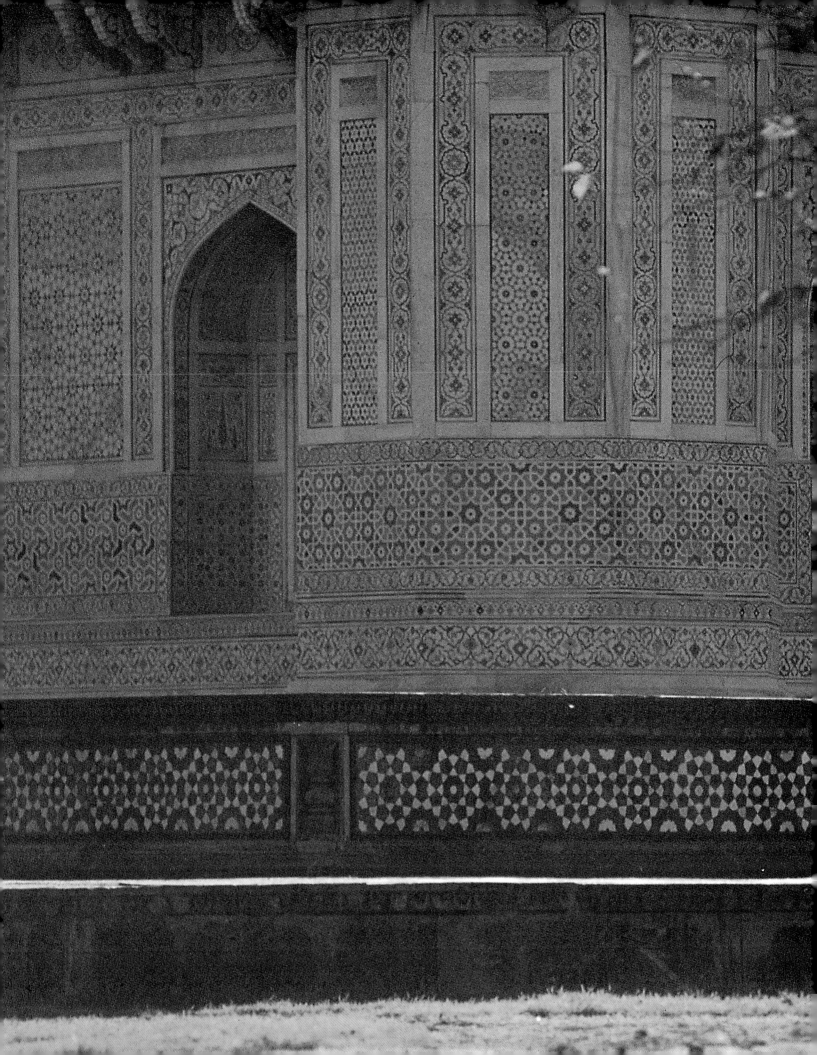

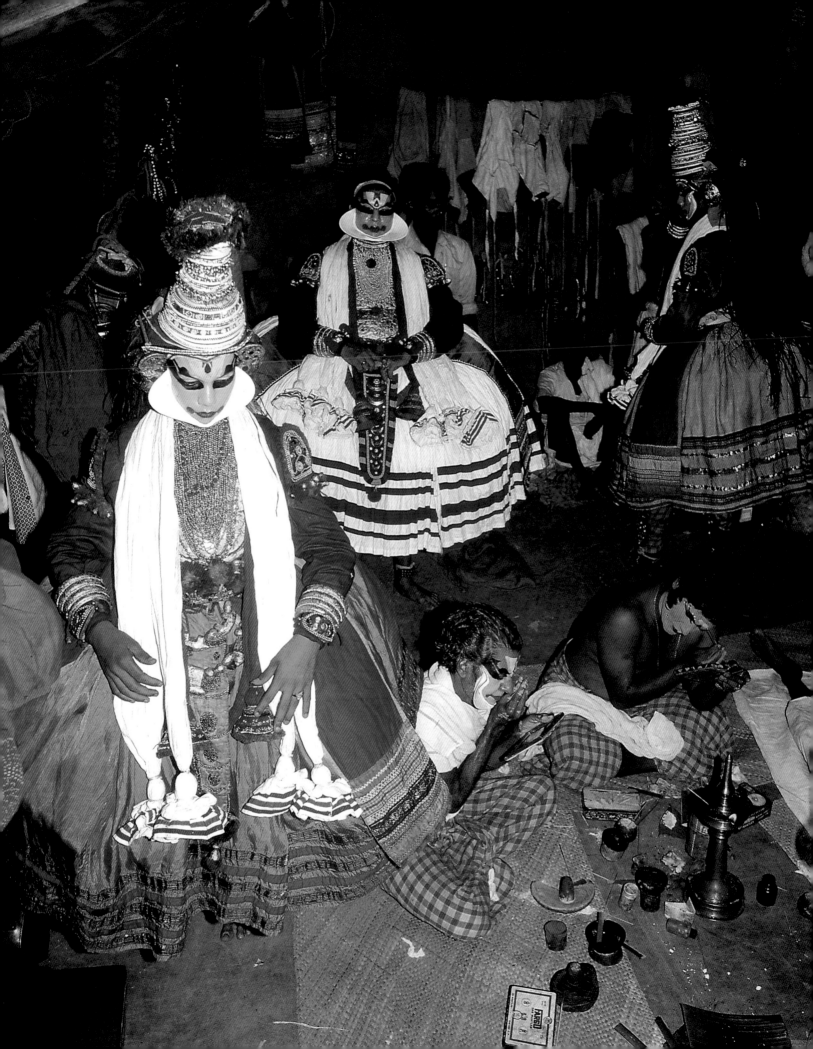

Dance, a Gift of the Gods

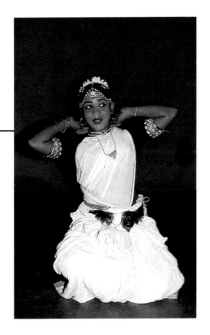

64 *One of the main forms of classical Indian dance has developed over the centuries in Kerala, on the southwest coast. Known as Kathakali, the dances are concerned with stories from the Hindu epics. The costumes and make-up of the dancers (male only) are most elaborate and take several hours to apply. However, this is justified by the following performance, which lasts throughout the night.*

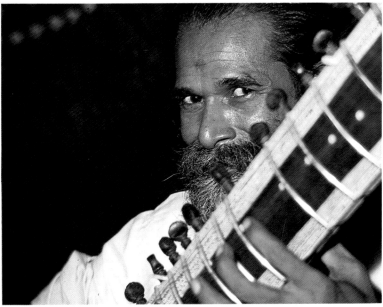

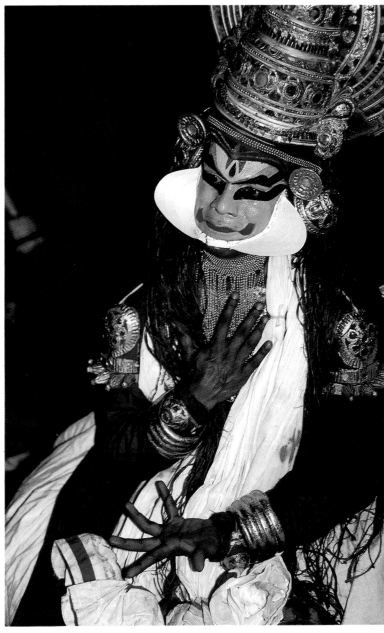

65 top *The* bharatanatya *dance, performed by women, plays an important role in daily life. This dance sums up both grace and beauty and is at the origin of all other forms of art: sculpture, painting, music. It is believed, in fact, that this dance was revealed to humankind directly by the gods during remote antiquity, so that humans could rise spiritually and enjoy divine pleasures.*

65 centre *India has an ancient, complex and subtle form of classical music, together with several unique instruments. Illustrated here is the sitar, a multi-string plucked "guitar". Musical training is long and arduous, and the virtuosi are greatly honoured in India, and more recently also in the west.*

65 right *The nature of a Kathakali dancer's make-up expresses the qualities of the character he is acting. Here, the green face symbolises the moral excellence of a god or mythological hero. Hand poses express the ideas also communicated through gesture and movement.*

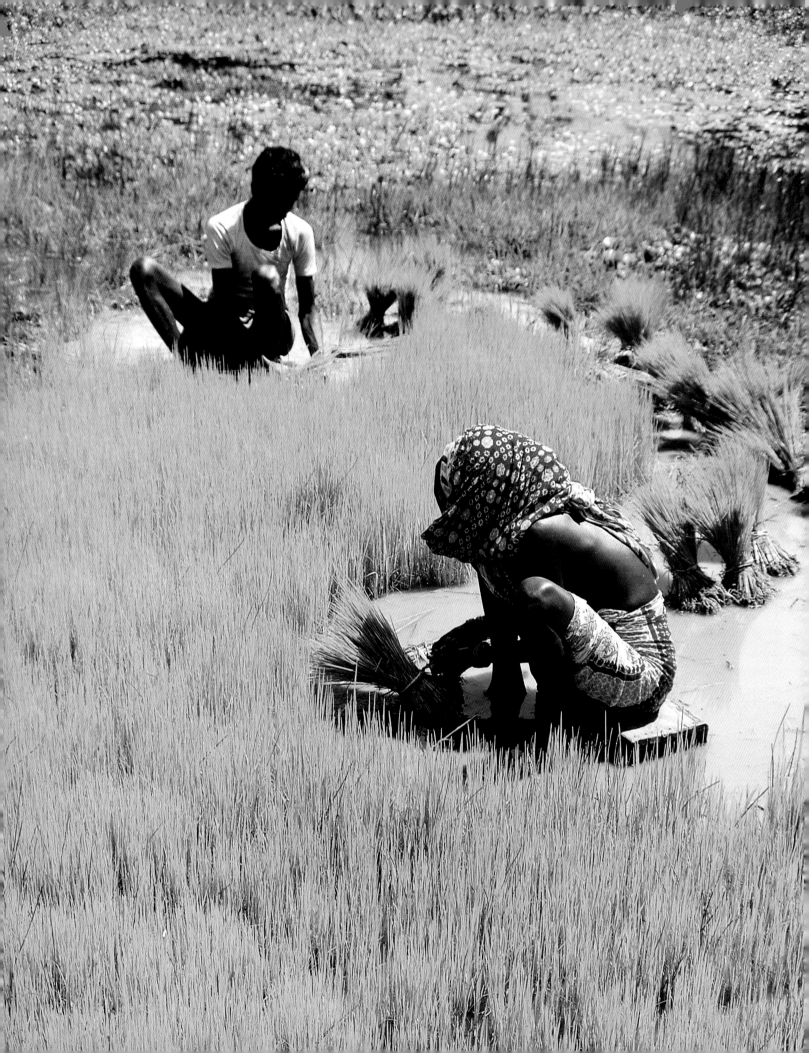

The Traditional Forms of Farming and Fishing

66 *Irrigated paddy is grown from seedlings which are transplanted, from nursery plots into well-watered fields. Rice is the staple food grain for many Indians in the south and east, wheat being the staple food for those in the north and west.*

67 left top *After ripening, the paddy crop is cut and the sheaves are threshed by hand before being winnowed, dried and stored.*

67 left and right bottom *Much coastal fishing is carried out from small boats and it is an arduous and often risky occupation.*

67 right top *An elephant walks on a road, taking its lunch with it. The animals are vegetarian, eating large quantities of leaves.*

68-69 *Peasants prize buffaloes for their rich milk, and for their dung which is used for fuel as well as for a fertiliser on their fields. Non-Hindus eat buffalo meat, and the hides of dead animals are used as leather. Hence, these are valued animals, whose welfare is tended to by a herdsman when they relax in cooling water.*

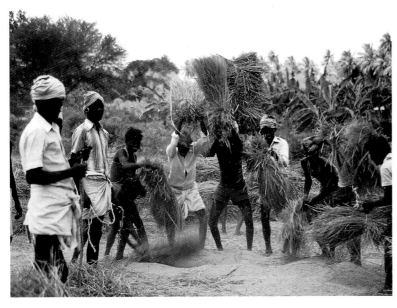

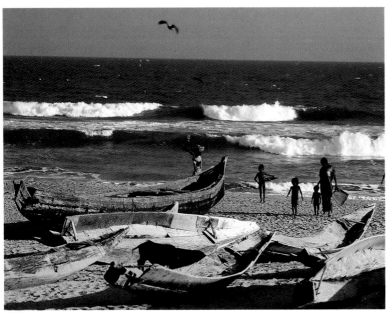

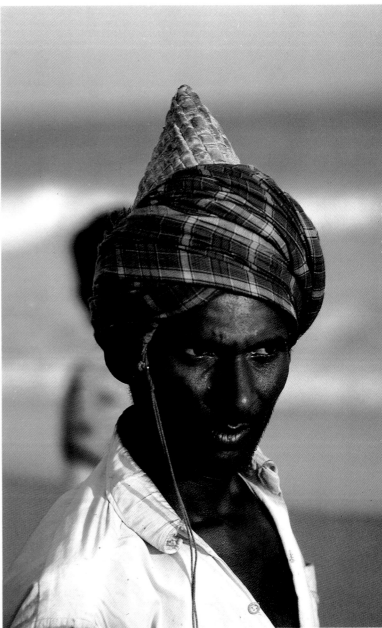

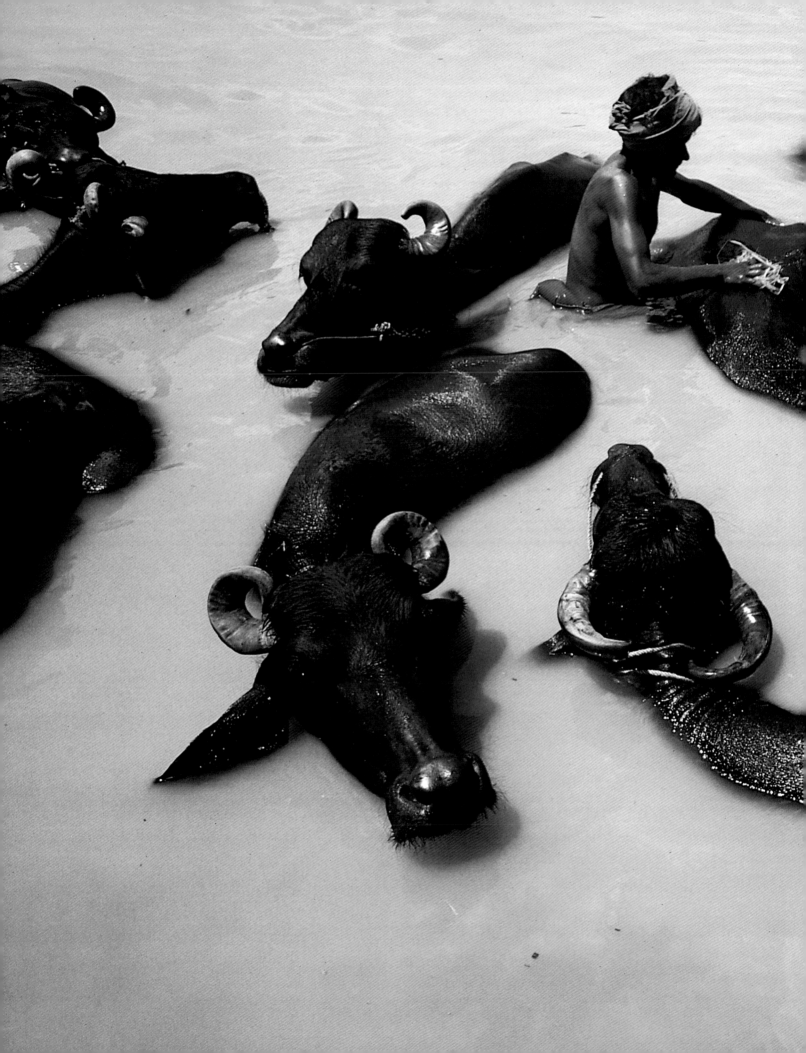

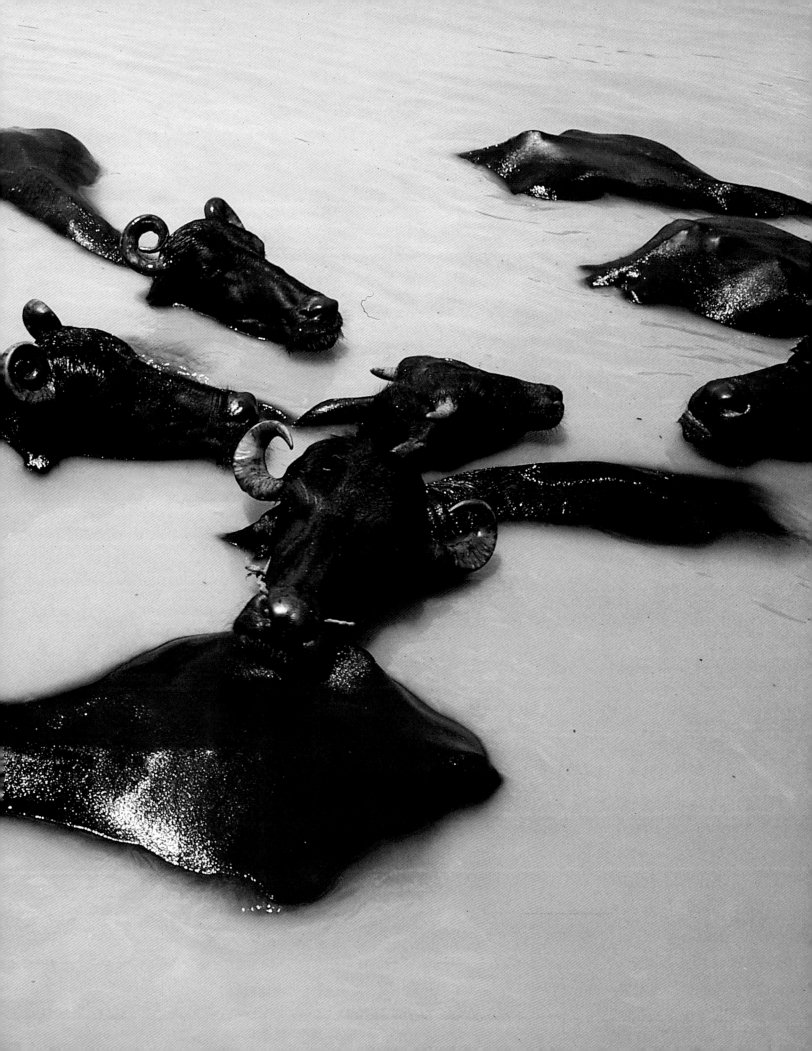

The Cities: Chaos and Harmony

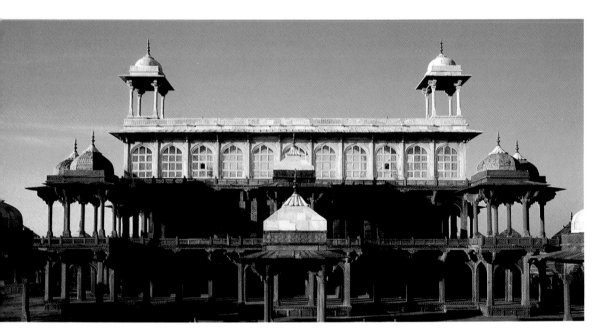

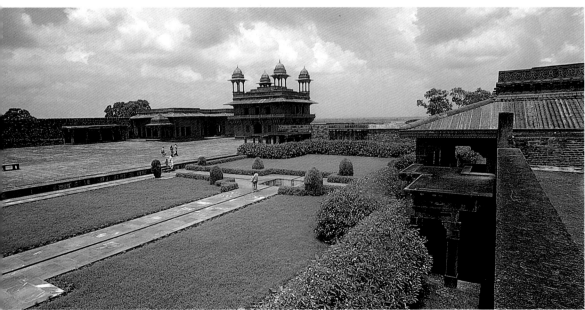

70 top *The greatest Mughul emperor, Akbar, died at Agra in 1605. In the tradition of his family, he had for some years previously been building his own mausoleum at Sikandra, a few miles outside the city. But at his death only the lower storeys of the mausoleum were complete. The rest was constructed by his son Jehangir in 1613. Being the work of two builders, the mausoleum is of a unique design and stands in an impressively spacious garden and with a profusely decorated entry gate.*

70 bottom *The emperor Akbar built a new capital some 25 miles from Agra, but lived there for only 15 years. Today, Fatehpur Sikri still lies as it was abandoned in 1584, a vast and empty capital. This view shows the Hall of Private Audience, where Akbar conferred with his ministers and held the philosophical discussions that so interested him.*

71 *The city of Bombay sits on an island which partly encloses its extensive harbour. Reclamation of land has taken place on the seaward side, the first project forming the curved Marine Drive in 1920. This is a favourite place for an evening stroll along the sea front with its cooling breezes, as well as being a major traffic artery lined with offices and hotels.*

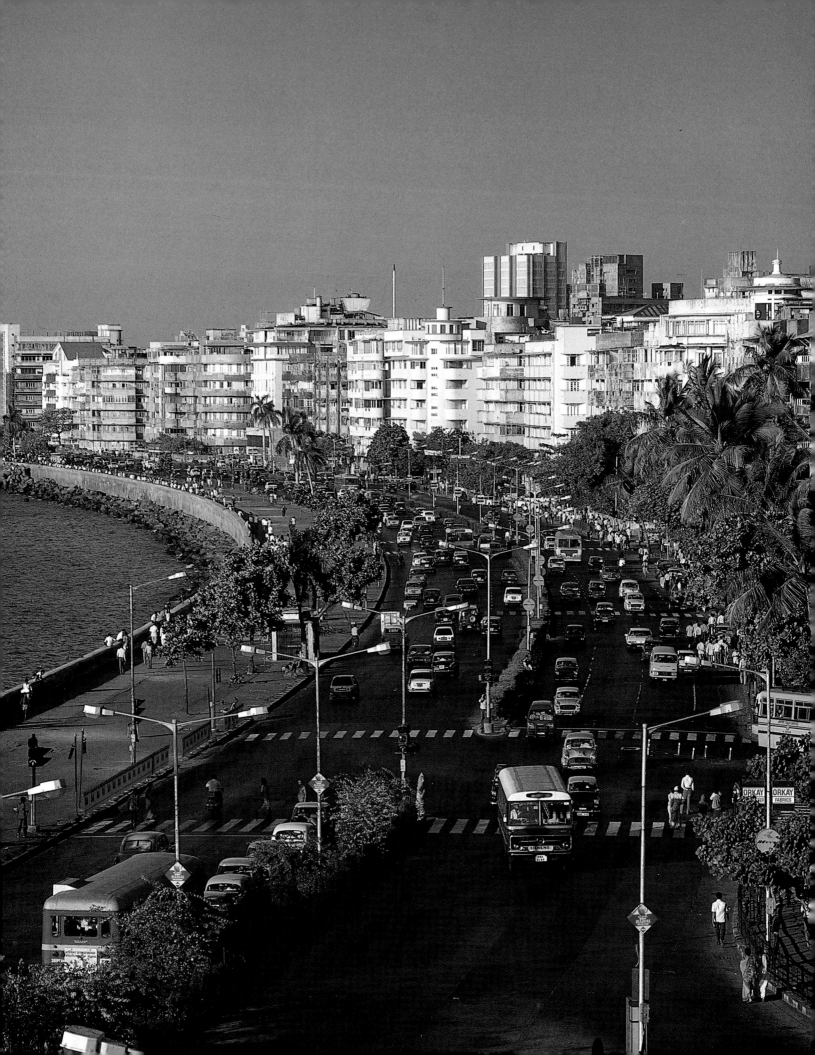

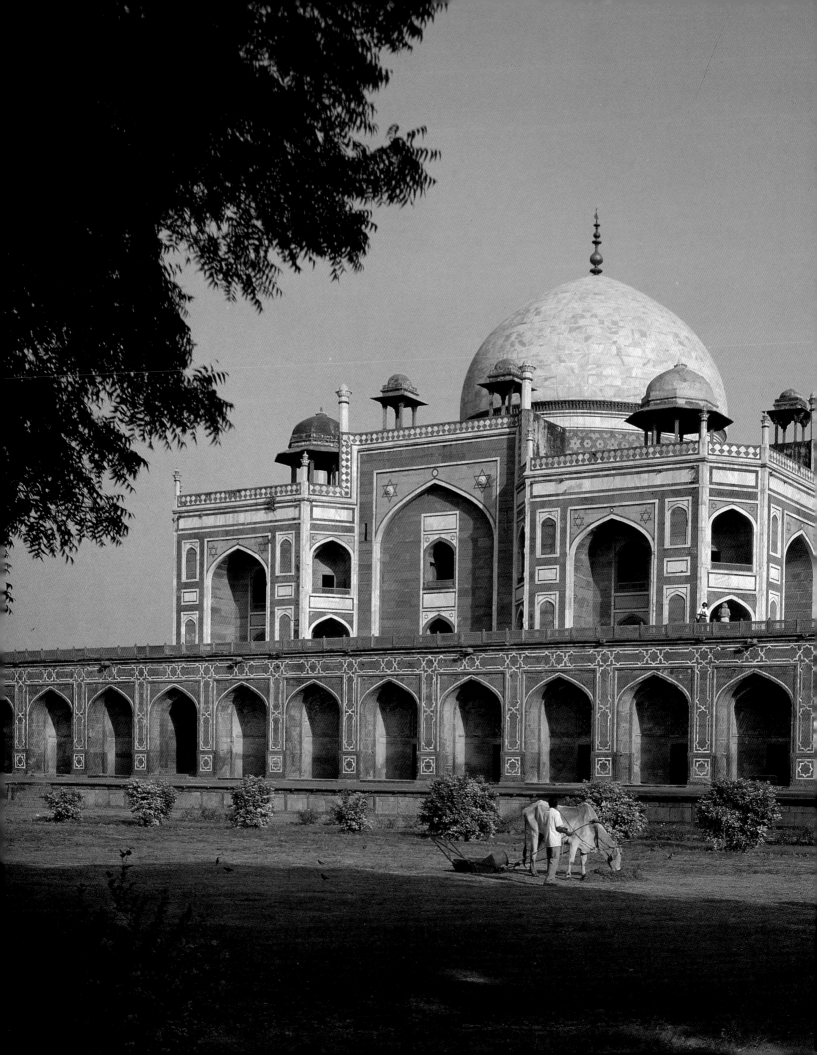

Delhi, a City of Living History

72 *The mausoleum built for the second Mughul emperor Humayun in 1565 was the earliest of the Mughul monuments. Being set in a landscaped garden enclosure, being octagonal in plan, having a "double dome" with inner and outer shell, and using red sandstone counterpointed with marble, it set the pattern for later buildings, culminating in the Taj Mahal.*

73 centre left *The imposing building shown here, a typical Mughul construction, is the tomb of Safadarjang, and it stands in Delhi.*

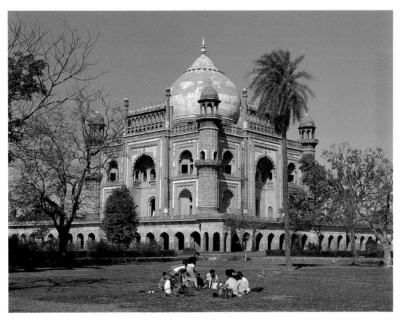

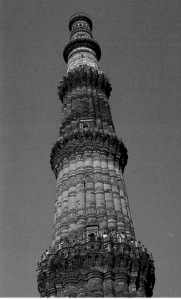

73 *Delhi's first Muslim monuments include the Qutb Minar (centre right) a tower commemorating the victory over Delhi's Hindu ruler in 1192, whose inscription says that it is "to cast a shadow of God over east and west". Standing 240 feet high, it excited the envy of a later ruler, who started an even larger tower (seen in the background to picture top), but who died when it had reached a height of only 89 feet.*

73 bottom *Of all the Mughul emperors, Shah Jehan ruled with the greatest magnificence. Besides beautifying Agra, in 1638 he started the construction of a capital at Delhi, of which the most imposing monument remains the Red Fort. The buildings within it are reached through this imposing gateway of red sandstone, from the colour of which the fort is named.*

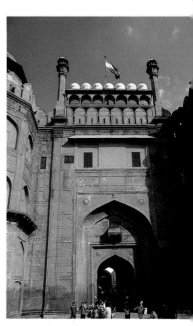

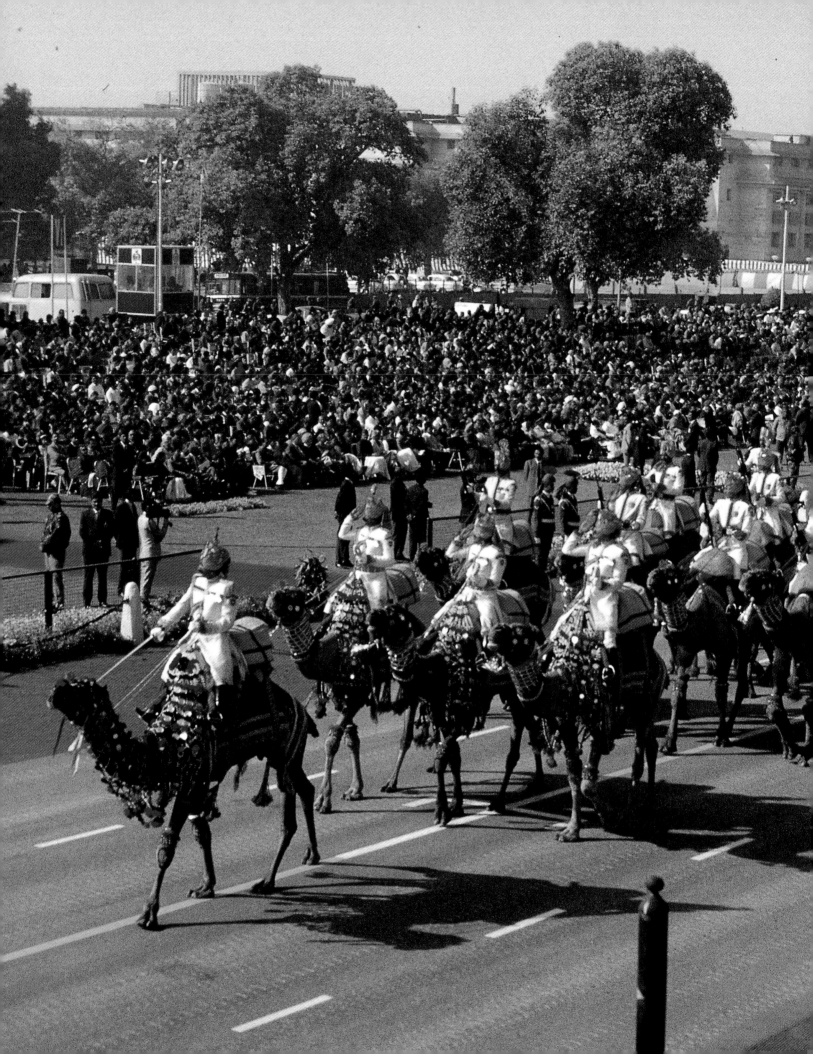

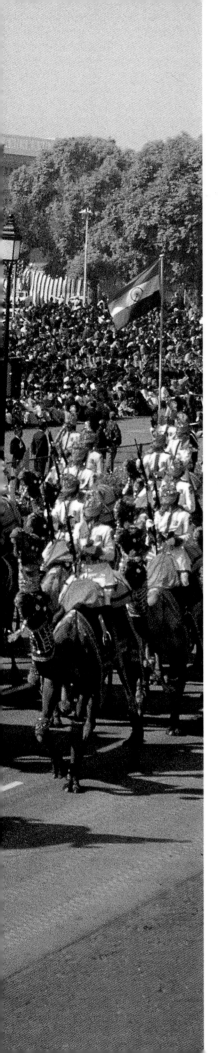

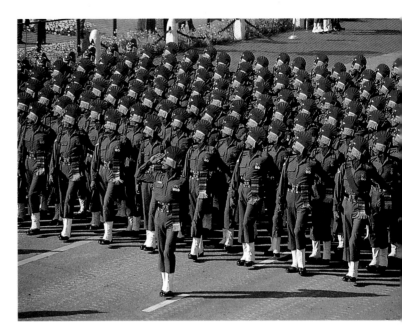

74-75 *The first capital of India under British rule was Calcutta. But in 1911 it was announced that Delhi was to become the capital, and two celebrated architects, Sir Edwin Lutyens and Herbert Baker, were asked to design a new city to stand alongside Shah Jehan's. By 1939 a spacious city had grown up, of imposing public buildings and of dwellings situated along wide avenues and leafy streets. Although New Delhi has expanded enormously since independence in 1947, many of the buildings and streets of the British city still remain. Of the latter, the most important is the Raj Path, a magnificent avenue leading from the India Gate (bottom) to the President's Palace: it is a memorial to the fallen of the First World War. Along this passes the annual Republic Day parade on January 26. This includes a march-past of the infantry (top), of the Camel Corps (left) and of richly caparisoned elephants (centre).*

76-77 *Constructed by Shah Jehan, Chandni Chowk was Delhi's main thoroughfare until the building of New Delhi. Running westwards from the Red Fort (seen here in the background), the street formerly had a canal running down the middle, and the residences of nobles to each side. Slowly it became a street of commerce and developed into Delhi's main bazaar. To this day, it remains an important trading street, lined with shops and full of traffic.*

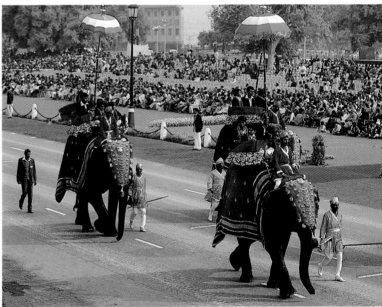

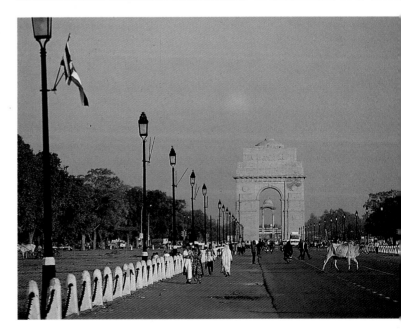

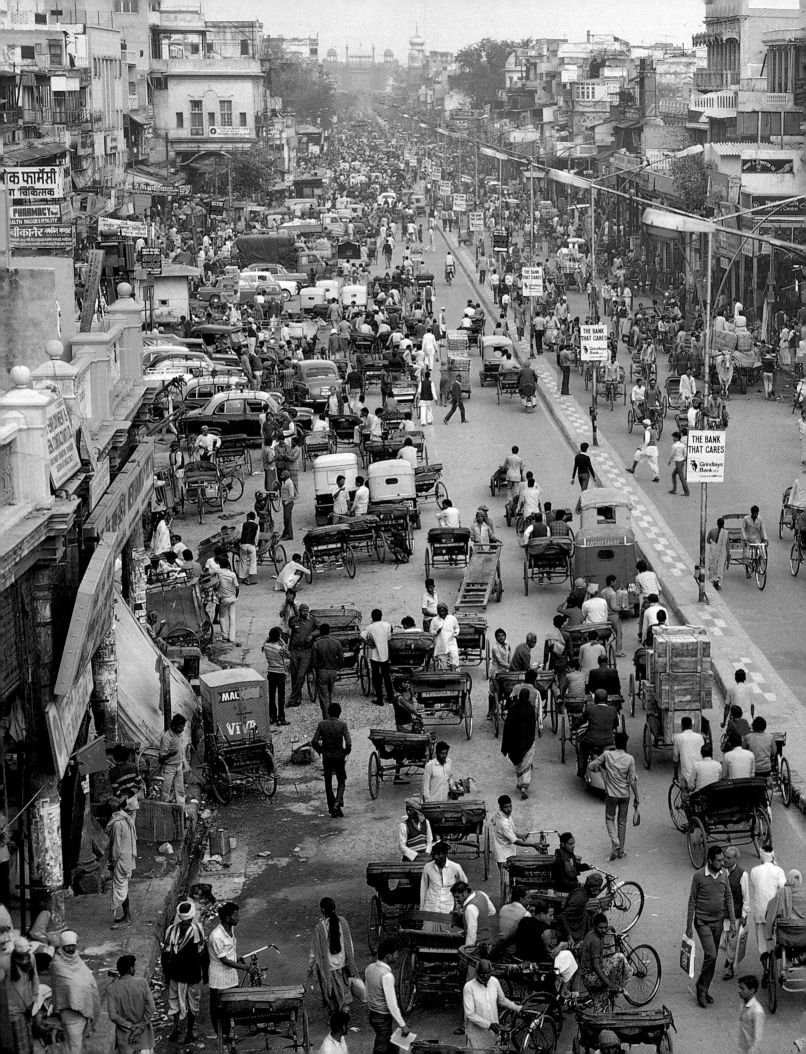

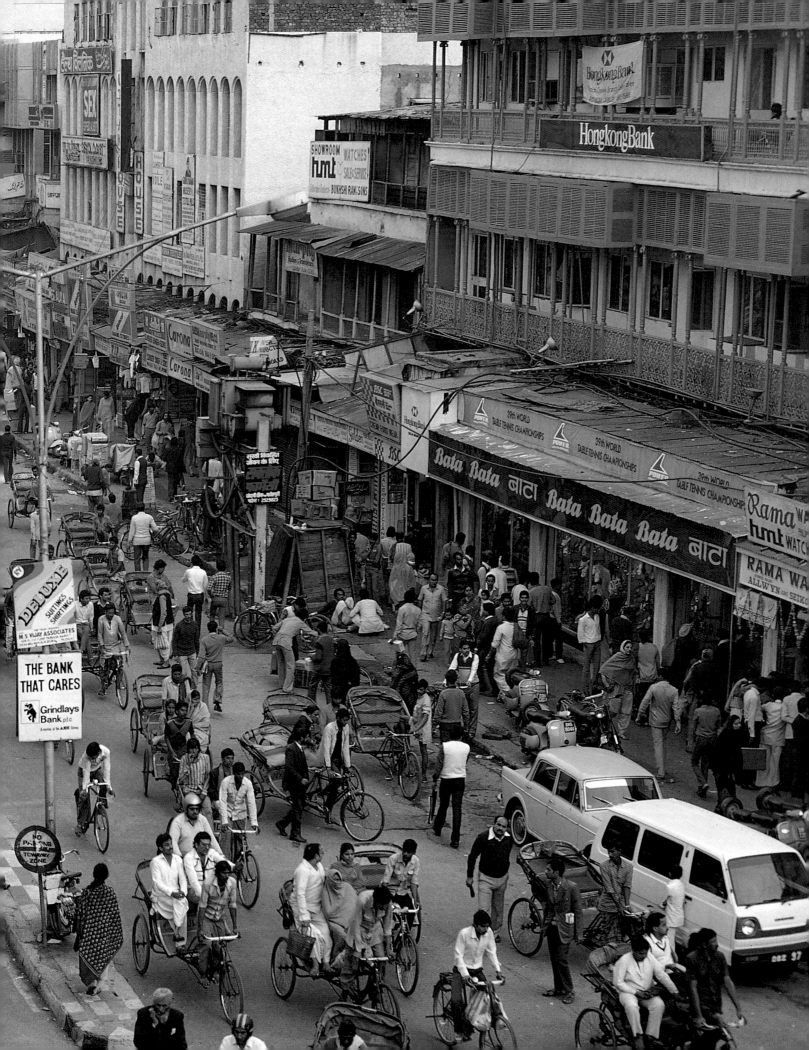

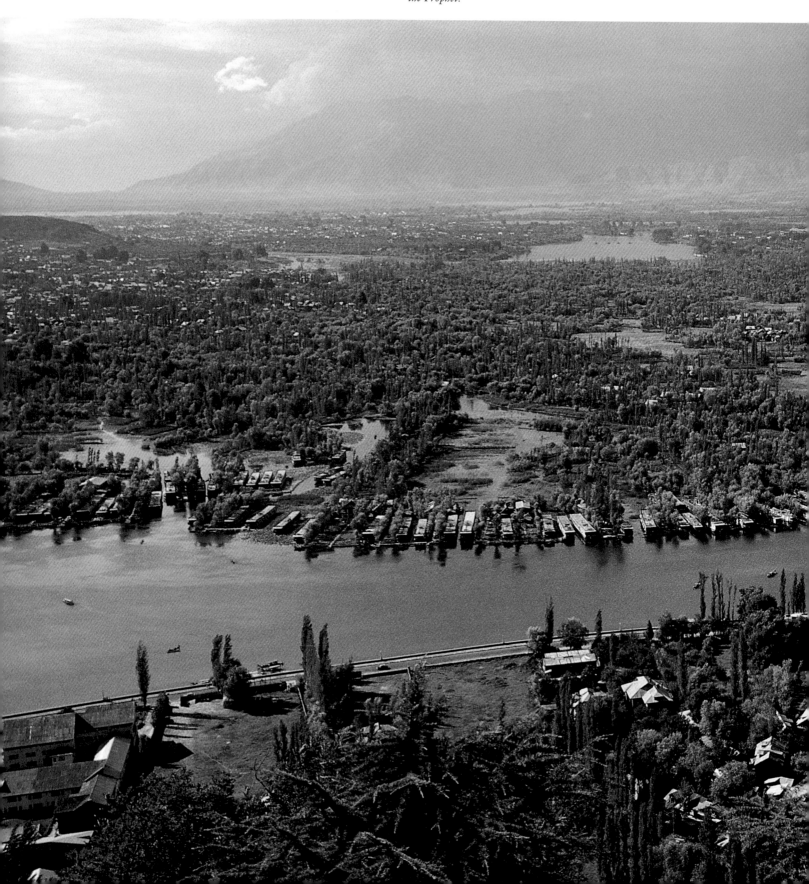

78-79 *To th north of Srinagar city lies the Vale of Kashmir, surrounded by hills and containing lakes and waterways. In the picture's foreground can be seen a line of houseboats, and further off the white dome of the Hazratbal mosque, enshrining a hair of the Prophet.*

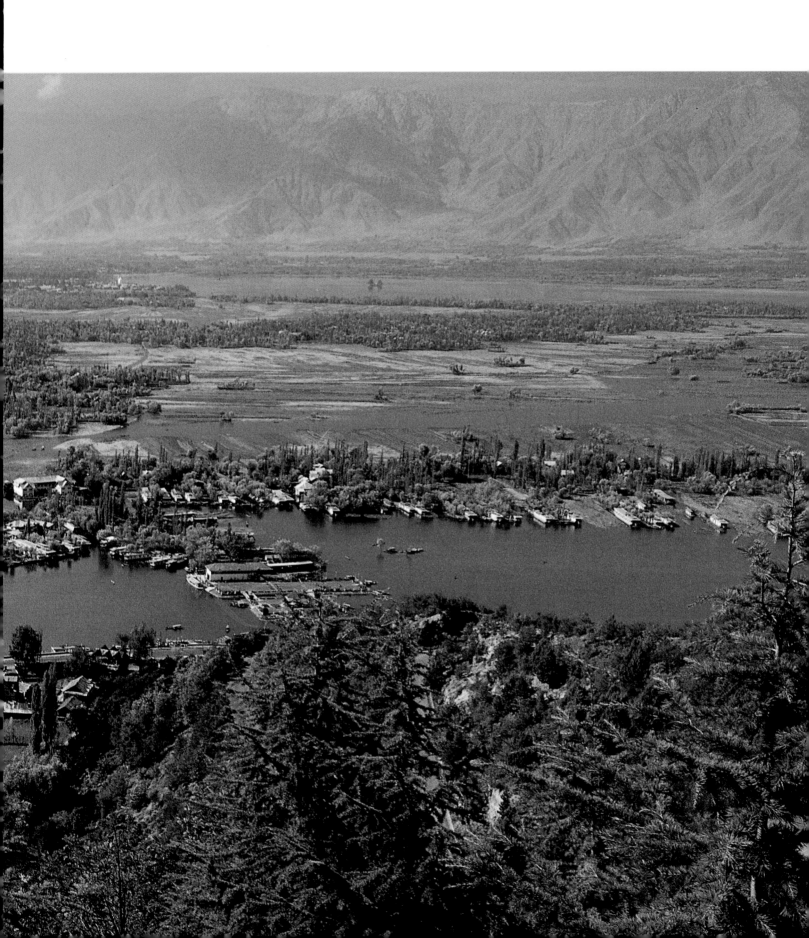

Bombay, an Alluring Mixture of Races and Cultures

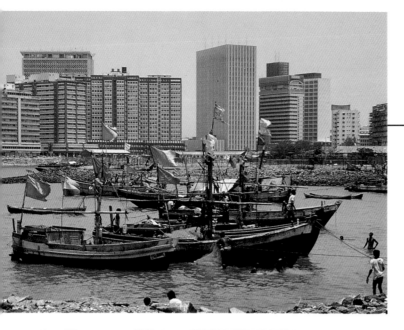

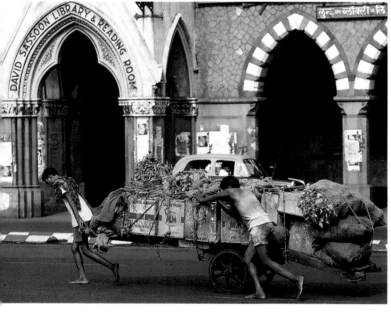

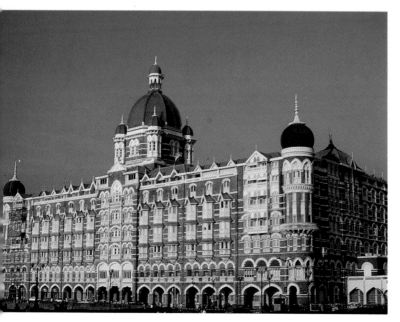

80 top left *Tall modern buildings on newly reclaimed land on Bombay's western shore contrast with the traditional boats of an unchanging settlement of fishermen.*

80 centre left *Despite a modern transportation system, much local movement of goods in Bombay is still made with handcarts and muscle power. Behind is the former Mechanics Institute, built in 1870 and now a library.*

80 bottom left *The Taj Mahal hotel was built in 1903 for J. N. Tata, the most famous of India's early industrialists. It has always been Bombay's premier hotel. Its architecture is representative of much that was built in the late 19th century in Bombay - a unique mixture of western and Indian features.*

80 right *Of the 500-600 full length feature films produced annually in India, about half are made in Bombay's "Bollywood" studios. Audiences are enormous, and the film stars have a popularity which some have successfully transferred to the political scene.*

81 *Maintenance work on one of Bombay's modern office blocks requires only a minimal scaffolding.*

82-83 *The only British monarch to visit India was King George V who in 1911 first set foot in India at Bombay. In commemoration, the Gateway to India was completed in 1927. Modelled on 16th-century Gujarati architecture, it is perhaps Bombay's best known landmark. Through it in 1948 marched the last British regiment to leave India after independence.*

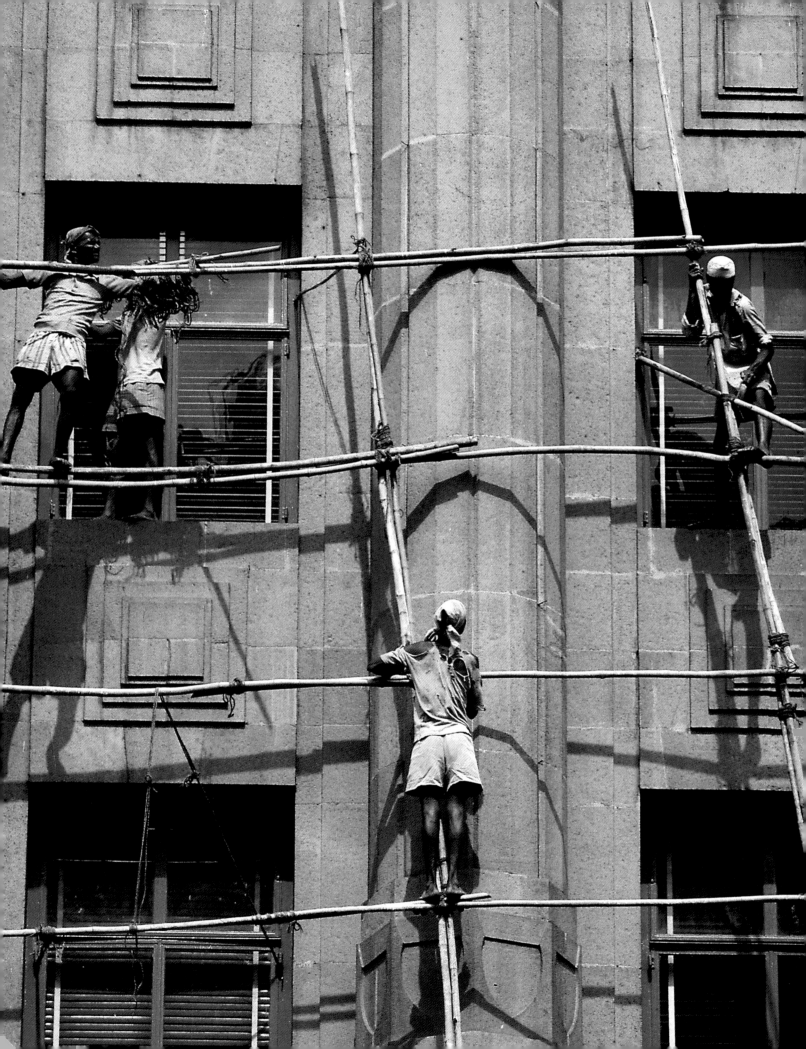

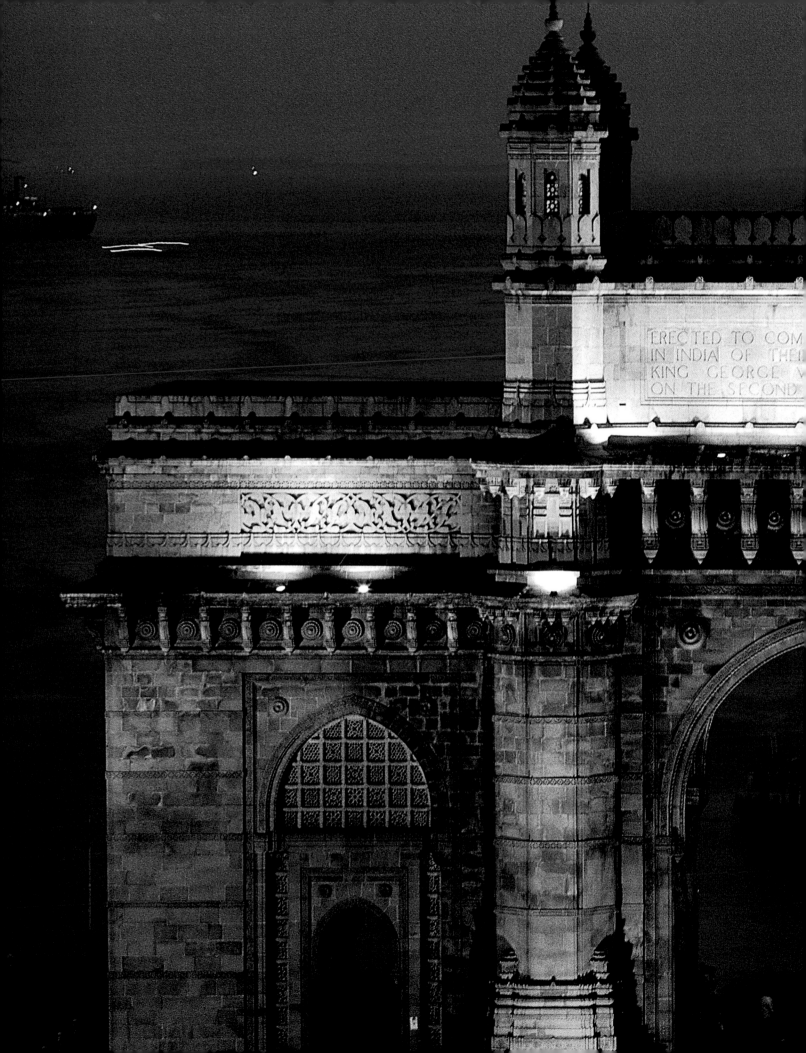

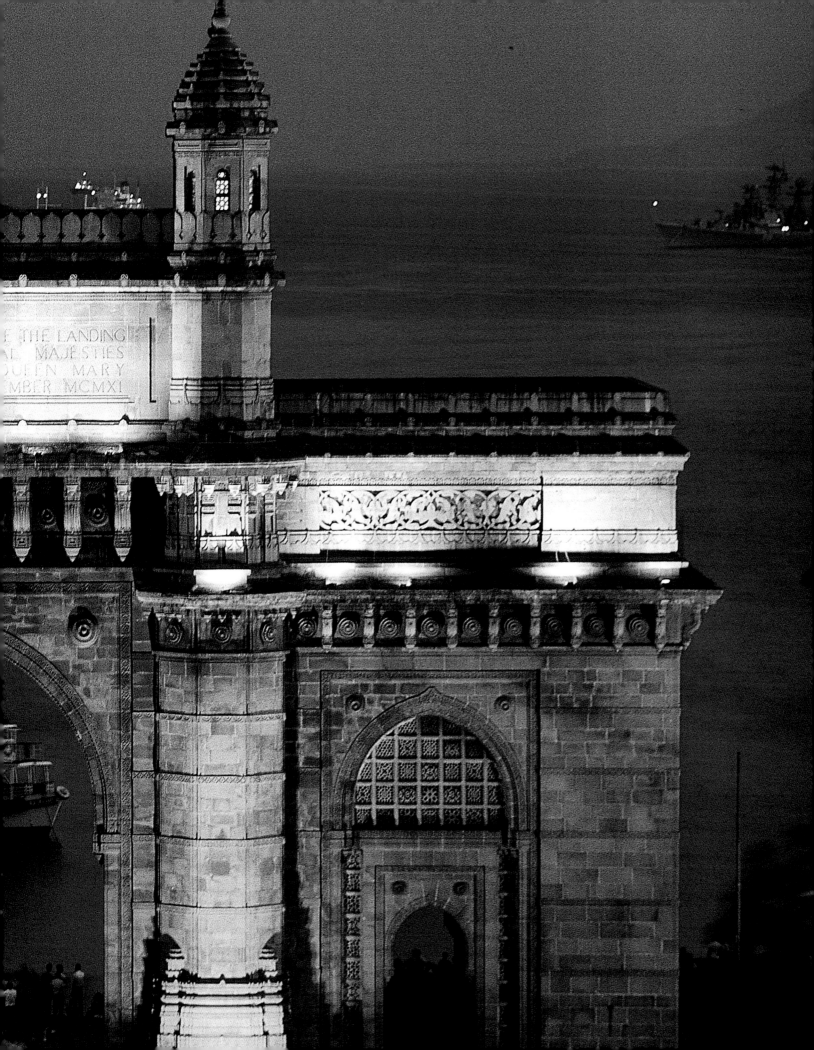

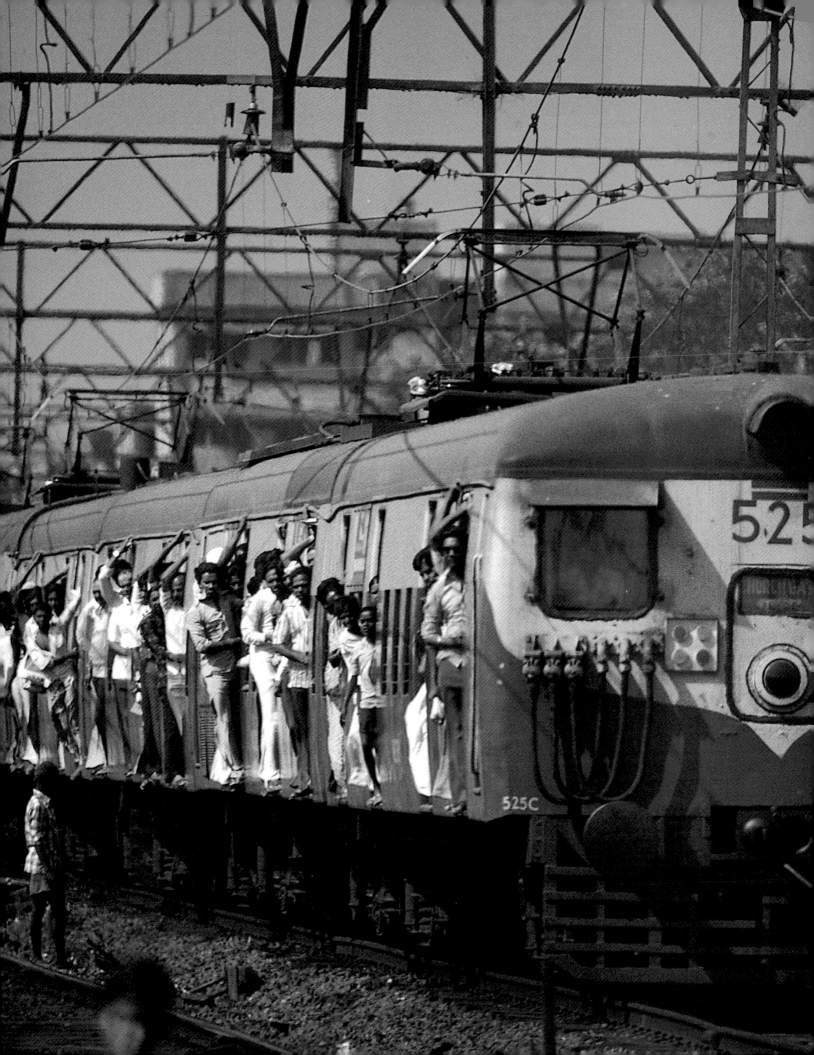

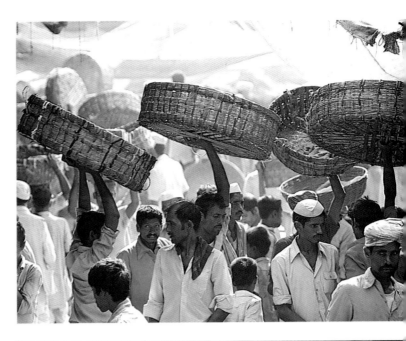

84 Bombay is a city of some thirteen million people, and its suburban railway system is consequently usually crowded, at least in the rush hour. In this it is similar to other large cities: but at least the last passengers to board the train can enjoy fresh air.

85 left A member of the Bombay police force. Instead of a truncheon he carries a long staff, known as a lathi.

85 top right Porters at one of Bombay's many markets.

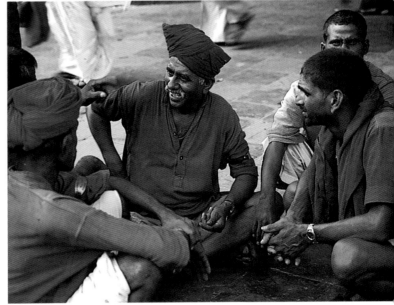

85 centre right Railway porters enjoy a respite from work, whilst resting on a platform.

85 bottom right Crawford Market was the first covered market to be built by the British in Bombay in 1870. The father of the writer and poet Rudyard Kipling designed it and also executed the bas-reliefs over the entrance.

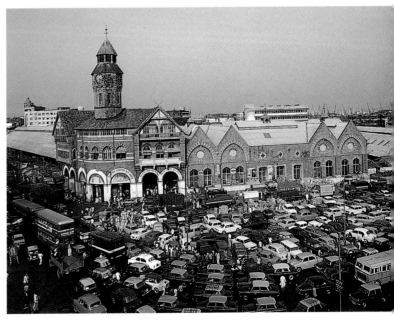

Calcutta, the Megalopolis

86 top *Devotees make offerings at a Calcutta roadside shrine.*

86 bottom *As in other large cities, Calcutta streets are full of pedestrians as well as traffic, including the many yellow-topped taxis.*

87 *Calcutta is separated by the Hooghly river from its smaller twin city of Howrah. Until 1943, these were connected by a pontoon bridge. But in that year the Howrah bridge was opened, its single cantilever span*

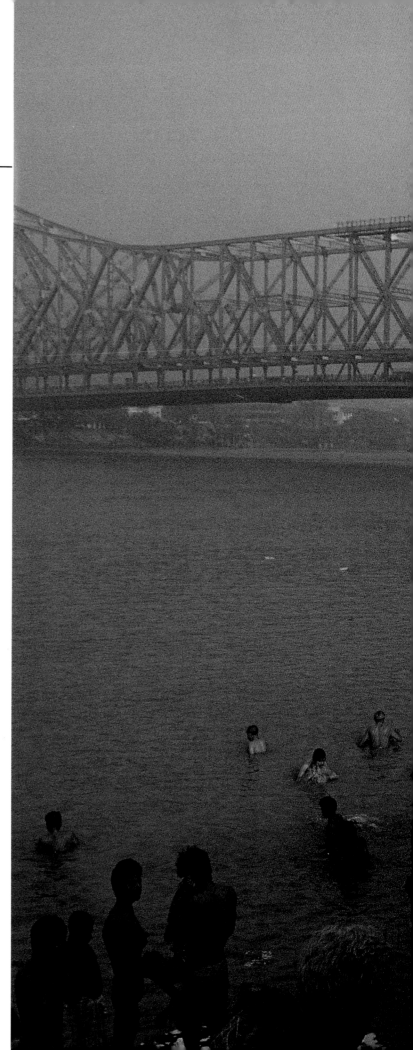

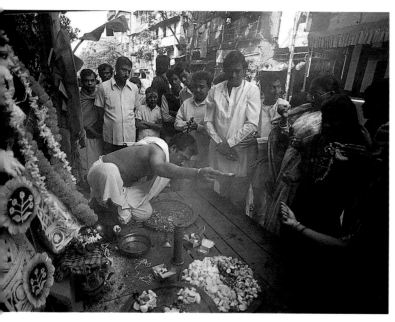

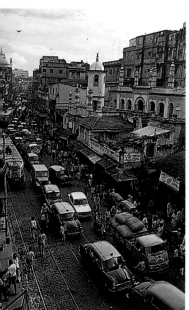

stretching for 1,478 feet. It at once became a symbol of the city like its Sydney counterpart, as well as becoming crowded with traffic. Recently a second bridge has been opened to connect these two cities with a combined population of some 12 million people.

88-89 *Calcutta is a low-lying city, and is sometimes flooded at the height of the monsoon rains, which occur between June and August. It is also one of the few Indian cities which has maintained some unmechanised rickshaws.*

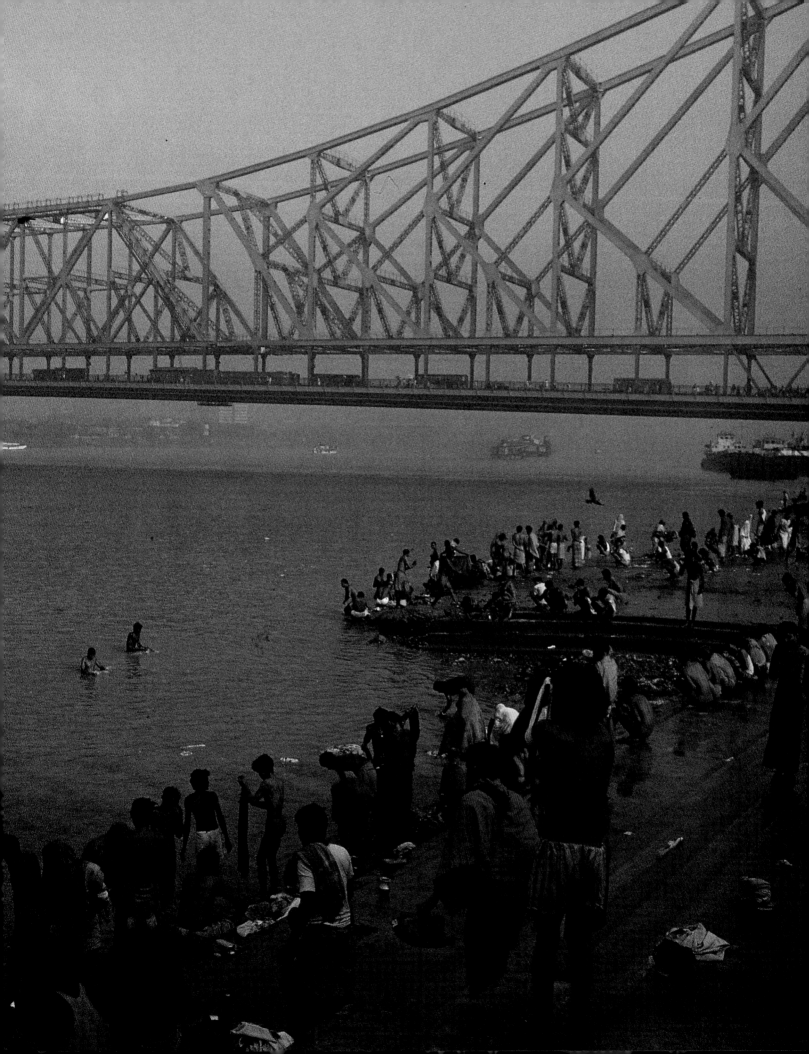

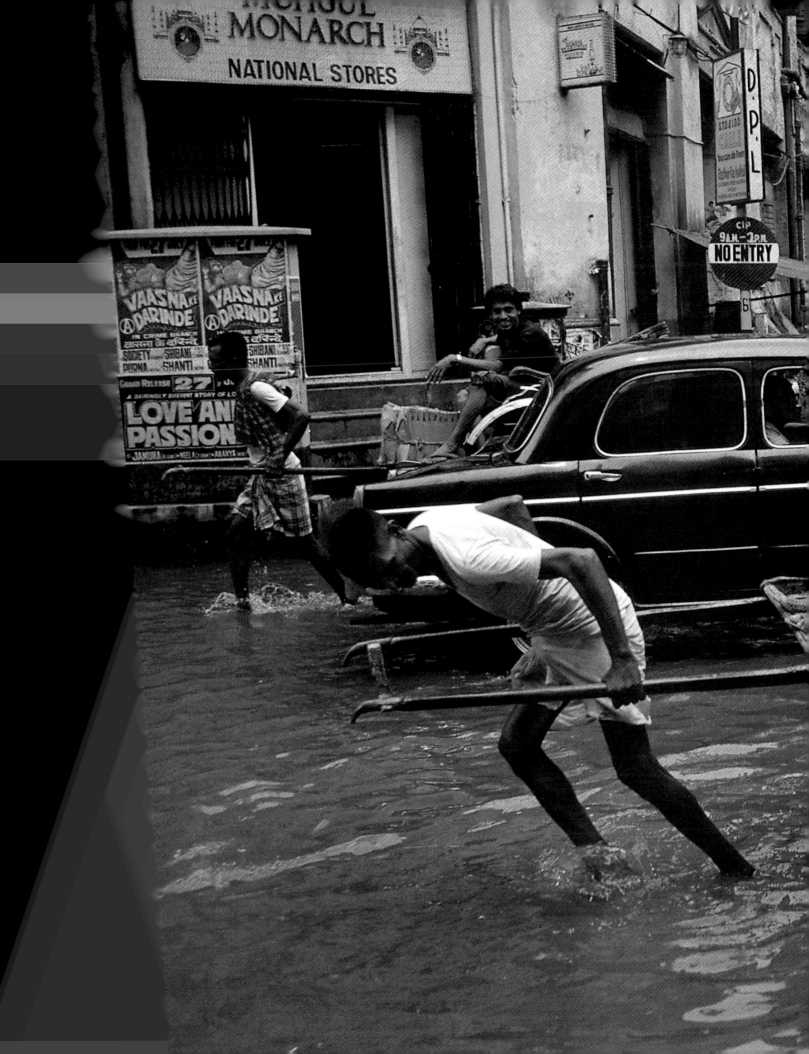

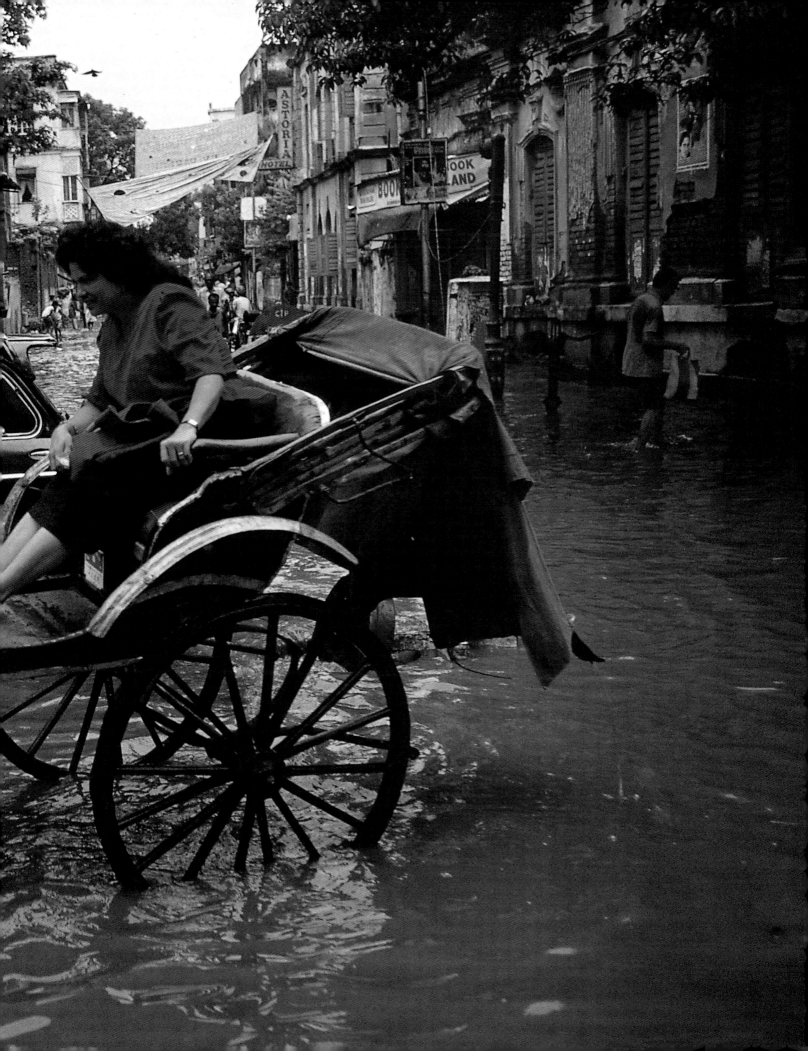

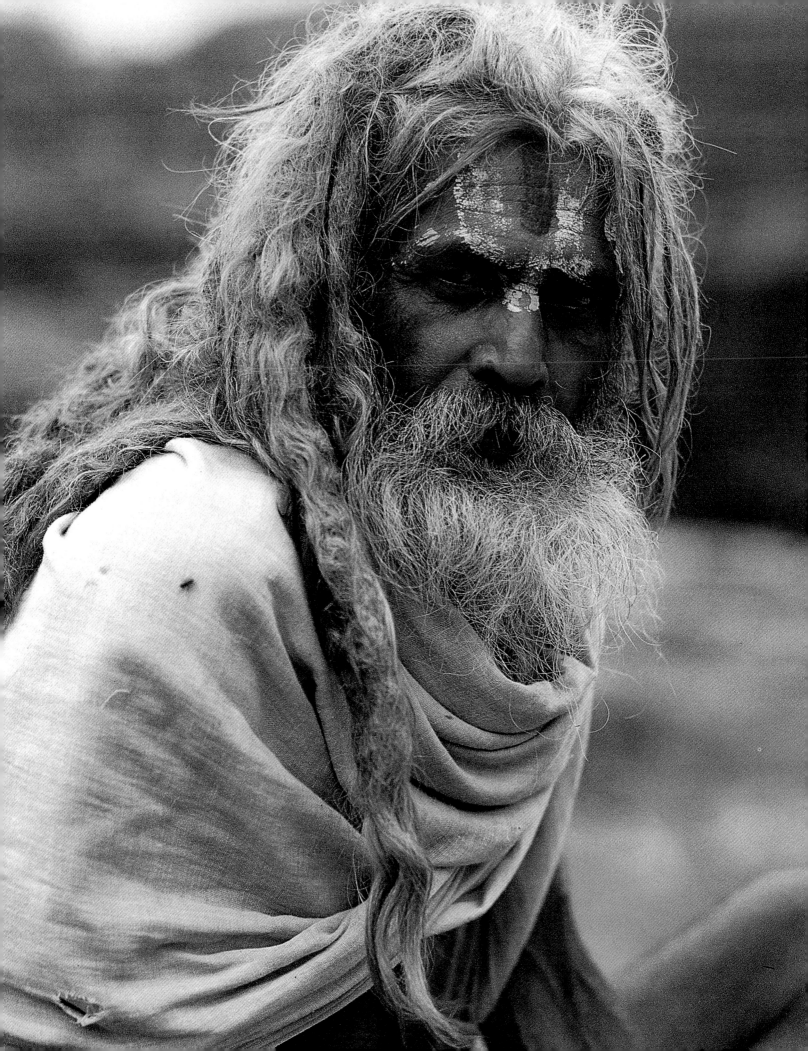

Varanasi, the City of the Dead

90 *An ascetic at one of the 12-yearly bathing festivals.*

91 *The city of Varanasi and the river Ganges are considered to be sacred places by Hindus. Here Lord Shiva, as Overlord of the world, is believed to be the presiding deity of the town. Being the God so close to humankind it is a common belief that the waters of the river Ganges can purify a person and that to die in Varanasi can give a person liberation from the cycle of reincarnation.*

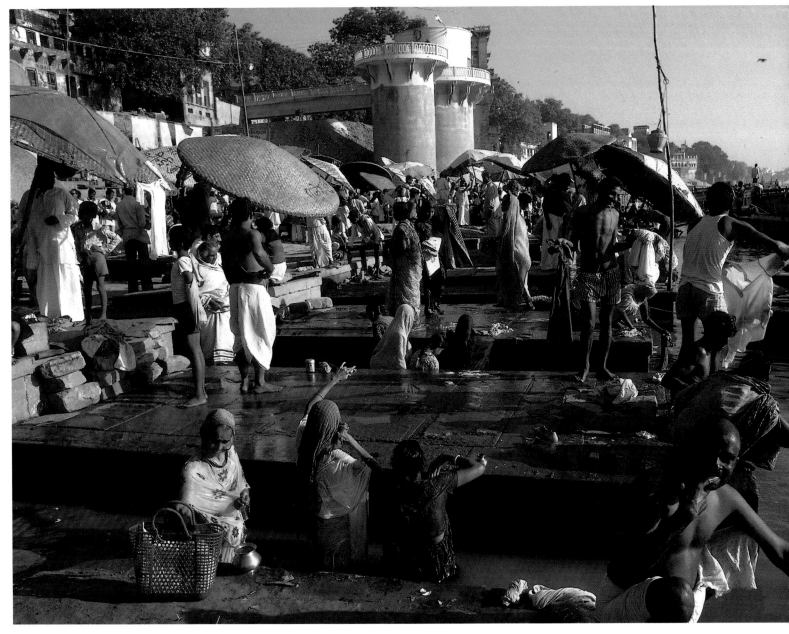

The Sacred Waters of the Rivers

92 *The banks of the Ganges at Varanasi are lined with temples, and boats take pilgrims to view them and the steps down to the river.*

93 *Each year a festival is held in honour of India's many sacred rivers. They are worshipped with garlands and lights, which are then left to float on the water.*

94-95 *Dawn on the river Yamuna. Above is the Taj Mahal, mysterious in the early light. Below, the washermen are already at work, and camels cross the river, made shallow during the dry season.*

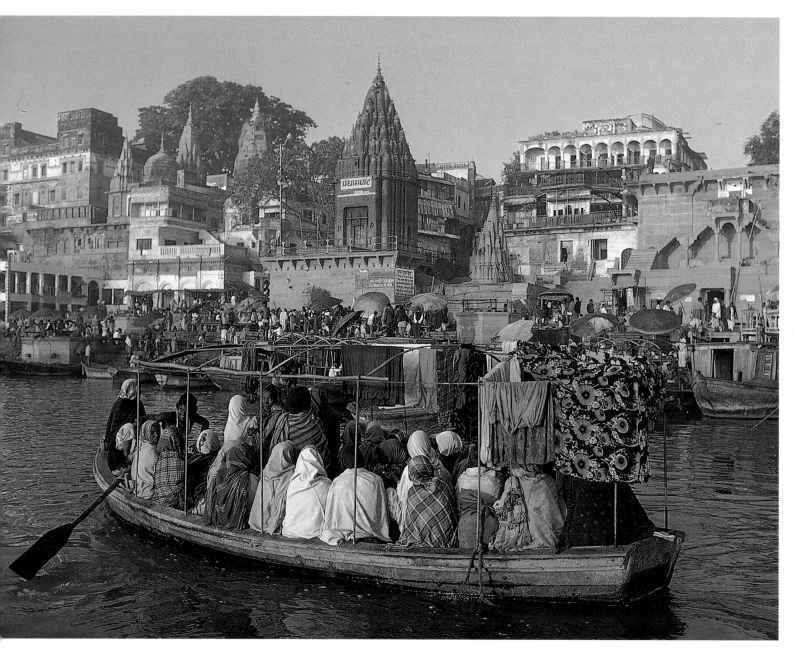

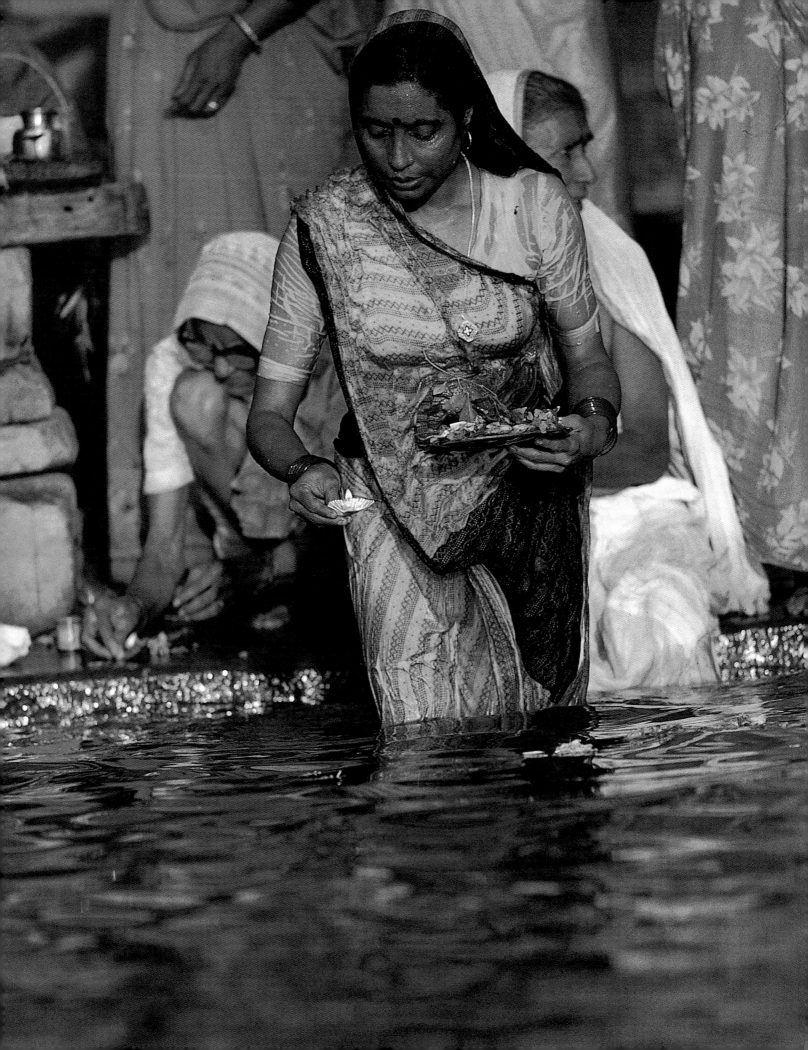

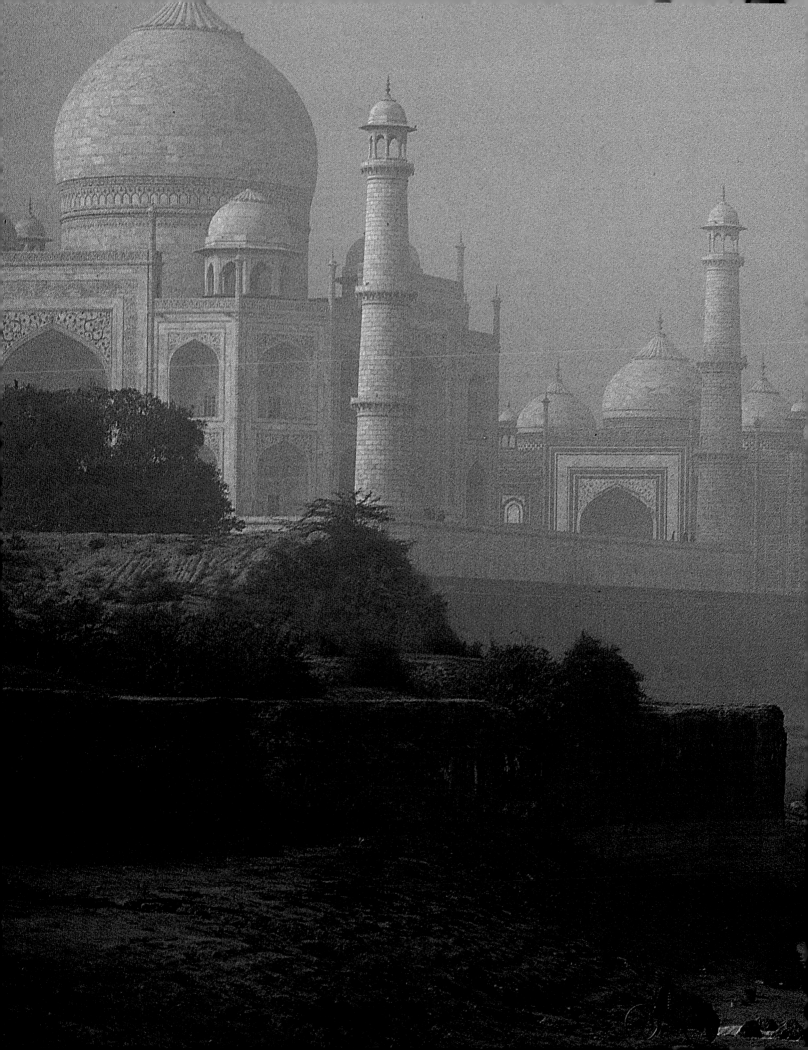

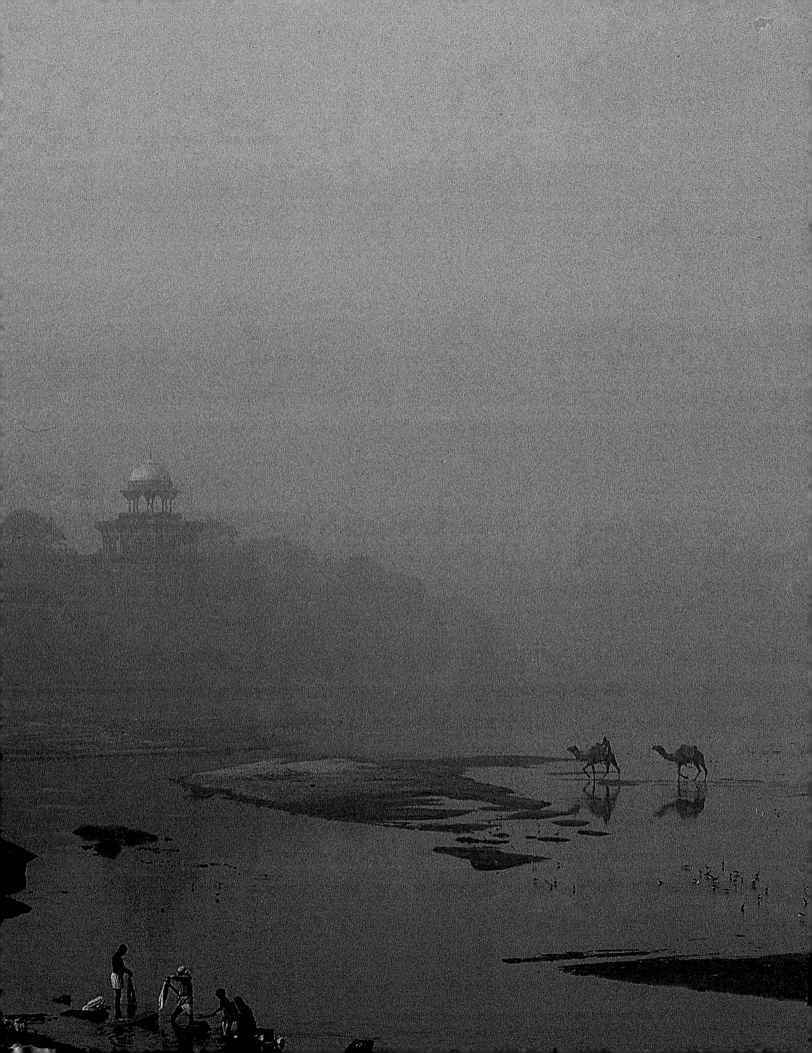

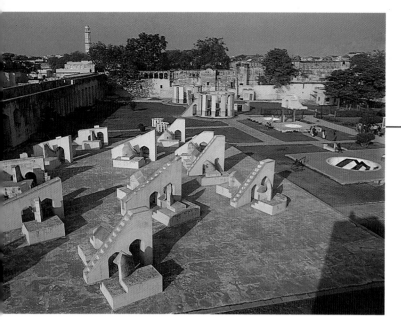

Jaipur, the Pink City

96 top *The city of Jaipur is a comparatively modern one, being founded by Maharaja Jai Singh II (after whom it was named) in 1727. The city was laid out according to classical Hindu rules, and remains one of the best situated and organised places in India. Jai Singh was interested in many fields of knowledge and was an expert astronomer. He built five observatories, of which the one in Jaipur is the best preserved. With these he was able make accurate star charts and to calculate planet movements.*

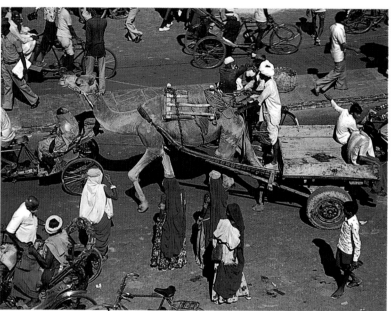

96 centre right and bottom *Women in a Jaipur market. They have come with things to sell (vegetables, grains and spices). Their head shawls are patterned with traditional techniques of decoration tie-dye and block printing.*

96 centre left *A street scene in Jaipur shows that camels are still the major beasts of burden in both countryside and city, being excellently adapted to the dry climate of this part of Rajasthan.*

97 top *The city laid out by Jai Singh II had a pattern of straight streets and houses of similar height. This has been maintained in modern Jaipur. The uniform colour of the buildings stems from the order of Maharaja Ram Singh in 1875. Since then, Jaipur has of course been known as the Pink City.*

97 bottom *Built by Maharaja Pratap Singh in 1799, the Palace of the Winds was a palace from which the royal ladies and their retinues could view the Maharaja's processions from the privacy of screened rooms. The palace presents a wonderful example of projecting windows under curved and domed eaves and has become the Jaipur building best known to the outside world.*

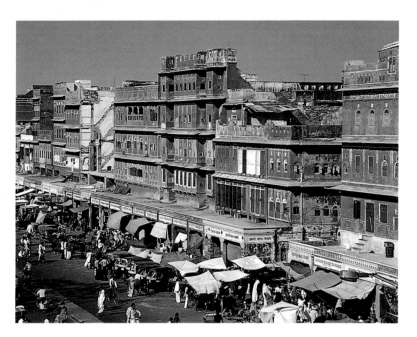

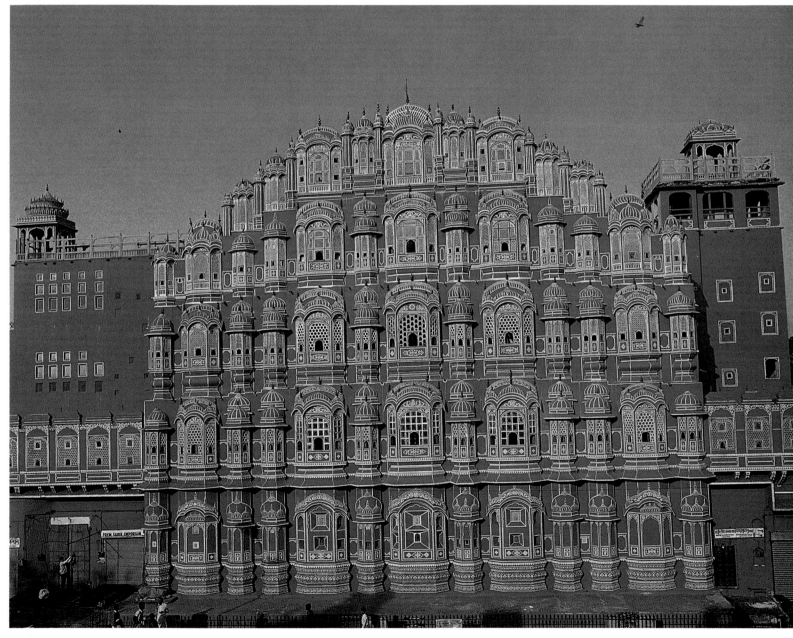

98 *The City Palace in Jaipur forms a complex of buildings and courtyards, dating from the founding of the city. Included are the Halls of Public and Private Audience, the Guesthouse and the seven-storeyed Moon Palace (pictured here), still the residence of the Maharaja. Note the pool and its fountains, as well as the wall paintings. Beside them stands a palace servant.*

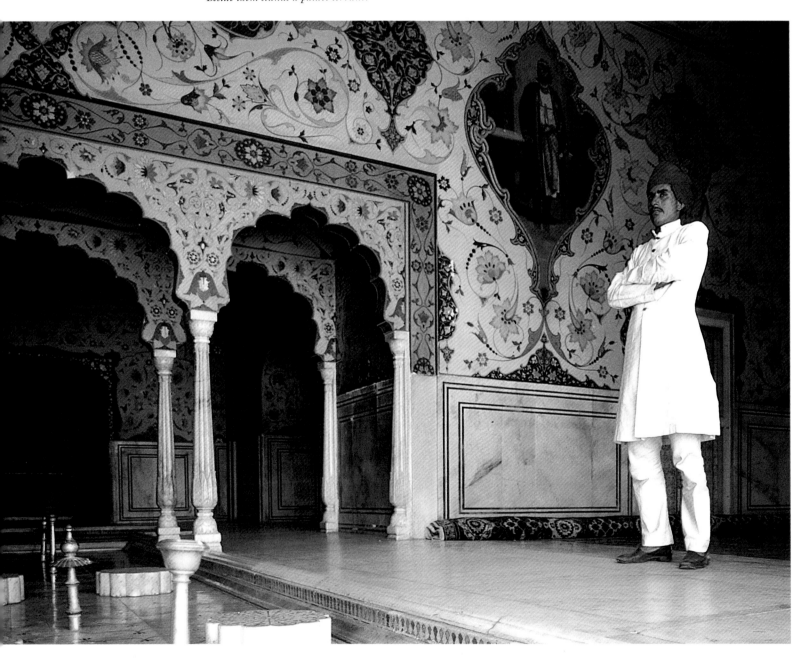

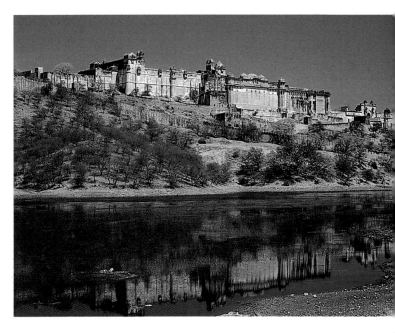

99 left and top right *Before the founding of Jaipur, the ruling dynasty's capital was at nearby Amber. The palace shown in the photograph (top) here was started in 1592 on a ridge overlooking an artificial lake. Like the Jaipur palace, it comprises a number of public and private buildings, as well as a portion devoted to the women of the royal house. The more private part is entered through a gate dedicated to the deity Ganesh (left). It is painted in bright colours, and above are screened windows through which the royal ladies could observe public assemblies in the courtyard below, whilst themselves remaining in seclusion.*

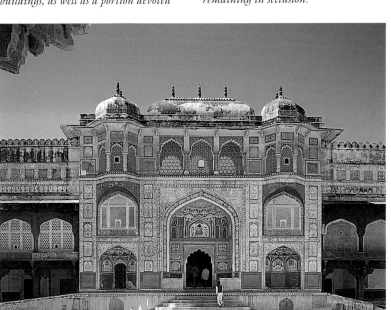

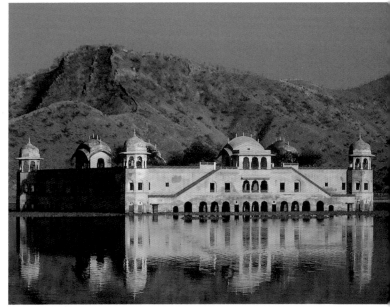

99 centre right *Halfway between Jaipur and Amber lies a lake which was, in olden days, a haunt of wildfowl. The Jaipur Maharajas contructed a small country palace in the middle of the lake, to which they went for duck shooting and recreation.*

99 bottom *Several forts were built on the hills surrounding Jaipur, to act as a military protection for the city. Temples were also built, of which this is one, to ensure the spiritual protection of the populace below.*

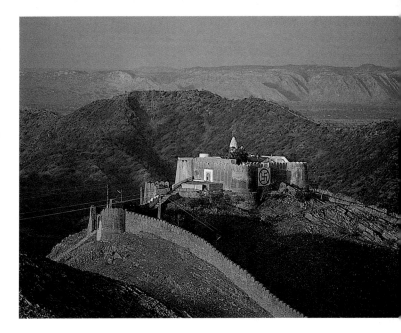

Jodhpur,
Classical Elegance

100-101 *Jodhpur is, after Jaipur, the largest city in Rajasthan. Formerly the capital of the Princely State of that name, the western side of the city is dominated by an immense fort, built in 1459 and the scene of stirring sieges and many acts of bravery. Equally impressive is the modern Umaid Bhavan palace overlooking the city to the east. Built between 1929 and 1943 by a workforce of some three thousand people, it has three hundred and forty-seven rooms and its central dome soars to a height of one hundred and eighty-* *five feet. Architecturally, it provides perhaps the best synthesis of east and west of any Indian building. Its interior, with a sweeping double staircase, an underground swimming pool, splendid reception rooms, and countless suites and other rooms, is now an hotel. However, the Maharaja of Jodhpur continues to live in the viceregal suite. We see him and his family strolling in front of the palace* (right), *and others walking in the ornamental gardens that form part of the palace's surroundings* (left).

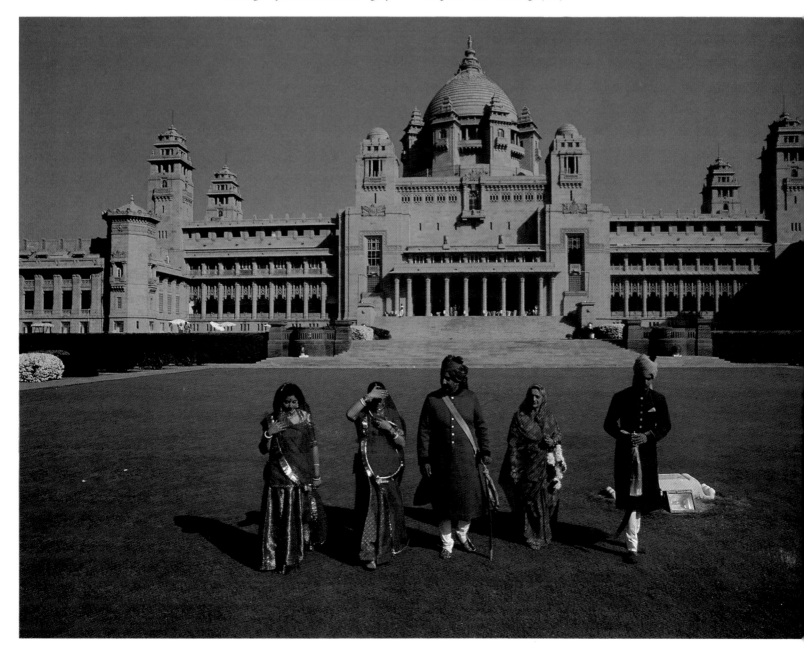

The Arabesques of Jeisalmer

102-103 *The most western of the former Princely States lies in Rajasthan's semi-desert, stretching to what is now the border with Pakistan. Its capital was Jeisalmer, renowned for the fort founded in 1156, and here seen with its curved, honey-coloured battlements bathed in the sunset.*

104-105 *Traditionally, Jaisalmer was an important centre on the great trade route from the middle east to India. Its merchants were wealthy, and vied with each other in the size and luxury of their houses.*

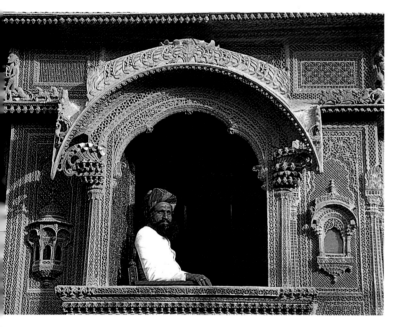

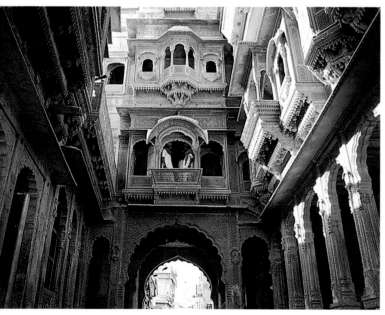

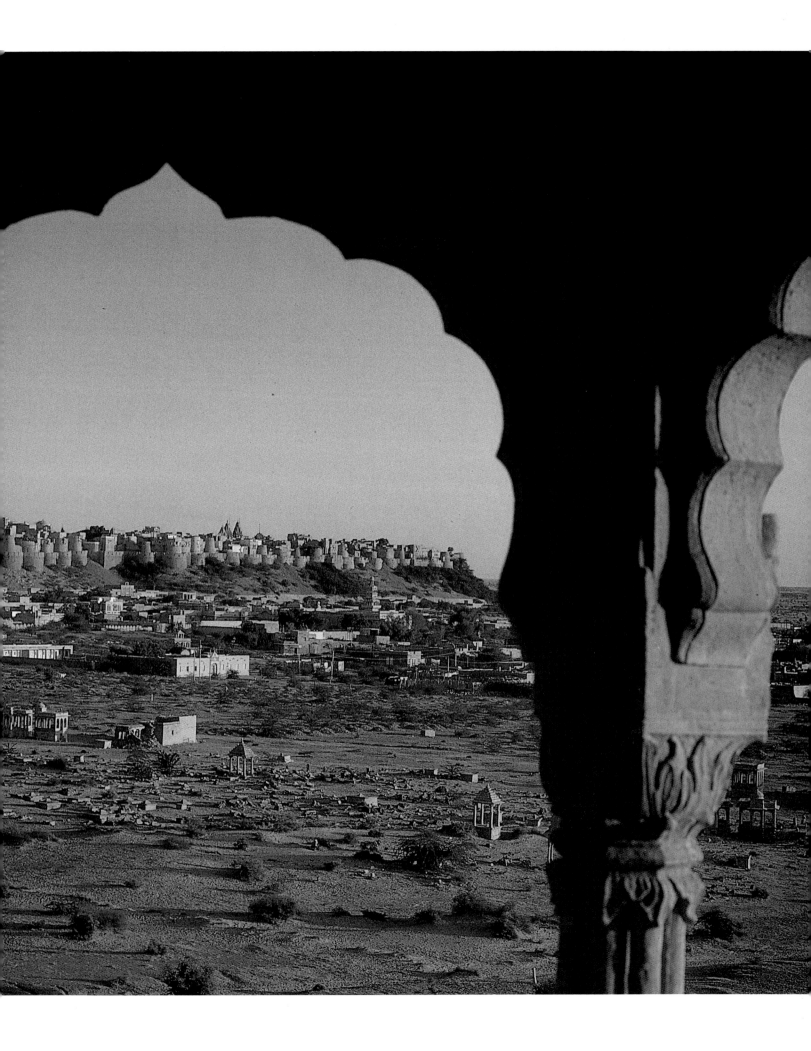

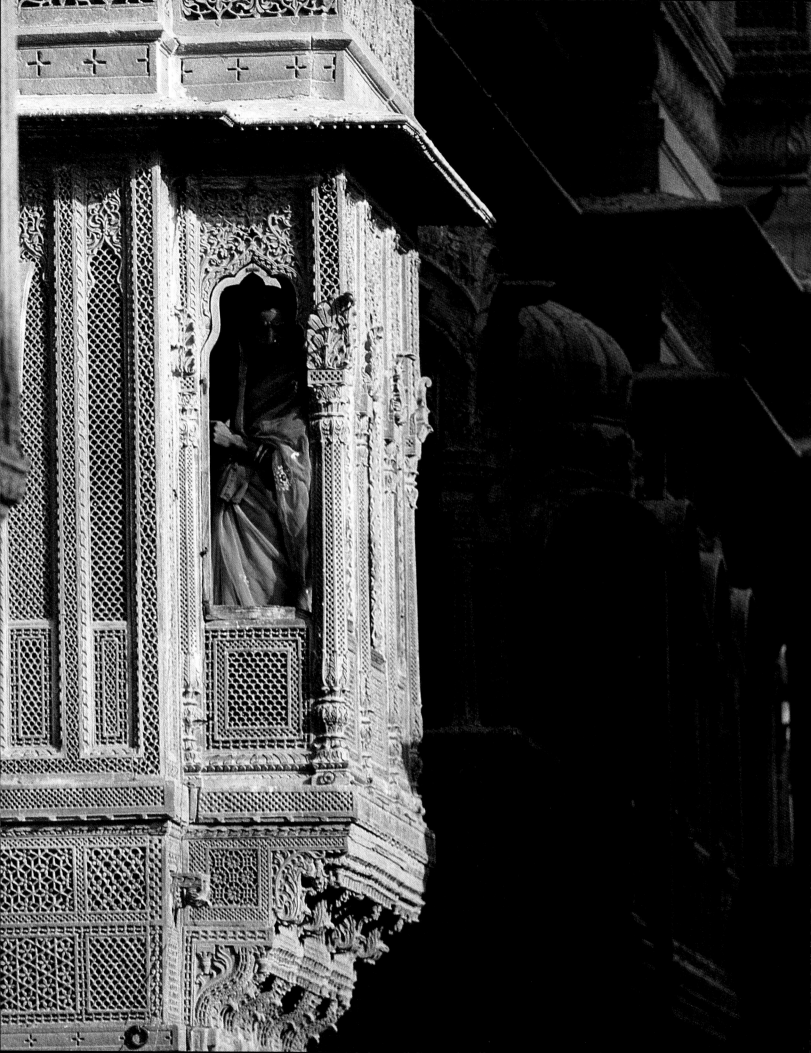

The Sites of Divine Worship

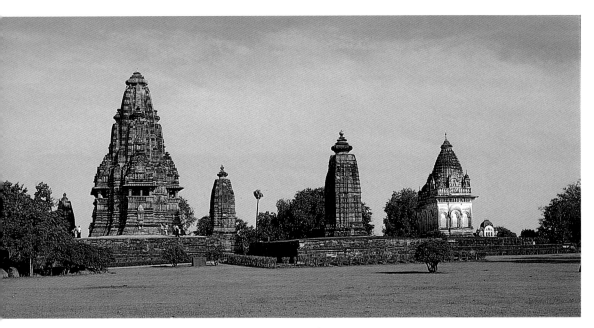

106 top *The Hindu temples at Khajuraho in central India were built in the 10th and 11th centuries, by kings of the Chandela dynasty, whose capital this was. They represent the culmination of the north Indian temple style, with lofty spires over the central shrine, high plinths and magnificently plastic sculpture.*

106 bottom *The Hindu temples at Bhubaneshwar near the east coast were erected between the 7th and 11th centuries. The curved style of the spire differs from that of north Indian temples. But in each case there is a tension between massiveness and delicacy of outline which has great aesthetic quality.*

107 *Many of the great temples of southern India show a development in which the towers over the four gates to the sacred compound containing the shrine, rather than the shrine itself, are architecturally important. The 17th-century temple to the goddess Minakshi in Madurai is an example. In the plate, the shrine (denoted by its golden roof) is on the left, but is physically dominated by the towers over the inner and outer courtyards.*

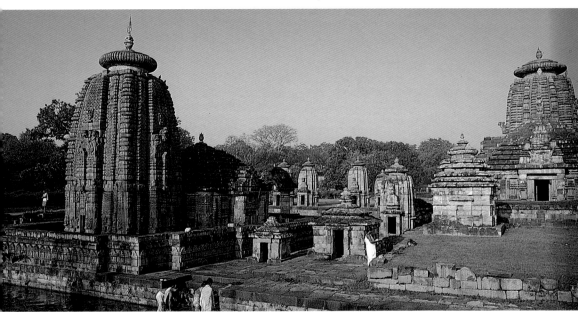

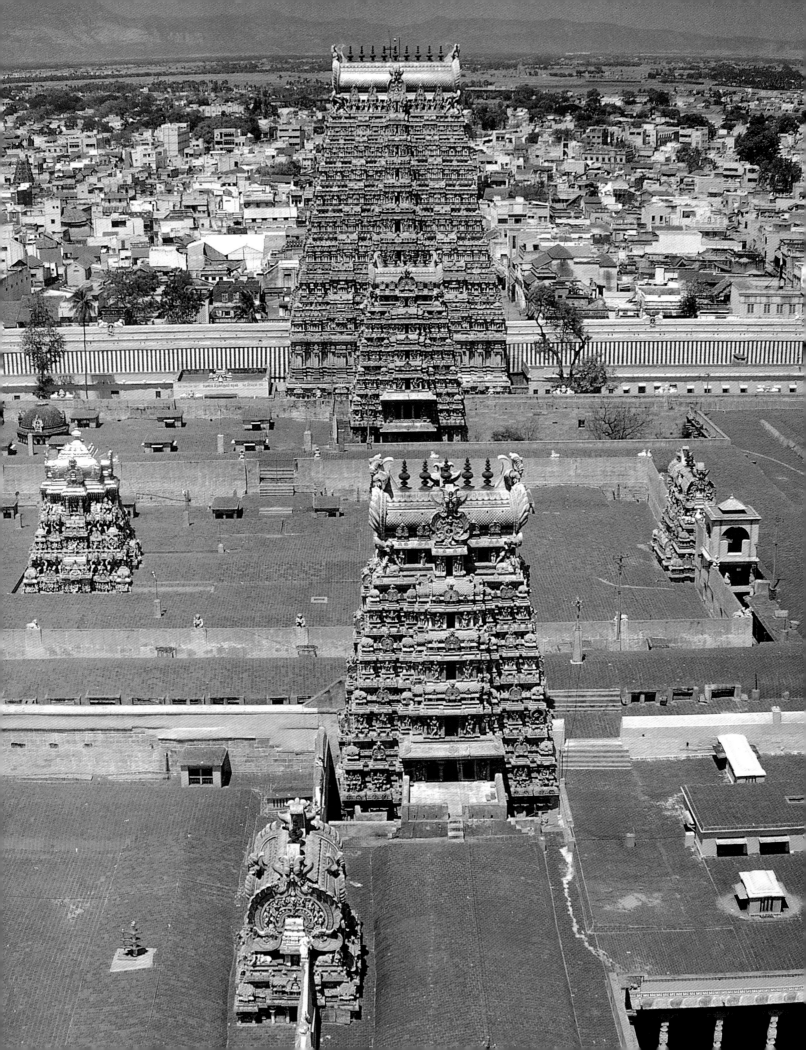

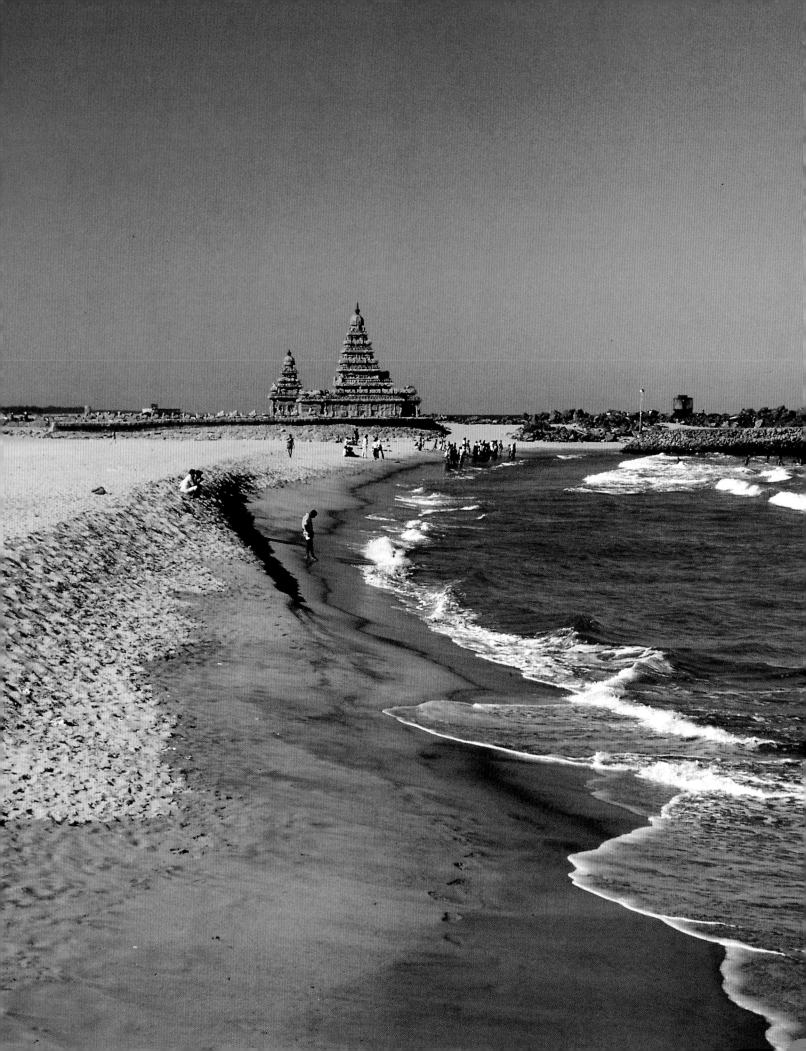

Where Art
Meets Faith

108 *The Shore temple at Mamallapuram, some 37 miles south of Madras, is the earliest example of a free-standing masonry temple in southern India. Built in the early 8th century, it superseded temple chambers cut into rock, or temples cut from a large monolithic stone. The form of the spire set the pattern for subsequent architecture, making it a very significant building.*

109 top *One of the most impressive works of Indian sculptural art is the 7th-century Arjun's Penance at Mamallapuram. Carved into the living rock, the frieze contains the figure of the culture-hero Arjuna, together with gods and goddesses, semi-divine beings, and a multitude of animals. The entire frieze shows both naturalism and vitality of a high order.*

109 bottom *Mamallapuram contains a group of five monolithic monuments, carved into temple-like shape. They are incomplete, perhaps because the progression to the masonry free-standing contruction of the nearby Shore temple rendered this technique obsolete. Here we see three of the five "chariots" as they are called, together with an accompanying elephant.*

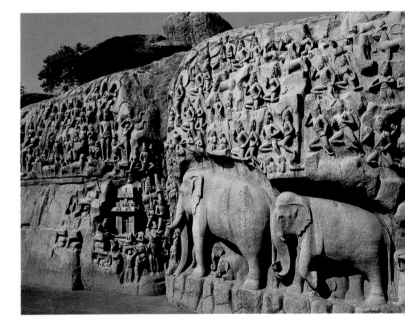

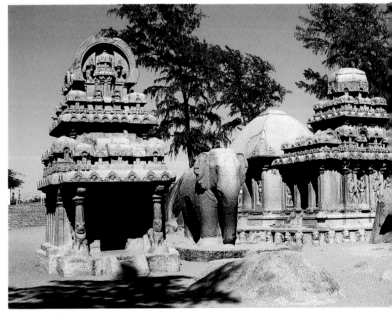

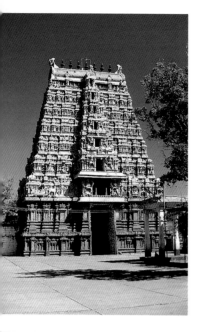

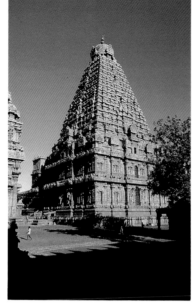

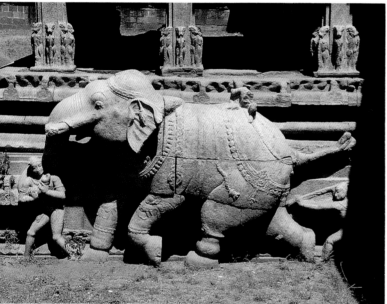

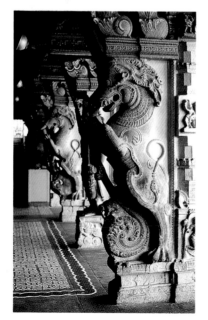

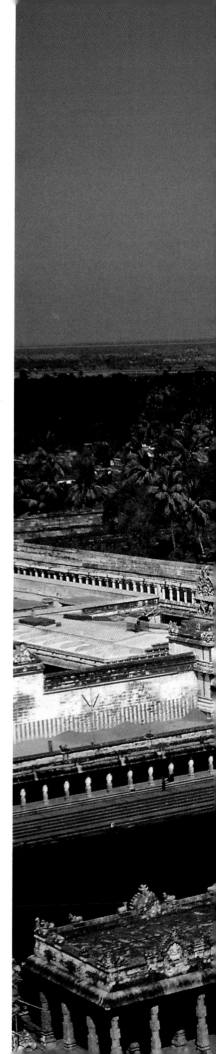

110 top left *A good example of the south India gateway-tower is the tower at the 13th-century Nataraja temple in Chidambaram.*

110 top right *Contrasting with the generality of south Indian temples, the 11th-century Brihadishvara temple at Thanjavur has its main spire over the shrine. Built by the greatest of the south Indian rulers, it is above all a royal temple devoted to the king's patron god.*

110 centre *A fine carving of a running elephant, with its attendants. Animals play a significant part in temple sculpture. The horse is another favourite subject, a symbol of royalty as well as an essential part of any king's armoury.*

110 bottom *Dragon-like animals guard the temple precincts, forming a series of marvellously carved pillars.*

111 *To provide water for devotees to purify themselves with, south Indian temples contain within their precincts large pools of water, bordered by colonnades and approached by flights of steps.*

112-113 *Gaily-painted guardians adorn a south Indian gateway tower. To build higher and higher towers became a point of honour for each temple's patrons. This continues to the present, with the highest tower of all being completed in 1987 at Srirangam. This is 236 feet high and its 13 storeys took eight years to build, on the foundation of a tower started 400 years previously.*

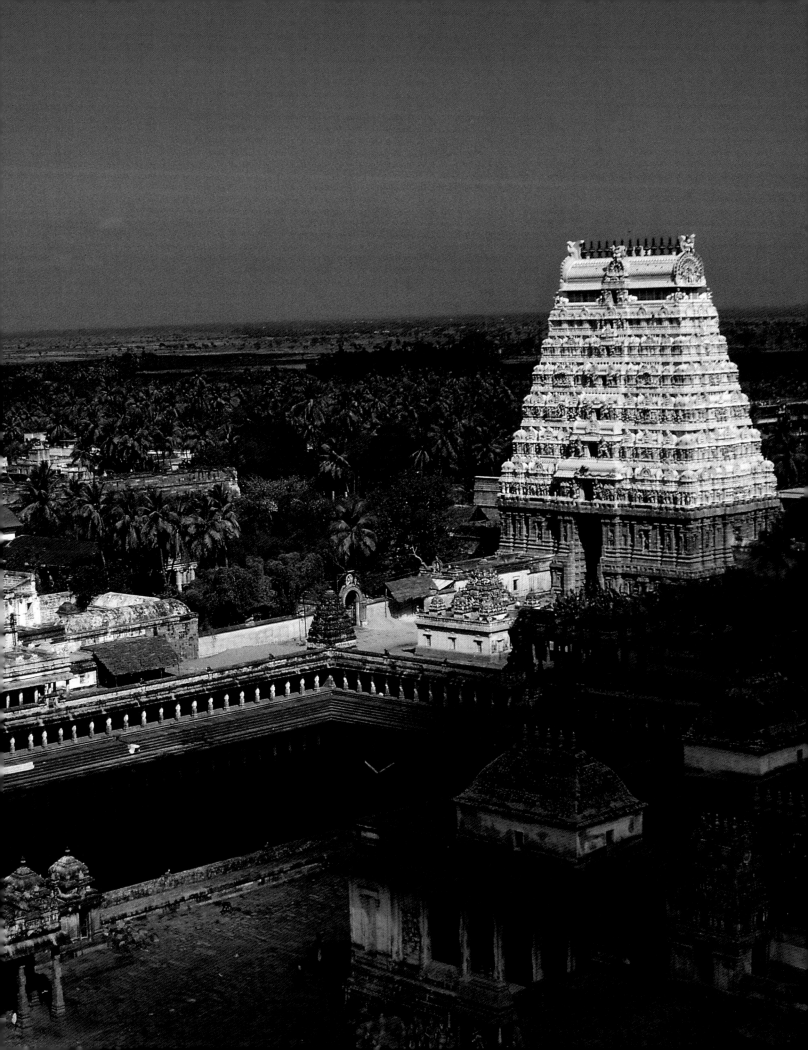

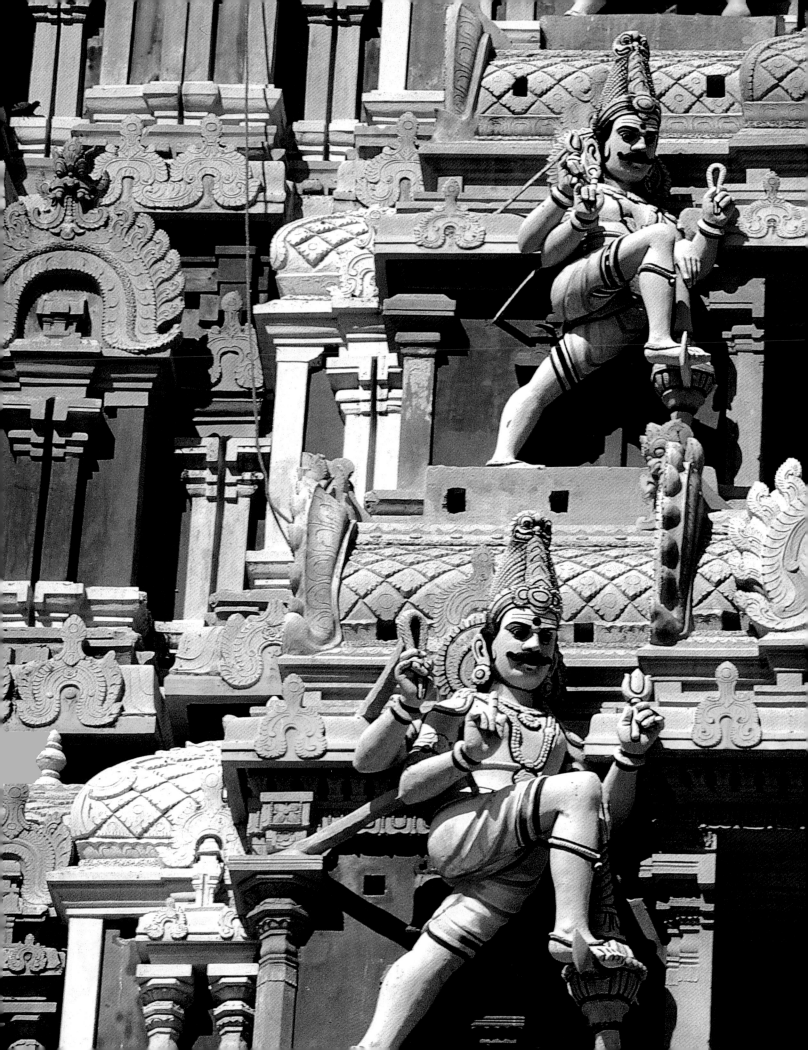

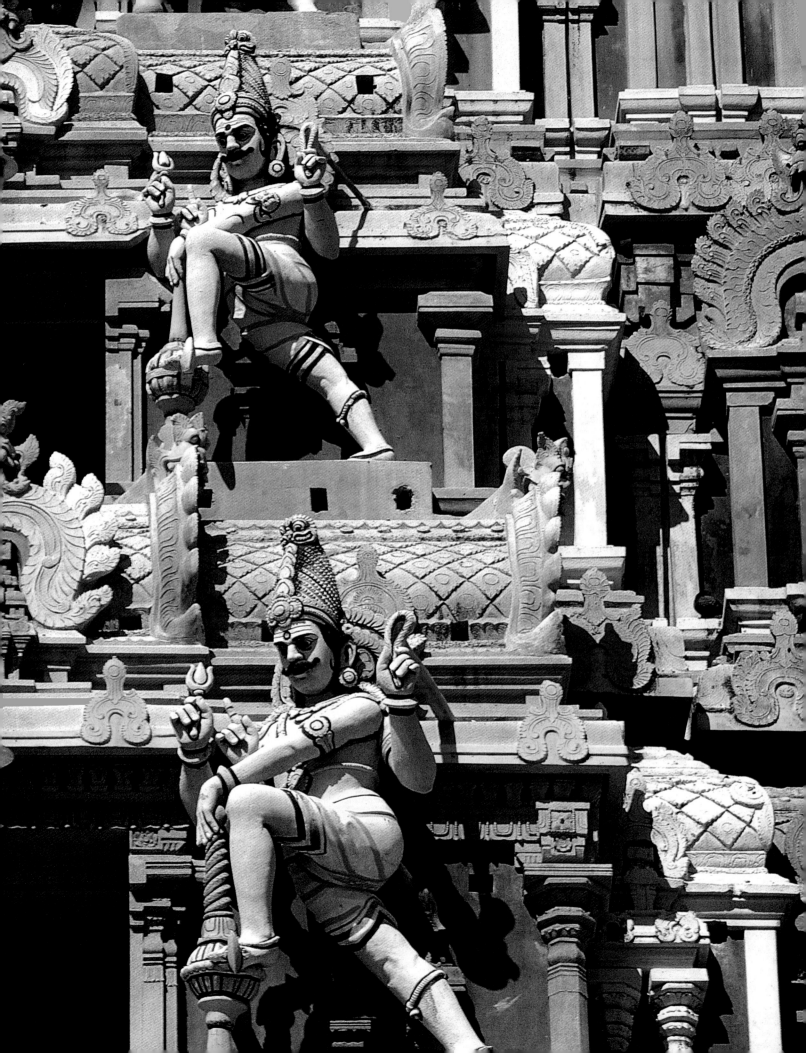

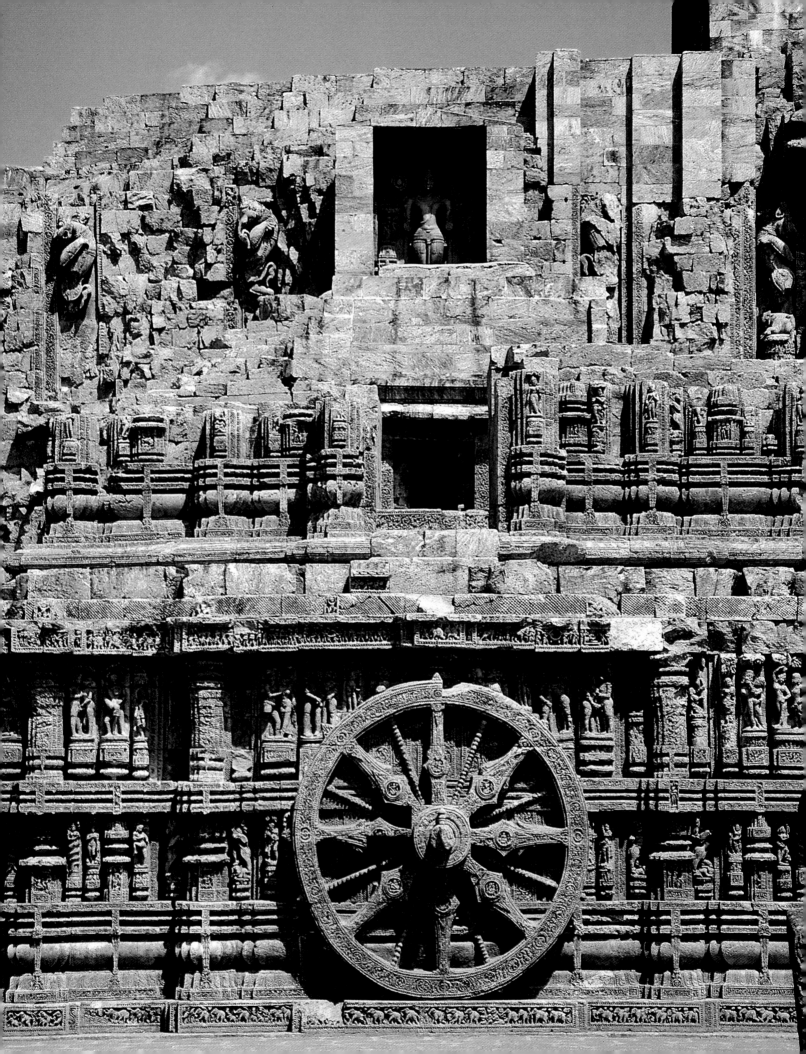

The Temple of the Sun God

114 *The culmination of Orissan temples in eastern India is the temple at Konarak. Built in the 13th century and dedicated to Surya the sun god, it was conceived of as Surya's chariot. Hence the temple "rests" on twenty-four massive wheels and is "drawn" by flying horses. It is supported by a frieze of elephants, and over the whole gaze statues of Surya. In between, there are friezes of figures, especially prominent being heavenly nymphs, serpent kings and queens, and fabulous beasts.*

115 top *The main tower of the temple collapsed more than a century ago. The massive dimensions of its porch, the only remaining building and shown in this picture, indicate how large and high the main shrine must have been.*

115 centre left *A detailed photograph of one of the wheels shows the elaborate and meticulous carving that covers it. Both the decorative patterns and the human and animal figures show an astonishing technique and mastery of detail.*

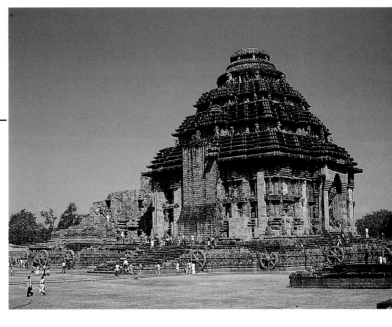

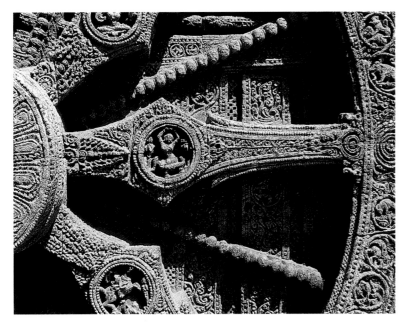

115 bottom *A detail of the frieze which encircles the temple indicates the profusion of sculpture. This example is of drummers and dancers. Other carvings depict loving couples. All are carved with a delicacy and immediacy which makes them intensely human.*

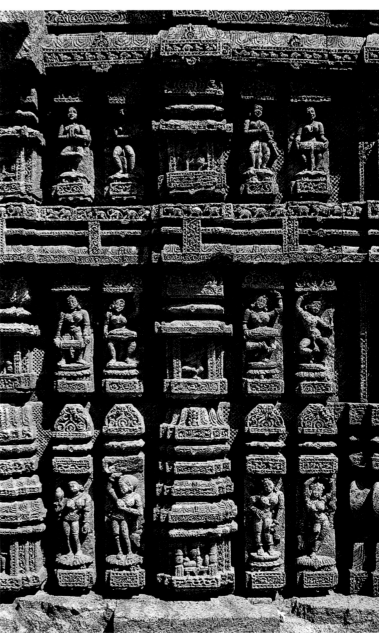

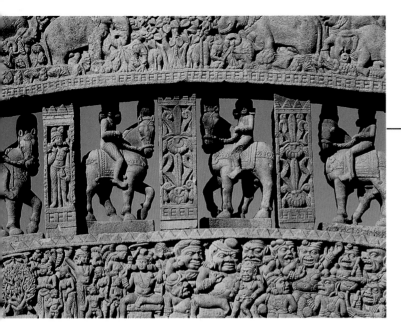

The Elaborate Forms of Buddhism

116 top-117 *Originating in the 5th century B.C., Buddhism was made the state religion by the emperor Asoka (273-232 B.C.). At Sanchi, in central India, Asoka made a memorial mound (stupa) to house a relic of the Buddha. This became a major place of pilgrimage, and in 75 B.C. it was* *beautified with four gates, carved with scenes from the life of the Buddha in this and previous incarnations. The pictures show details from the north gate (left), and the west gate (right) with its splendid lions and the pot-bellied and expressive dwarfs who support the upper structure.*

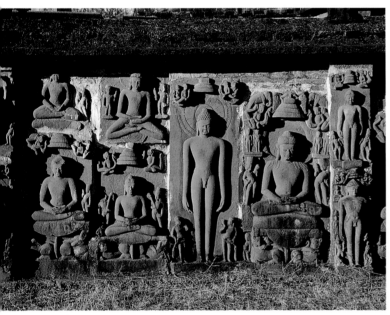

116 centre *The 24 Teachers of the Jain religion are portrayed in a highly stylised form. The more conservative sect of Jains portrays them without clothes, signifying their non-attachment to worldly matters. At Kandali fort, near Deogarh in central India, these images have been gathered into the series shown in the picture (centre left). Not very far away, the cliffs on which the great fort of Gwalior is built also house rock-cut sculptures for devotees to honour (centre right).*

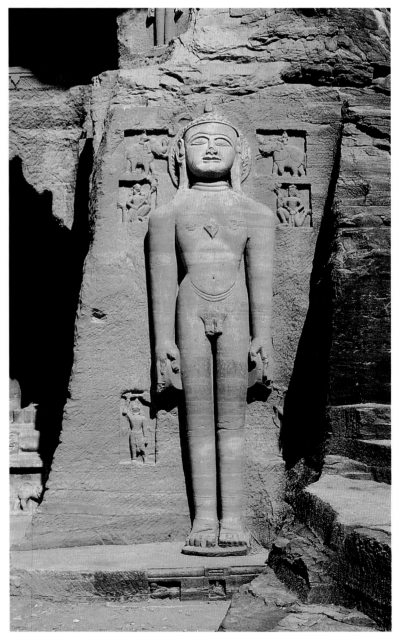

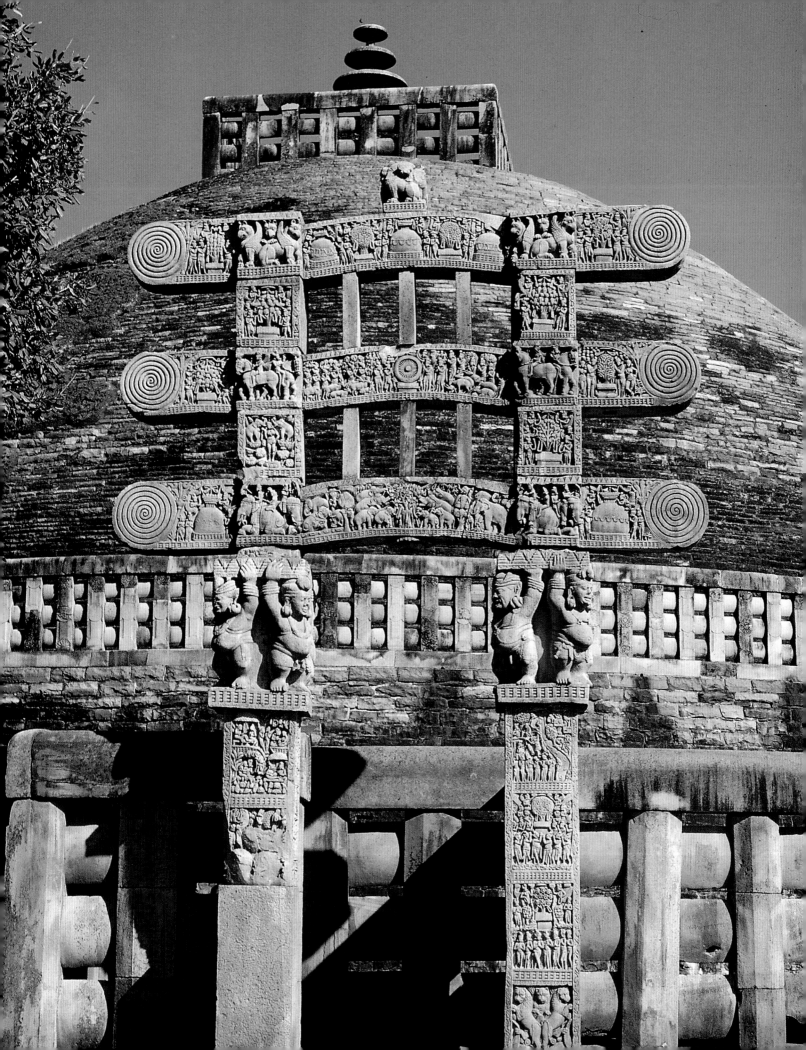

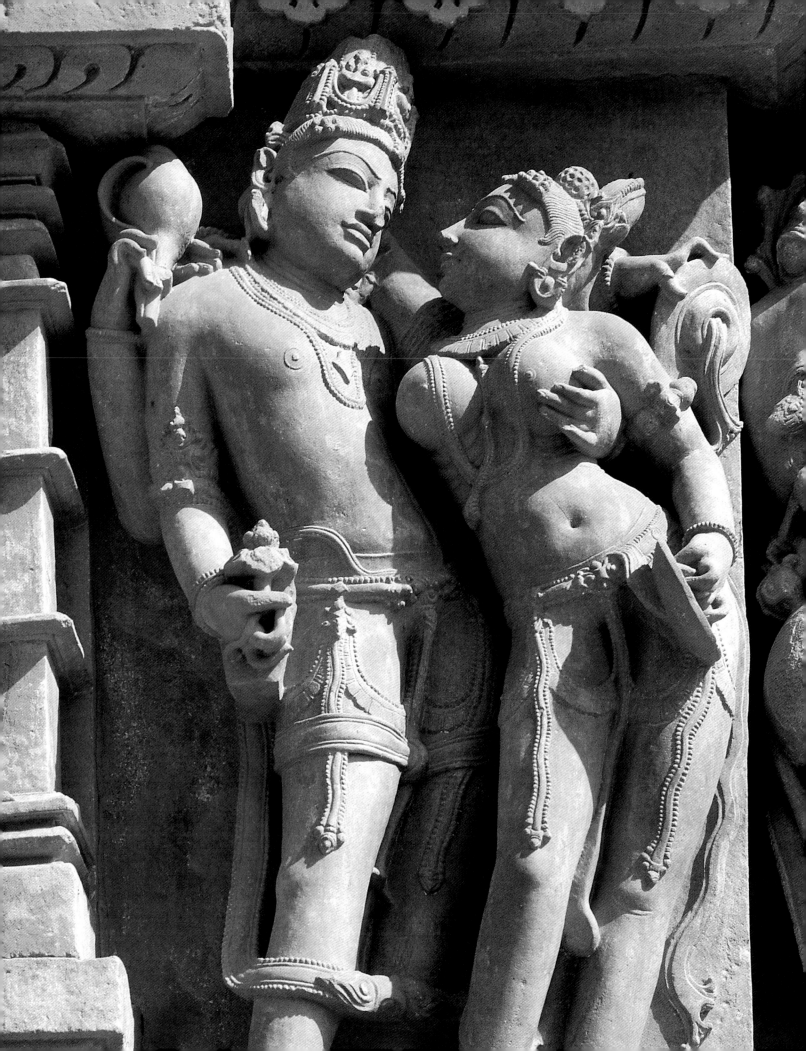

Khajuraho:
the Temple of the Senses

118-119 *The largest and most impressive of the temples at Khajuraho is that of the Kandariya Mahadeva, dedicated to the god Shiva. Completed in about 1030, it shows an architectural style at its most developed. The temple sits on a high plinth, divided from the spire by the openings* *of an ambulatory passage around the shrine. Above this, the spire symbolises the sacred mountain which is the home of Shiva. It rises in stages from its surrounding towers, to a peak which culminates in a pot-shaped finial symbolising material and spiritual well-being.*

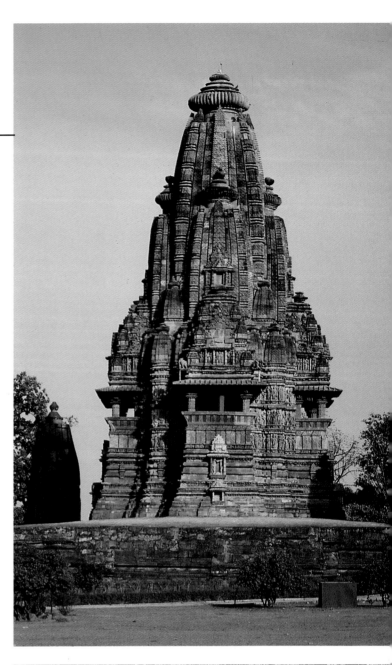

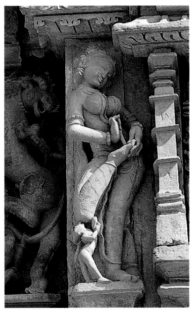

118 *Friezes around the Khajuraho temples depict human life in all its aspects. Perhaps best known are the sculptures which provide an unashamed depiction of love and desire, as exemplified by this graceful couple.*

119 left and centre *Many of the sculptures depict heavenly nymphs in a number of postures. Here, one is adorning herself (left) and the other takes a thorn out of her foot (right).*

119 top right *The Kandariya Mahadeva temple rises in all its majesty.*

119 bottom *The Kandariya Mahadeva temple has three bands of sculptures running around its walls. Here we see some of the many figures, whose forms are subtly varied by the interplay of the recesses and projections of the walls, providing a constantly changing angle of view to the onlooker.*

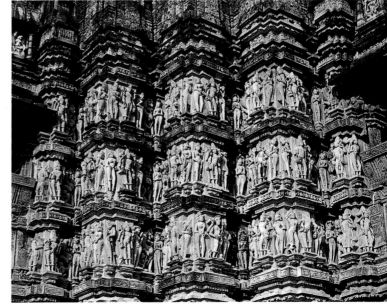

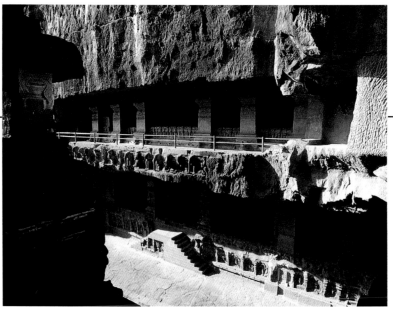

The Caverns
of Worship

120 *At Ajanta, in the region of Maharashtra, it is possible to see caves, used as monasteries and prayer halls, that were cut directly into the living rock during eras as far back as the second and third centuries B.C.*

121 top *In Bombay harbour lies Elephanta island, on which is a cave shrine cut from the rock in the 8th century. It contains nine massive panels on which are carved aspects of Shiva. This picture shows Shiva as lord of the dance.*

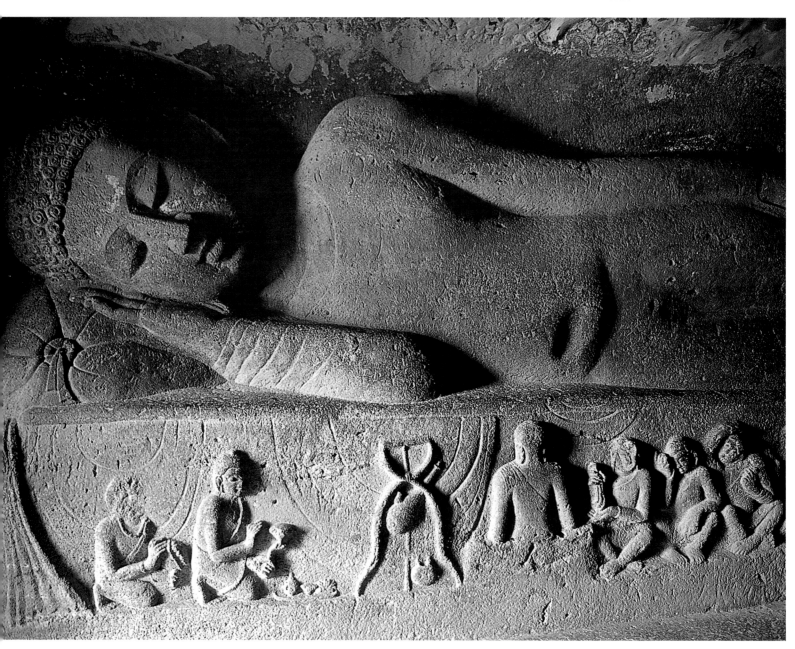

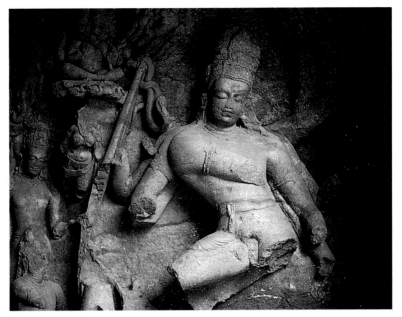

121 bottom *Three miles from the Hindu temples of Bhubaneshwar are the rock chambers at Udayagiri, constructed in the 1st-2nd centuries B.C. In this photograph we see the Queen's Cave.*

122-123 *Jains form a numerically small minority on India's religious map. Most live in western India, and it is here that their main centres of worship are situated. One of the most important is at Mount Abu in Rajasthan.*

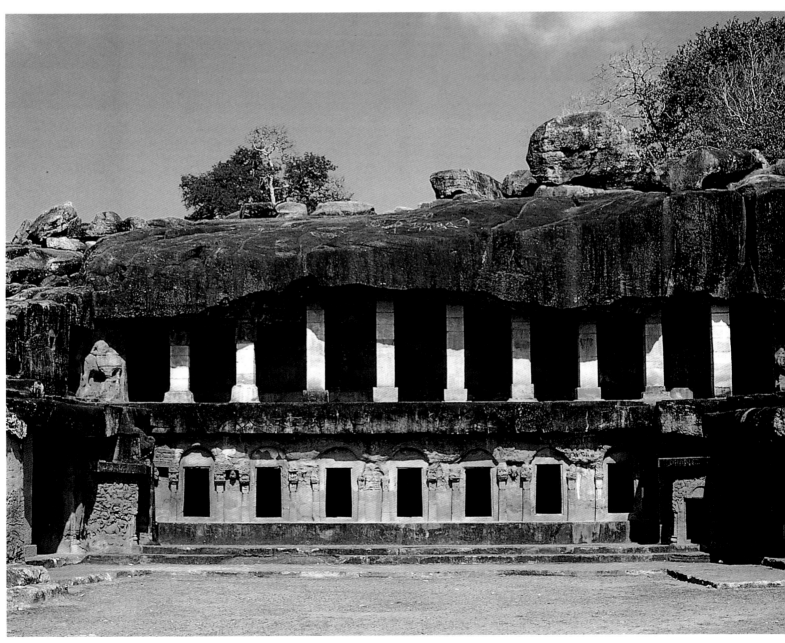

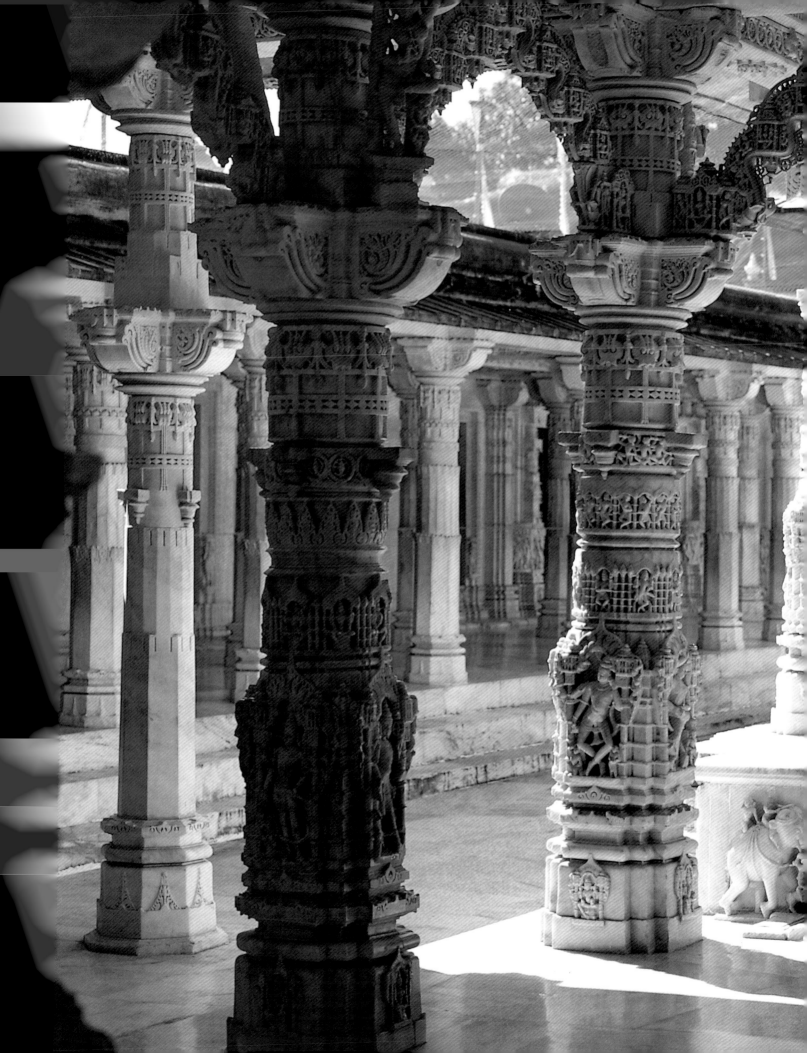

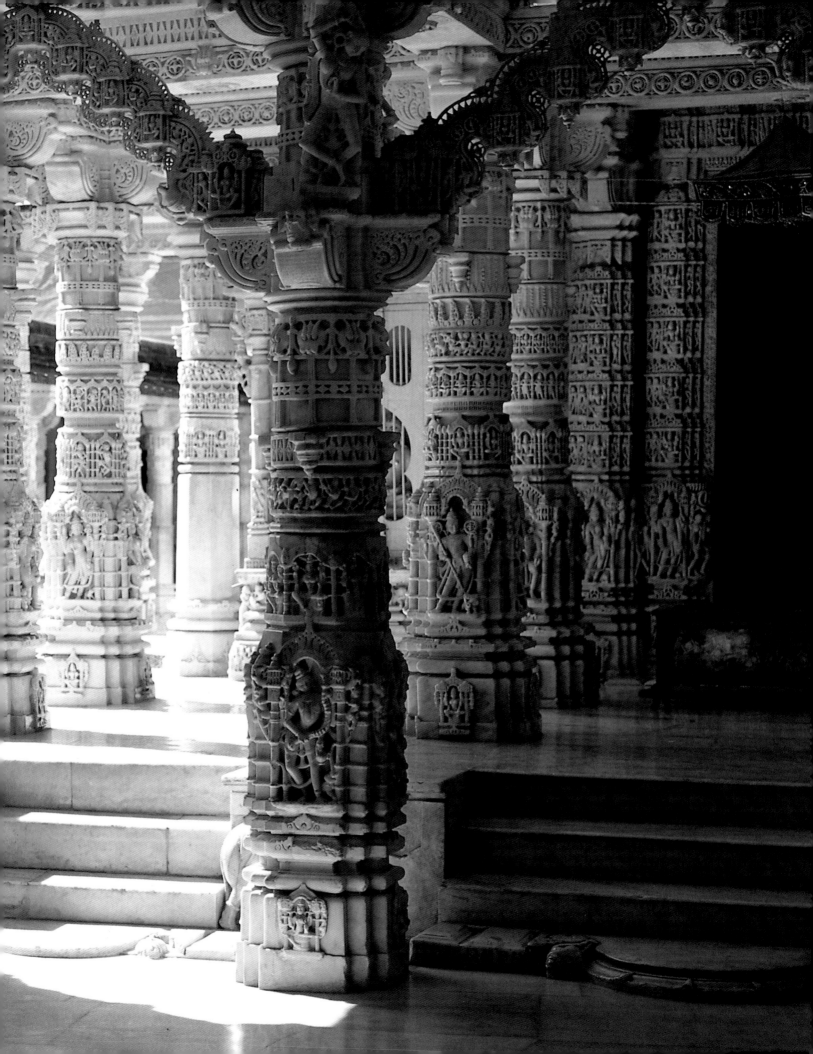

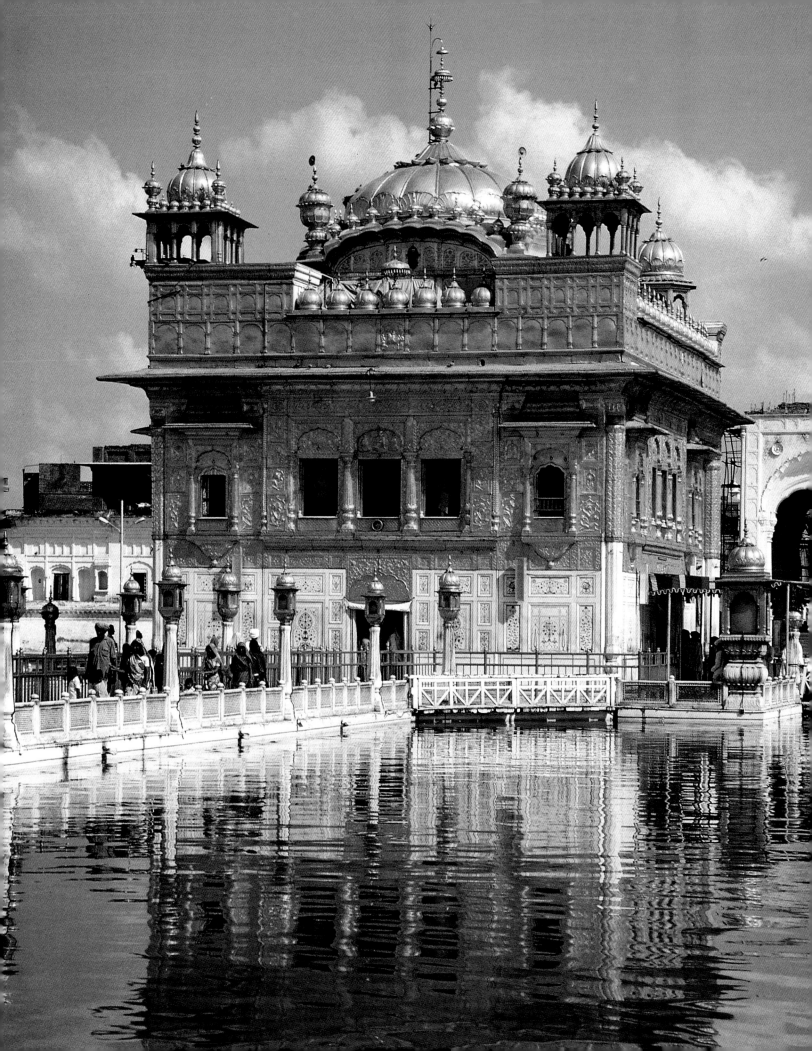

The Glittering Splendour
of the Golden Temple

124 *The religious focus of India's Sikhs is the Golden Temple at Amritsar in the northern state of Punjab. Completed in 1601, it stands in the "Pool of the Nectar of Immortality", identified as sacred by the 4th Teacher (guru) because of the healing qualities of its water. Within the temple, the sacred Book is read, and pilgrims pass in a perpetual flow. Sikh temples are called "Doors to the Teacher" (gurudvara), and are open to all.*

125 top *The first floor inside the Golden Temple has a balcony which overlooks the hall where the Book is placed. Here, pilgrims can sit and listen to the chanted readings of the hymns of which the Book is made up.*

125 centre *A Sikh and his family pay a visit to the Golden Temple. He and his sons wear the five insignia of the*

Sikh fellowship - uncut hair, a comb to keep the hair in place, under shorts (a symbol of preparedness to defend the faith), a sword or dagger, and an iron bangle.

125 bottom *A Sikh bathes with his son in the holy pool; behind is the Golden Temple. He carries his dagger in his turban. His son's hair is tied in a topknot and kept tidy with a head covering.*

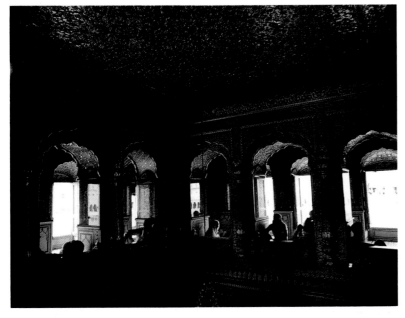

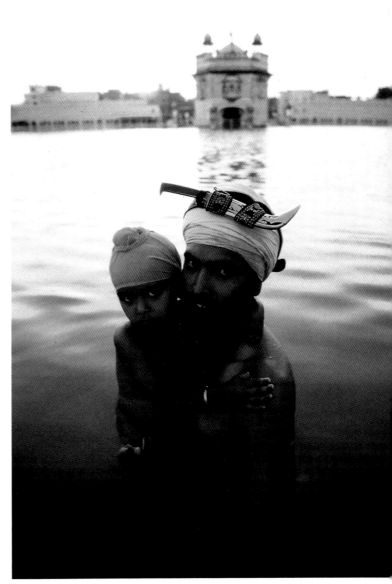

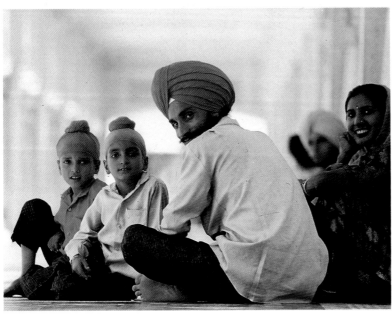

Ladakh, the Medieval Spirit

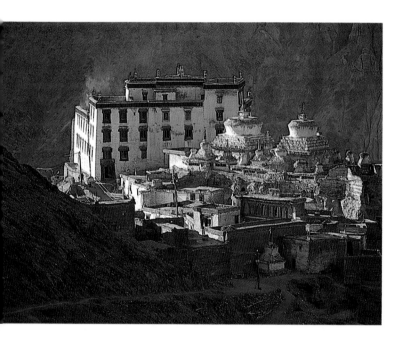

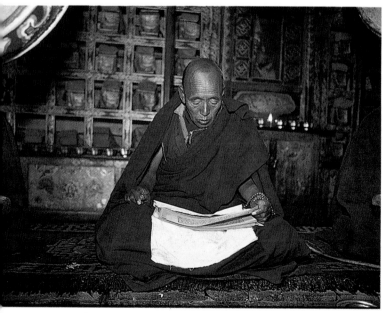

126 top *Lamayuru, considered to be one of the oldest monasteries in Ladakh, has long been a major religious and cultural centre. The complex is composed of numerous buildings which house countless deities and incarnations of Buddha.*

126 bottom *A lama is shown, intently reading the sacred scriptures in a hall in the monastery of Thikse, in Ladakh.*

126-127 *The serene countenance of Buddha illuminates the richly adorned walls of one wing of the monastery of Thikse. This giant statue, which depicts the Maitreya in a seated position, is two storeys tall.*

128 *The statue of a Hindu deity shown in this picture is housed in the Mayuranatitasvamin temple at Mayuram, in the Tamil Nadu region.*

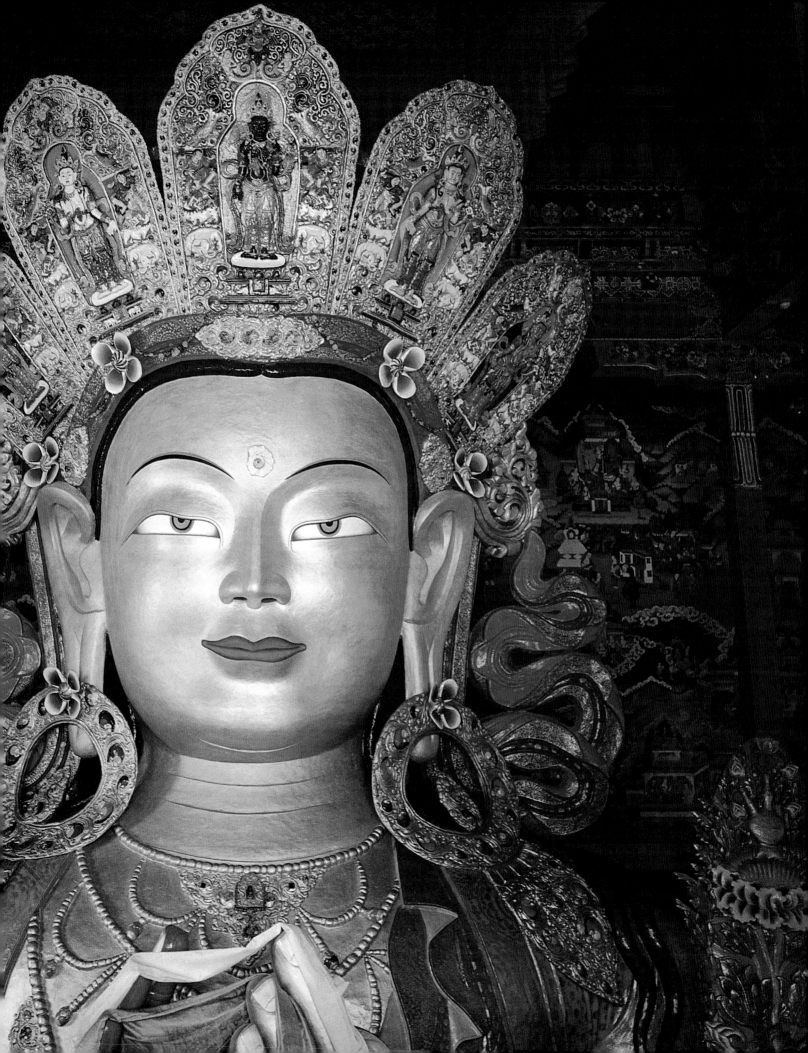

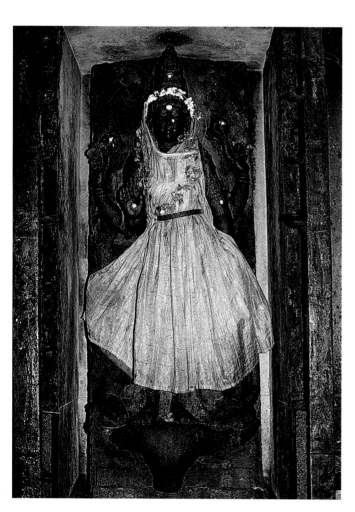